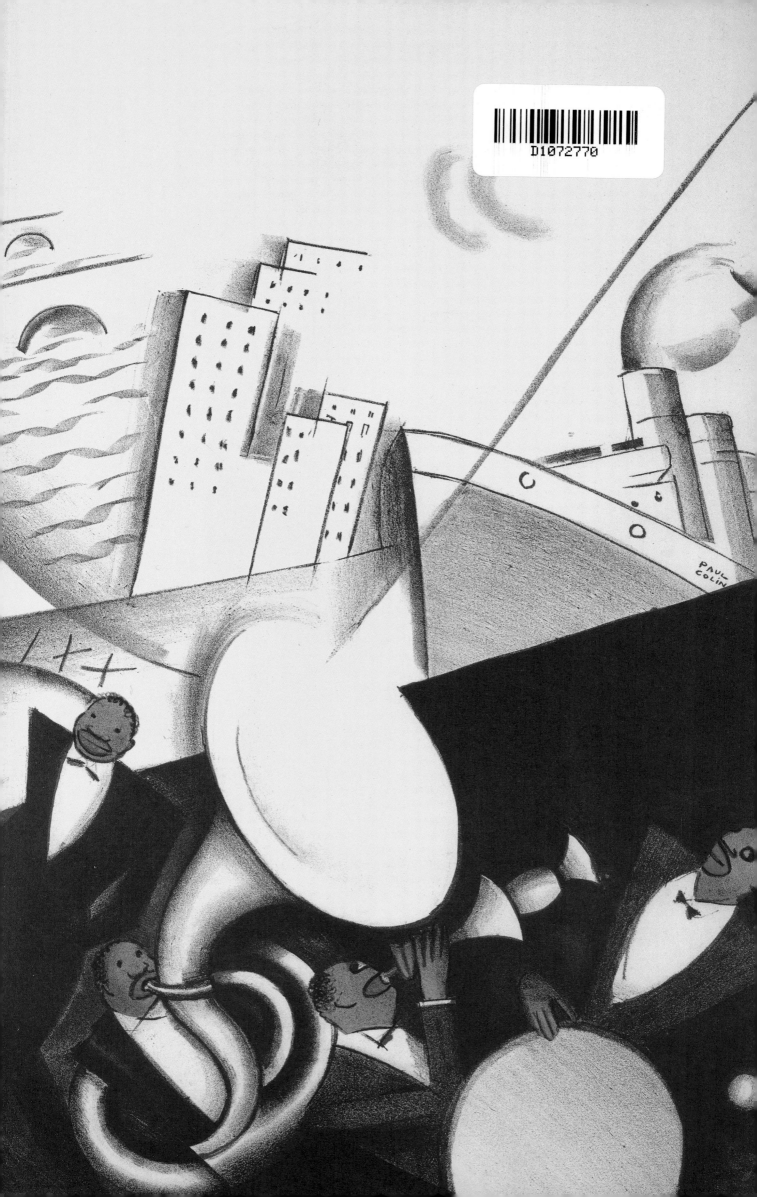

THE JAZZ AGE IN FRANCE

THE JA

JAZZ AGE IN FRANCE

CHARLES A. RILEY II

Everyone was there in the 1920s:

Pablo Picasso

Fernand Léger

Ernest Hemingway

Coco Chanel

Sergei Diaghilev

Gertrude Stein

Cole Porter

Josephine Baker

Gerald and Sara Murphy

F. Scott and Zelda Fitzgerald

Harry N. Abrams, Inc., Publishers

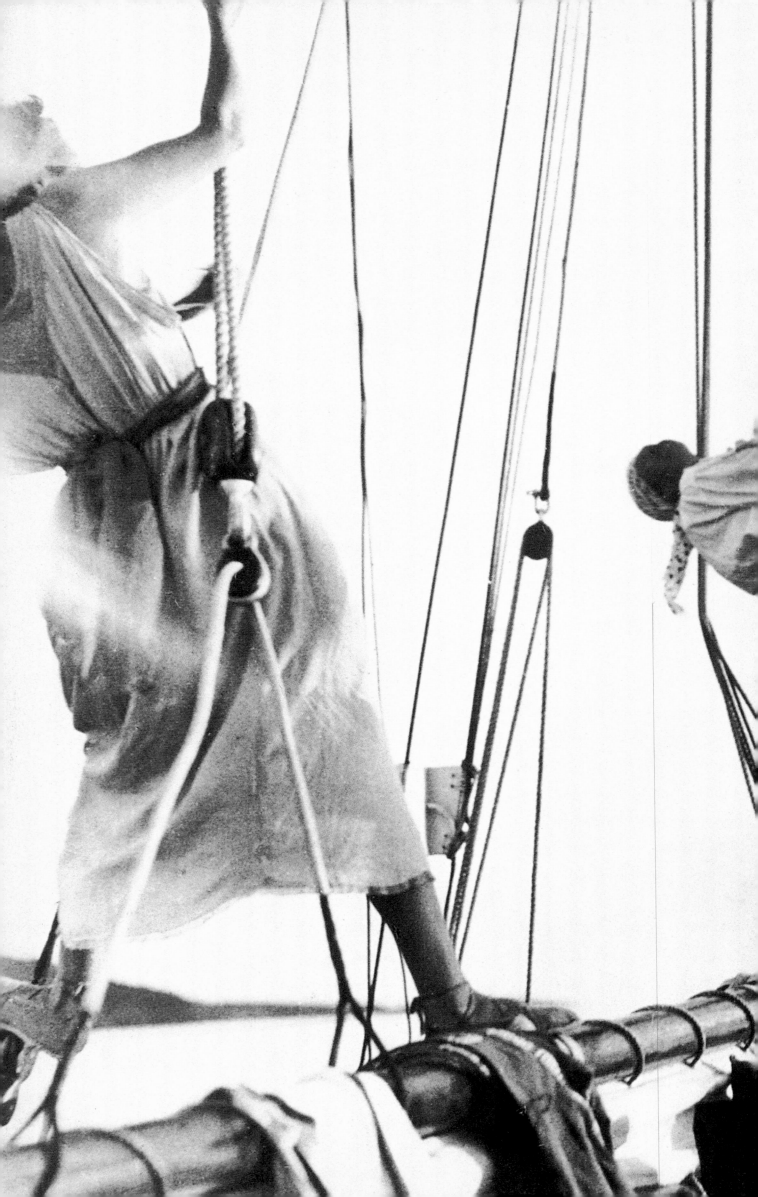

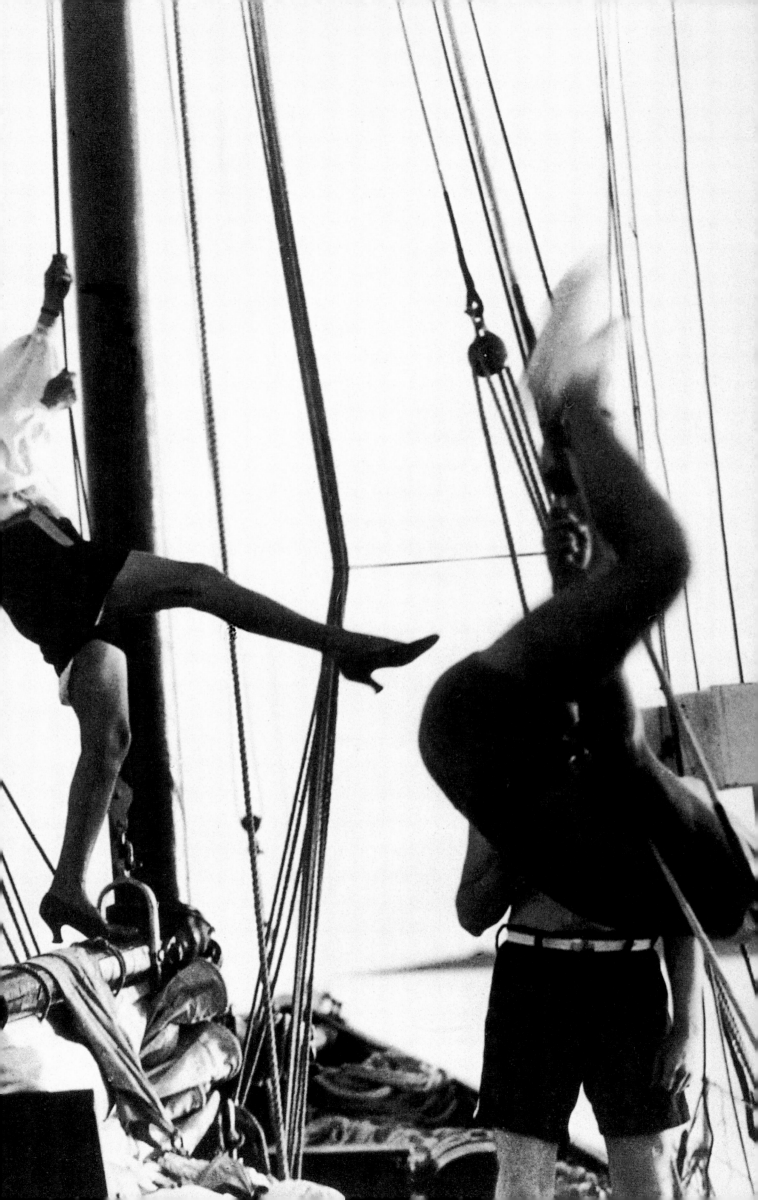

Project Manager: Margaret Kaplan
Editor: Sharon AvRutick
Designer: Judy Hudson
Production Manager: Maria Pia Gramaglia

Library of Congress Cataloging-in-Publication Data
Riley, Charles A.
The Jazz Age in France / Charles A. Riley II.
 p. cm.
Includes bibliographical references and index.
ISBN 0-8109-5578-4 (hardcover)
1. France—Social life and customs—20th century.
2. France—Intellectual life—20th century. 3. Arts—
France—History—20th century. 4. Americans—
France—History—20th century. 5. Artists—France—
History—20th century. I. Title.
DC33.7.R475 2004
944'.3610815—dc22
2004009022

Printed and bound in Singapore

10 9 8 7 6 5 4 3 2 1

Harry N. Abrams, Inc.
100 Fifth Avenue
New York, N.Y. 10011
www.abramsbooks.com

Abrams is a subsidiary of
LA MARTINIÈRE
GROUPE

endsheet
In Paul Colin's hand-stenciled lithograph (pochoir)
for the portfolio *Le Tumulte Noir* (1929) he uses sharp
contrast and strong rhythms to portray a shipboard
big band.

pages 4–5
Gerald and Sara Murphy's yacht, the *Weatherbird,* was
the scene of much carousing. Left to right: Ellen Barry,
Sara, and the playwright Philip Barry, with Gerald in
the stern.

page 7
The daughters: Fanny Myers, who became an artist
with Gerald's encouragement, and Honoria Murphy
aboard the *Weatherbird.*

For my dear sister Robin, who opened the door to magnificent art,
memorable lives and letters, and the pleasant people who attend greatness.
With my heartfelt gratitude for sharing with me the initial step in this
lovely voyage into another, better, era.

Preface

The pleasures of compiling a book of this kind are manifold. Who would mind homework that includes listening to Cole Porter albums, rifling through manuscript boxes in the rare books rooms of Yale, Harvard, and Princeton, or sitting in the private "killing room" of a 57th Street gallery while the enthusiastic proprietor summons his favorite Parisian paintings of the twenties from the storage area? Even after earning a doctorate in literature, I found it refreshing to romp for the first time through dazzling but challenging writings by Archibald MacLeish, Jean Cocteau, E. E. Cummings, and John Dos Passos, unjustly neglected in our politically correct era. A similar treat was in store as I revisited evergreen masterpieces by F. Scott Fitzgerald and Ernest Hemingway, Pablo Picasso, Fernand Léger, and George Balanchine, recalling first encounters during blissful morning seminars at Princeton, Saturday matinees at Lincoln Center, or Sunday afternoons at the Museum of Modern Art. I do get a kick from artistic greatness, and this volume is loaded with examples of it, from paintings to snippets of poetry (including Porter's witty lyrics) and purple passages from the classics. I also relish the opportunity to bring neglected work out of the shadows, and these pages present unpublished works of art, texts, and photographs that were thrilling to unearth.

This book is about the pleasures of the twenties: its brilliant art, music, architecture, fashion, and writing; about a time when the bubbles were still in the champagne and personal tragedies as well as global ones were still in the offing. Call me naive, but I prefer the pre-1929 hilarity and bonhomie of these circles to what precipitously followed. Rather than discourse upon the perils of alcoholism every time Fitzgerald picks up a glass, or lower my voice suggestively whenever Picasso and Sara Murphy are alone on the beach at La Garoupe, I am taking a hint from the artists themselves and concentrating on the moment and the beauty at hand. This is what strikes me as the overlooked aspect of the era, owing to our posterior view of it as a prelude to disaster, the tragic image of the "Lost Generation" in all its decadence and fatal excess: What about the gorgeous, exuberant, sunny yet prescient art it produced? That is where this celebration begins and ends, interlaced with the cheerful

bits about the wild times and solid friendships that, in their plenitude, make me jealous. Who would not wish to have been there? Without doubt there was a dark side. One only has to recall those shattered Venetian glasses the Fitzgeralds flung over the edge of the Murphys' terrace, the broken hearts Picasso left behind, the deterioration of Nijinsky's mind. Elsa Maxwell had a point when she complained, "Nothing spoils a good party like a genius." However, it is also true that these glittering stars, when gathered by the Murphys at Antibes, Diaghilev or Coco Chanel in Monte Carlo, or Gertrude Stein in Paris, spurred each other on to greater heights.

Putting a premium upon the unpublished, the neglected, and the unfamiliar led to a wonderful treasure hunt through galleries, museums, and family collections in old houses and apartments, from Paris to the Hamptons, wherever the echoes of the Jazz Age might linger. Like an archaeologist dusting a ceramic shard, I had the unforgettable frisson of first encounters with paintings, manuscripts, photographs, and objects that directly brought me in touch with a world I had known through books, recordings, or museum highlights such as Picasso's *Woman in White* (a portrait of Sara Murphy, according to some) or Murphy's *Cocktail* — a highlight of the Whitney Museum's permanent collection even though it is less familiar to informed art lovers than comparable works by Edward Hopper or Stuart Davis. This is one of the reasons for including virtually all of Murphy's oeuvre in these pages. When I have mentioned the book to art professionals, the universal response has been a hearty call for any means of bringing Murphy's work to the fore again (the 1974 Museum of Modern Art retrospective's catalogue was in black and white, so this may be the first time that some of these paintings have been reproduced in color). Murphy is one of the genuinely undervalued pioneers of twentieth-century American painting.

Another thrilling aspect of putting together a treasure chest like this has been the opportunity to meet the descendants of many of the major figures of the twenties. A gesture, an expression, a glint in the eye as talk turns to memories of the beach at Antibes — split-second vestiges of the past in which we catch

a momentary glimpse of what it may have been like to enjoy a tête-à-tête with Murphy, Fitzgerald, Dos Passos, Cummings, and the others, were as precious to me as any material souvenir of the Jazz Age. I have never been so convinced of the potency of genetics as I was, for instance, sitting one summer afternoon in the open window of a bistro on Park Avenue across a small table from Richard Myers Brennan, grandson of two of the nicest people in this story (Alice and Dick Myers). His forebears were among the most generous and artistically savvy of the American couples in Paris and in some ways rivaled the Murphys in supporting artists in distress. Magnanimous, brimming with ideas and enthusiasm, spontaneous in his support, artistic in his own right (he is an architect and serious amateur musician), and just plain fun, Brennan measured up in every way to his brilliant grandparents. Sitting there with him talking about the accomplishments of the Antibes set, I came close to sampling the high level of conversation — and the wit and charm — that filters down through the letters of his grandparents that I read at Yale's Beinecke Library some weeks later. It is also there in memoirs of the literary stars of the period and reflected in the smiling faces we see in the photographs. Richard Brennan supplied the phone numbers of John and Laura Donnelly, grandchildren of Gerald and Sara Murphy and keepers of the archives, and a delightful series of phone calls ensued as I pursued the intimate images you see in these pages. Similar encounters with Nathaniel Benchley, the witty grandson of a great wit (Robert), Charles Scribner III, and Patrick Hemingway convinced me that it would have been fascinating to sit with all their grandparents under the famous linden tree at the Murphy's Villa America or at a Montparnasse restaurant, and permit the conversation to wend its course like the smoke of a Gauloise winding upward and around quips about the latest ballet, a fresh Josephine Baker scandal, a recent studio visit, the publication of a novel, an imminent society divorce, or the politics of a changing Europe.

This all began with a lecture series on the Lost Generation at Hutton House, a delightful pseudo-Georgian mini-mansion on the Gold Coast of Long Island just around the corner from both Gatsby's estate and the Piping Rock Club, where Cole Porter was injured when he fell from a horse. Following one public question-and-answer session, a few audience members descended on the lectern for more private chats. Waiting patiently behind them was a gentleman named Paul Sheeline — his name instantly recognized since his son, Bill, not only played hockey against me from the

age of eight but became my next-door office colleague as a reporter for *Fortune* magazine. Mr. Sheeline wanted to reminisce about his time as a child playing with Jack "Bumby" Hemingway, Ernest's infant son, on the beach at Antibes, where Gerald Murphy was very much in charge. As delightful as it was to lecture on the Olympian figures of the period, I doubt I would have pursued this project if it had not been for the simple words of Mr. Sheeline, "I remember Bumby on that beach." That is a veritable abracadabra for a writer, unlocking curiosity about what it was really like to be in that lucky circle, to leave these shores and test one's talents in France among the world's greatest artists, composers, and writers. His reference opened the doors to the sources of many of the intimate photographs you see in the pages that follow. Sadly, he passed away as the manuscript was in progress. I had looked forward to giving him one of the first copies of the finished book, which will now go to his son with my heartfelt thanks.

On the subject of support, let me acknowledge where I was most fortunate. My editor, Margaret L. Kaplan, furnished enthusiasm tempered with guidance all the way through the process of bringing the idea into a finished book. She is not only an editor of genius on the page but a trustworthy and discerning guide to the finer points of balancing nostalgia and originality, anecdote and art. For saving me from repeated syntactic and other embarrassments, and adding those all-important final touches to the manuscript, I am deeply indebted to Sharon AvRutick. Our ingenious designer Judy Hudson more than met the challenge of combining so many images, from masterpieces of painting to fragments from a scrapbook, in one flowing visual narrative.

The geniuses in France had their circle of friends and mentors; I had mine. My heartfelt thanks are reserved for those whose suggestions and support meant so much as the book moved forward, including Richard and Pat Armstrong, Nathaniel Benchley, Richard Myers Brennan, Liz Burns and her colleagues at the Cutchogue Free Library, Charlie Clough, Patrick Cullen, Charles Dietrich, John and Laura Donnelly, Asher Edelman, Lisa Hahn, Hally Harrisburg, Byron Holinshead, Richard Milazzo, Leonard Milberg, Mark Milloff, Peter and Barb Peck, Ken Perko, Barbara Ernst Prey, Michael Rosenfeld, Kay Sato of Hutton House, Lydia Schmid, Richard Sellery, Robert Straus, Anna Lynn Swan, Raoul and Bettina WitteVeen, and many others.

The photographs and works of art, many of them seen here for the first time, were assembled from far and wide, with the kind

assistance and patience of a large cast of characters without whom this book would never have reached this stage. Allow me to extend my heartfelt thanks to Amanda Ameer, Timothy Baum, Matthew J. Bruccoli, Alejandro M. Carosso, Katherine B. Crum, Rebecca Warren Davidson, Anita Duquette. Brian Eckert, Norman Friedman, Victoria Gelfand, Jennifer Gibbons, Charles E. Greene, Janet Hicks, Margaret Howland, Wendy Hurlock, Eric T. Larsen, Ken Lopez, Amy Munger, Susan Nurse, Anna Lee Pauls, Ben Primer, Erica Prudhomme, Sandra Roemermann, David Savage, N. Elizabeth Schlatter, Michael Stier, Mark E. Swartz, Jennifer Vohrbach, Richard Warren, Robert Pincus-Witten, and Gabriele Woolever.

If I learned one lesson from my homework, it was that writers and artists thrive on a steady diet of love, and in this I am most blessed. Liu Ke Ming, my answer to Sara Murphy, my *epinoia,* was my cheerful partner throughout this romp among the Jazz Age greats. My mother was the testing ground for anecdotes and ideas, her perfect taste and unflagging interest a constant aid. My sister Diane tapped her considerable literary background to remind me of books I should mention or consult, while our sister, Robin, started this ball rolling by inviting me to speak on the Jazz Age and continually supplying her dog-eared paperbacks, helpfully annotated, about the women of the period, including Zelda Fitzgerald, who receives far better treatment in these pages (I was never a Zelda fan, frankly) because of her. My cousin Stephen Horne remains my most trusted consultant on art and technique.

Echoes of the Jazz Age are everywhere. The fashion seasons often mention shades of Gatsby in the periodic return to elegance, the best of Broadway is Cole Porter redivivus, one of the most successful Metropolitan Opera commissions of the past few seasons is John Corigliano's *The Great Gatsby,* now in the repertoire, while the trends section of the *New York Times* carries stories about flapper dinner parties or the perpetual rediscovery of the martini. It all may have been "just one of those crazy flings," but it has lasted far longer than anyone might have dreamed.

THE CEREMONY OF INNOCENCE

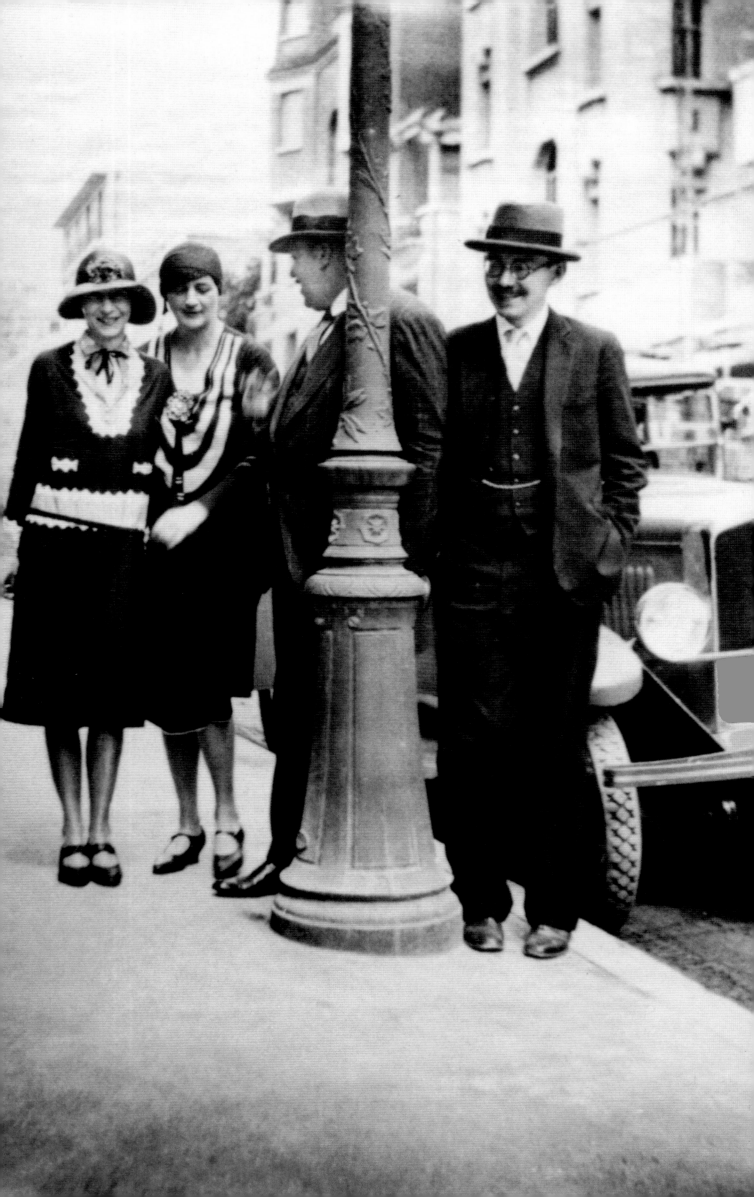

The Jazz Age, that blissful pavane of parties without end, exerts its timeless pull upon our envious imaginations. The players in the drama were the beautiful people who made the world more beautiful with their art and wit, the *jeunesse dorée* of a fabled interval between world wars gathered about a core group of Americans in Paris and on the Côte d'Azur: Sara and Gerald Murphy, F. Scott and Zelda Fitzgerald, Ernest Hemingway and a bevy of muses, John Dos Passos, E. E. Cummings, Man Ray, Archibald MacLeish, Dorothy Parker, William H. Johnson, Elsa Maxwell, Virgil Thomson, George Gershwin, and Cole Porter. Their European counterparts (teachers and friends) were such luminaries as Pablo Picasso, Fernand Léger, Jean Cocteau, Sergei Diaghilev, Natalia Goncharova, George Balanchine, Coco Chanel, Erik Satie, Raoul Dufy, and André Derain.

For many art and literature lovers, the artistic community in France during the twenties represents the first pick of history's most glorious gathering of people in one place at one period. It offers the ideal mix of personalities and ideas, talent and fun, elegance and edge. Drawn by an emergent tolerance for the avant-garde in the arts, the American painters, composers, writers, and designers who headed to Paris and founded an artists' colony in Antibes took on the risks of Modernism and, trailed by collectors and patrons, reaped the rewards of mutual inspiration. Their French hosts found the newcomers refreshingly energetic and liberating. The results were nothing less than dazzling. The powerful outpouring of highly original fiction, music, paintings, choreography, fashion, and interior design was so profuse that it belies the brevity of the period itself — scarcely a decade, beginning in 1918.

"Art is a circle," Manet once observed. "You are either in or out." That truism, as apt in our own time as it was in his, is especially suited to the Jazz Age. The roles assumed by the various "players," from moneyed patron to impoverished artiste, earnest amateur to Olympian genius, the saints and sinners, the pioneers and the hangers-on, were shaped within a group dynamic. It may seem as though they all knew each other well, but there were a few interlocking circles involved. At the center of each, picture a maypole, that charismatic figure or couple around which the others danced in tethered attendance. Sara and Gerald Murphy's

familial embrace in Antibes may have been the most fun and best-documented center of a notable circle, but there were others. Picasso was the artistic focus of Montmartre. Diaghilev drew crowds in Monte Carlo. An invitation to Cole and Linda Porter's apartment in Paris separated the "in" from the "out" expatriates, while Coco Chanel's address book served the same function among the Europeans. Gertrude Stein and Sylvia Beach shared the honors for the Parisian literary set, at least until Hemingway, later in the decade, became a magnet for the journalists-turned-novelists. When, one by one, the African-American painters who had begun the era in Harlem crossed the Atlantic, the éminence grise each sought was Henry Ossawa Tanner, who had already been in Paris for years. The maypoles were focal points in the revelry, nodes of mutual support and inspiration, high-spirited connections, and keys to the all-important patronage that characterized the era.

The guest lists of some of the Murphy soirees alone compose a dazzling roster of the great minds of the time, from Picasso to Diaghilev to Stein and dozens more of the leading figures. What more attractive combination of pleasure and creativity can one find? While the fetes were phenomenal, we must also remember that the personalities in attendance made some of the greatest masterpieces of the twentieth century, including many works that have fallen into neglect. The joy of revisiting a subject as storied as the Jazz Age is prompted by the opportunity to make new discoveries. Consider their taste in the visual arts. Hemingway the macho wordsmith turns out to be a connoisseur of contemporary art. Porter, Dos Passos, and Cummings, the glib populists, harbored a passion for drawing and painting. Diaghilev, who commissioned many of the greatest painters of the day, began his professional career as a renowned art curator who was always eager to teach his dancers in museums during their rare days off on tour. Even Zelda Fitzgerald, quintessential hyperactive flapper, spent hours before her easel. The closer you look, the less like caricatures these gifted personalities are, and the fuller our appreciation grows of their many achievements.

Leafing through these pages, the reader may be charmed or even astonished, as I was, by the range of what they knew and did. This spectrum of capability seems to hark back to

Innocents abroad: Richard and Alice Lee Myers with Stephen Vincent Benét and his wife, the journalist Rosemarie Carr, whom he met in Paris.

the intellectual range of the fabled nineteenth-century salon. In this day of overspecialization, it is refreshing to encounter a group that is culturally literate in the best sense of that term. The villas of the Riviera and the palatial apartments of Paris in the years *entre deux guerres* were bursting with competent, if not brilliant, creativity. Sketchbooks, sheet music, and manuscripts crowded the desktops and piano lids. The evenings were filled with art openings, poetry in recital, storytelling, amateur theatricals and dance, private chamber music, and opera performances. Well-educated dinner guests (Harvard, Yale, and Princeton predominated among the Yanks, the elite art schools and conservatories among the Europeans) had the good sense to recognize the wealth of talent at their elbows.

The young but sophisticated American contingent shared a quality that has been underplayed by biographers more taken with portraying Fitzgerald as a drunk, Millay as a vampire, Murphy as a spoiled preppy, Hemingway as a bully, and so forth. They had curiosity. That is at least in part how they wound up over there. Murphy slipped out the backdoor of his father's luxury goods empire, Mark Cross, out of a longing to explore painting. MacLeish escaped Boston and the law to test his allegiance to the mysterious pull of poetry. Dos Passos and Cummings fled rich families with high expectations to break the rules of writing and painting. Josephine Baker, Bricktop, William H. Johnson, and other luminaries of the Harlem Renaissance were exhilarated to sit down at an integrated supper table and bask in the adulation of Parisian fans. Porter, Millay, Parker, and Benchley followed their instincts for stimulus, not always healthy. Coat-tailing Hemingway and Fitzgerald, they were aiming higher in their fiction and poetry than the magazine gigs upon which they subsisted in New York.

It is by no means the claim of this book that all they did constituted major art. Many of the most charming pieces left to posterity are as casual as doodles or postcards home. However, there were ambitious and massively successful achievements — ranking as masterpieces — produced at this time, among them the monumental *Grand Déjeuner* of Léger, a stunning series of portraits of Sara Murphy by Picasso, Fitzgerald's *The Great Gatsby*, Cocteau's *Parade*, Stravinsky and Balanchine's *Apollon Musagete*, Hemingway's *The Sun Also Rises*, Dos Passos' *Three Soldiers* and *Manhattan Transfer*, Cummings' first four volumes of poetry, and Gerald Murphy's precious portfolio of seventeen completed paintings. Together with fin-de-

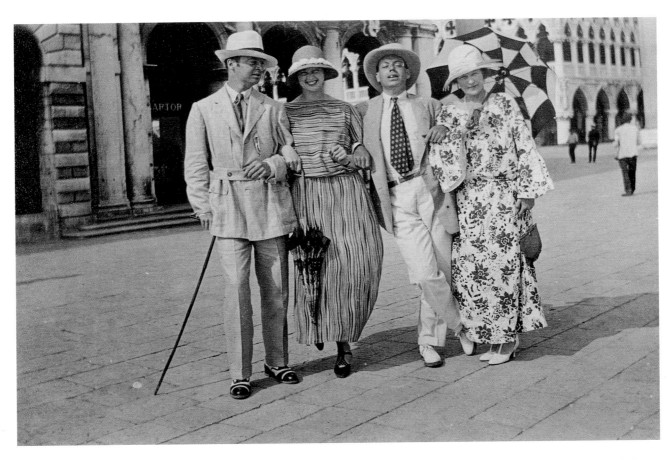

Gerald Murphy, Virginia Pfeiffer (Hemingway's future sister-in-law), Cole Porter, and Sara Murphy in Venice during the summer of 1923, when Gerald and Cole were at work on their jazz ballet, *Within the Quota.*

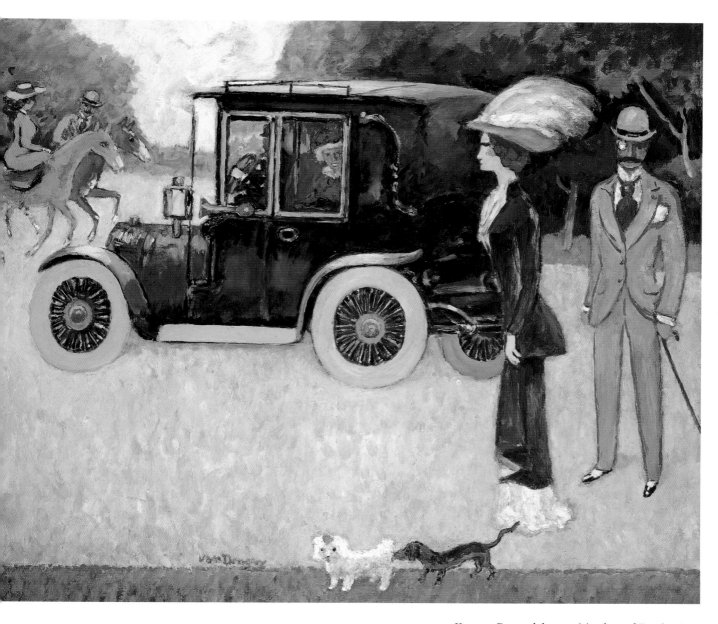

Kees van Dongen's keen satiric edge and Fauvist exuberance are felt in his *Automobile in the Park* (1925), a slice of Parisian life seen through the eyes of the colorful, Rotterdam-born painter and socialite.

siècle Vienna, Berlin and Bloomsbury in the thirties, and Greenwich Village in the fifties, Paris and the Riviera in the twenties contributed mightily to the canon of Modernism.

If there was one era that the Jazz Age most resembled, in many ways consciously, it was the Belle Epoque. The long echoes of that brilliant but brief period, barely two decades between the prosperity of the 1890s and the onset of war in 1914, were still savored by the Americans who arrived in time. After all, we forget that it was Oscar Wilde, in his play *A Woman of No Importance,* who coined the slogan, "Good Americans, when they die, go to France." Marcel Proust and Sarah Bernhardt were still alive and occasionally seen in Paris until their deaths in 1922 and 1923 respectively. Almost miraculously, many stars of Montmartre whom Toulouse-Lautrec had immortalized in posters that were already hanging in fashionable collections were, as though genuine deities, still on stage. Peering down her nose of dramatic proportions, relentlessly inscribed by Lautrec into one drawing and poster after another, the living legend Yvette Guilbert lingered to serenade the next Belle Epoque. In the twenties she performed for Murphy, Fitzgerald, and Hemingway at a club called Le Divan Japonais, her repertoire in that era an eclectic mix of medieval chansons, signature ballads such as "Le Fiacre," and jazz standards picked up during a tour of the United States. Another of the fixtures of Lautrec's cast of characters was Aristide Bruant, who until his death in 1924 was a force in the world of revues, cabarets, and café-concerts that packed as many as two thousand revelers a night into famous venues including the Moulin Rouge, the Bouffes du Nord-Concert, the touristy Folies Bergère, and the Olympia. As silly as the movie was, Baz Luhrmann's bizarre *Moulin Rouge* caught some of the insane exuberance of the hall, the surging, hungry crowds of well-dressed, wealthy patrons who turned out nightly for a dose of thrills and astonishment.

Montmartre in the 1920s had not lost its luster, thanks in part to the Charleston and exotic jazz orchestras. One knew, for example, that Mistinguett, "Queen of the Paris Music Hall," was strutting about in nearly two hundred thousand francs' worth of jewelry and finery, and that her legs had been insured for half a million francs. The press even picked up on the fifteen pounds of feathers and flowers perched on her head — Carmen Miranda, eat your heart out. Despite periodic protests on behalf of French-only shows, English was often heard onstage. Maurice Chevalier was a favorite of the Folies Bergère, and his time as a prisoner of war had partly been spent learning the lingo from British barracks mates. A Chevalier standby became the mantra of the easygoing era: "*Dans la vie faut pas s'en faire*" ("One mustn't take things so much to heart in life"). There was the stoic contralto Damia, upon whose act Edith Piaf would draw heavily. Her *Le Portrait* was recorded in 1926. In Lautrec's day, posters and magazines fanned the flames of music-hall celebrity. In the twenties the gramophone and radio blew audiences up to an undreamed-of scale. Fads thrive on mass media. Between the Charleston and the jazz virtuosi, along with the rise of professional spectator sports such as bike racing, fanaticism in the Jazz Era exceeded the benchmarks once set by ballet and opera.

The pride of the American contingent in the concert halls was, of course, the dynamo herself: Josephine Baker. She swung into Paris like a marauder. André Daven, her producer at the Théâtre des Champs-Elysées, vividly described her arrival at the Gare St. Lazare on September 22, 1925: "Out spilled a little world, rocking, boisterous, multicolored, carrying bizarre musical instruments, all talking loudly, some roaring with laughter. Red, green and yellow shirts, strawberry denims, dresses in polka dots and checks. Incredible hats — derbies — cream-colored, orange and poppy, surmounted thirty ebony faces, wild and joyous eyes." One of her massive revues was called, aptly enough, Le Tumulte Noir. For fifty years, Baker reigned, her power over the masses, the Corsican mafia, European royalty, and the expatriate elite secured by an electric blend of sexuality and exoticism, those "wild and joyous eyes" that blast out from the photographs no less mesmerizing than the charms just below the infamous banana belt, with all of which she was gloriously, uninhibitedly free. Baker not only dominated shows at the Folies Bergère and Casino de Paris — she even starred in her own operetta by Offenbach, *La Créole,* and launched a world tour in 1928. Baker's buzz surpassed by far the pallid banalities of Britney Spears, Madonna, or Michael Jackson in our time. She kept a menagerie, including a snake with which she danced, monkeys, a pig, dogs fierce as wolves (her adoptive son, Jean Claude Baker, explained that since during slavery blacks were hunted with dogs, prosperous entertainers kept them as a sort of revenge), and a cheetah she walked on the boulevards on a solid-gold chain leash. The closets of her luxurious apartments were bursting with new creations, by the couturier Paul Poiret in particular (never paid for, even after he unsuccessfully sued her), but she was renowned for gallivanting about the after-hours clubs wearing a lot less. Hemingway

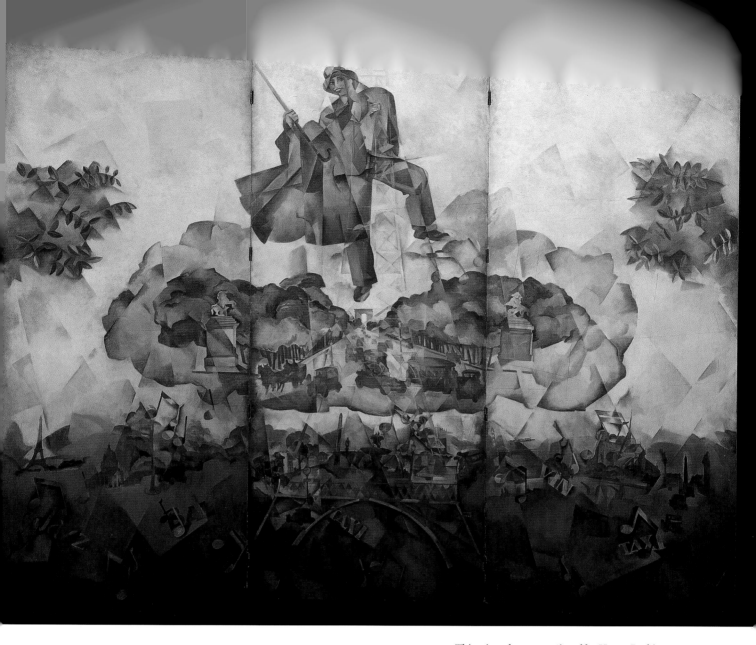

This triptych screen painted by Henry Botkin, dedicated to his first cousin George Gershwin's rapid conquest of Paris, was the centerpiece of the composer's living room all his life. Botkin taught Gershwin to paint and advised him on art collecting in Paris.

Pages 20–21:
Josephine Baker was a succès de scandale from her opening night in 1925 at the Ambassadeur, the club where Cole Porter's later revues launched his theatrical career.

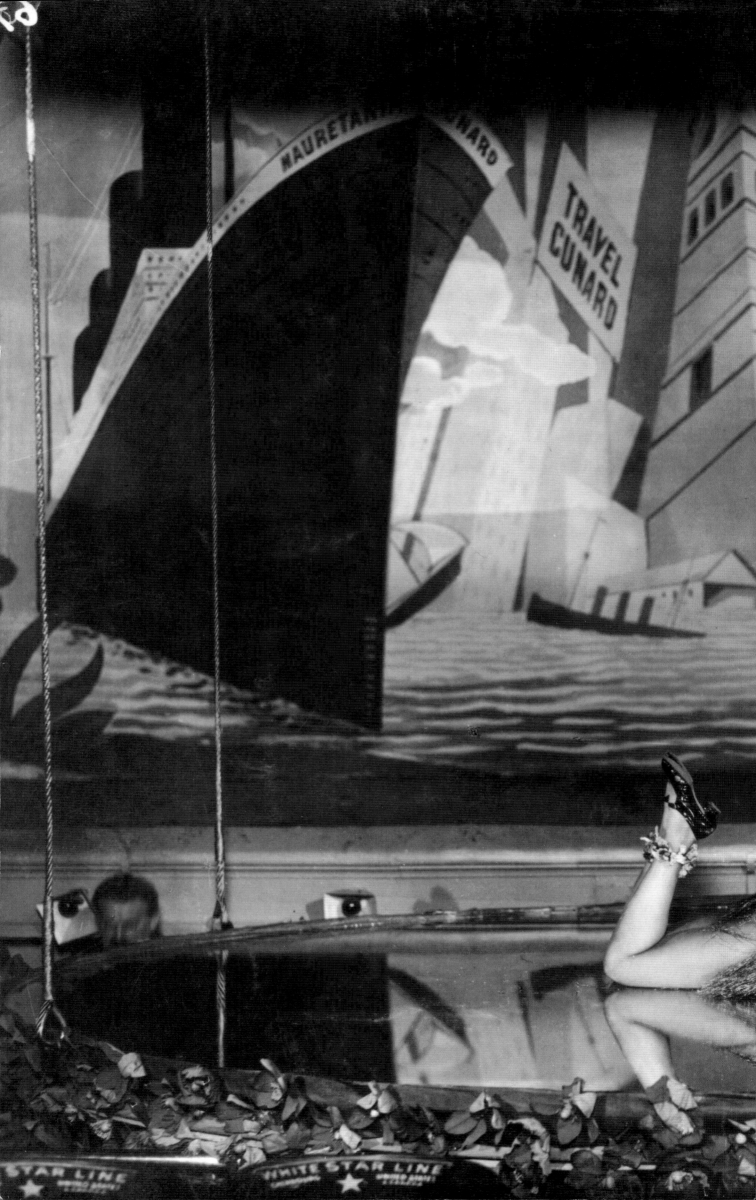

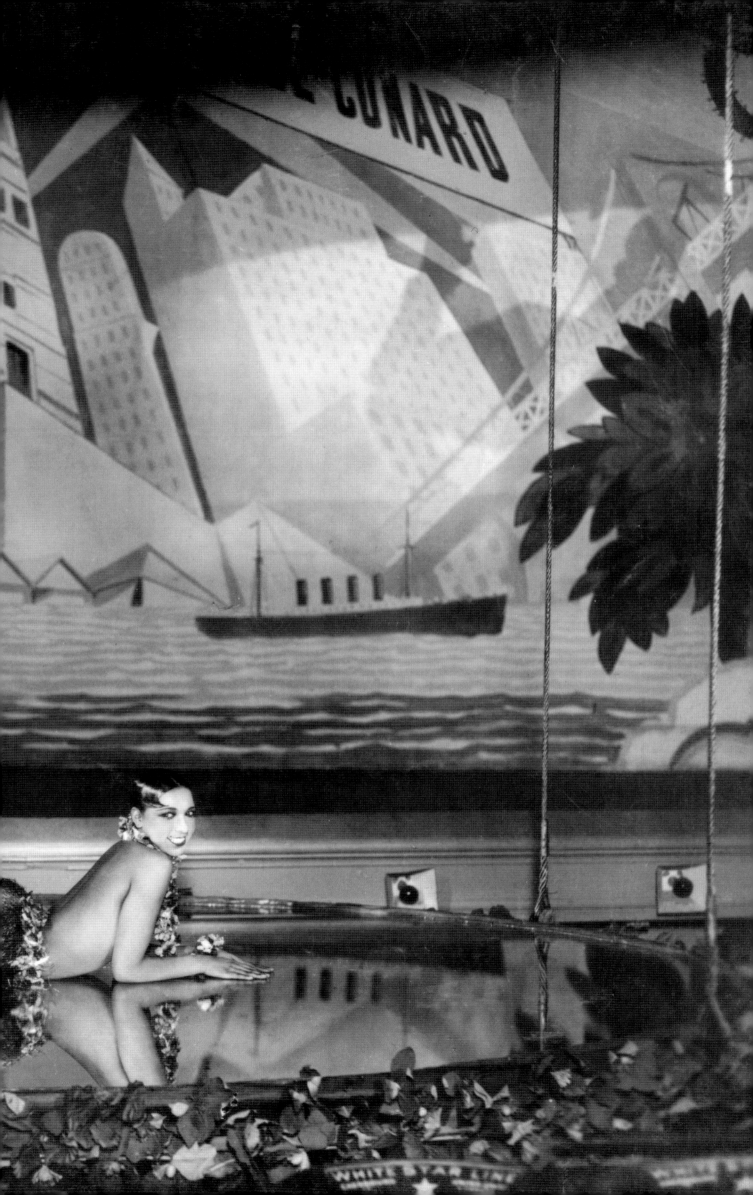

danced with her once: "Very hot night but she was wearing a coat of black fur, her breasts handling the fur like it was silk. Wasn't until the joint closed she told me she had nothing on underneath." Very hot night, indeed!

Revolutions in taste were the order of the day. If the old empires had effectively lost their political power, their styles still held sway in fashion, architecture, and society. Aristocrats found new roles to play, as artists, not just patrons of the arts. Now marginal vis-à-vis the new order in Europe, they joined the sideline forces of painters and poets whose critical eye examined their inheritors. France was a magnet for displaced nobility. The many-hued influx of Americans, English, Russians, Slavs, and others were allegorized as the harlequin to the rooster, emblem of France, in Cocteau's *Le Coq et l'Arlequin*, which alerted French readers to the rise of what we today would call "multicultural" influences on art and society. After the last of the American troops were withdrawn in 1920, the reverse tide of tourists, expatriates, and refugees was immense. While some historians suggest that thirsty Americans were fleeing the strictures of the Fifteenth Amendment (passed in January of 1920 and bringing thirteen years of Prohibition, a reflection of the chill New England Puritanism of Silent Calvin Coolidge's presidency), one can also point to the lure of France on pennies a day — with domestics, generous real estate, exemplary food, and, of course, ample wine from the right soils. The inflation-riddled franc was very weak. The British pound rapidly gained ground, from twenty-five francs to two hundred forty-three by 1926, while the dollar went from five to fifty in the same period. The party could not last forever, though. The crash of October 1929, and its fallout in foreign markets, effectively put an end to most of the dominant financial power that sustained la dolce vita through the decade.

The Americans brought more than their checkbooks. Jazz and its mentality proved a synesthetic force in Paris. From modest clubs to grand concert halls to painters' studios, *maisons de haute couture* and the literary scene, the impact of jazz was astonishing in its rapidity and breadth. The French music scene was a mad battlefield of the old and new in those days. The traditional orchestra — a sea of synchronized bows heaving under the imperious aegis of a distinguished conductor — was in the midst of transformation. The percussion section was growing, and strange new instruments were discerned among the reeds — saxophones and trombones, plucked double basses. Between the innovations of Stravinsky and the brassy new dissonances of jazz, concertgoers found themselves in a strange new world of sound even in bastions of tradition such as the Opéra Garnier and the Salle Pleyel. Other American traits that bore a family resemblance to jazz also came over — that acceleration of trends and life's pace, hammering at the venerable French love of leisure. It was a time when life became noisier, with radios and gramophones blaring, crowds cheering on professional athletes in sports such as rugby and bicycle racing (a favorite of Hemingway), wild dance trends, and an ever-surprising menu of art happenings around town. The age was named for the music that was symptomatic as well as symphonic. In the words of a contemporary critic, R. W. S. Mendl, writing in 1926:

Jazz is the product of a restless age: an age in which the fever of war is only now beginning to abate, its fury when men and women, after their efforts in the great struggle, are still too much disturbed to be content with a tranquil existence, when freaks and stunts and sensations are the order — or disorder of the day; when painters delight in portraying that which is not, and sculptors in twisting the human limbs into strange, fantastic shapes; when America is turning out her merchandise at an unprecedented speed and motor cars are racing along the roads; when aeroplanes are beating successive records and ladies are in so great a hurry that they wear short skirts which enable them to move fast and cut off their hair to save a few precious moments of the day; when the extremes of Bolshevism and Fascism are pursuing their own ways simultaneously, and the whole world is rushing helterskelter in unknown directions.

Each summer the party shifted to the South. All aboard Le Train Bleu of the P-L-M (Paris-Lyons-Méditerranée) line for the trip to the great villas of the Côte d'Azur and the pleasure palaces of Monte Carlo. Picasso, Cocteau, Diaghilev, and the lithe dancers of the Ballets Russes led the way, and the rich Americans, including the Porters, MacLeishes, Murphys, and Fitzgeralds followed. Somebody had to pay for the drinks! Nor were they the first artists to summer in Antibes. Several of the most important paintings in the history of High Modernism were created there. One of the most astonishing blue passages in the oeuvre of Paul Cézanne is the expanse of waxen azure extending across the right side of his large seascape of Estaque, now at the Metropolitan Museum. Henri Matisse lived in the tiny fishing village of St. Tropez in 1904, when it could only be reached by boat, and the drawings he made of bathers and picnicking families on

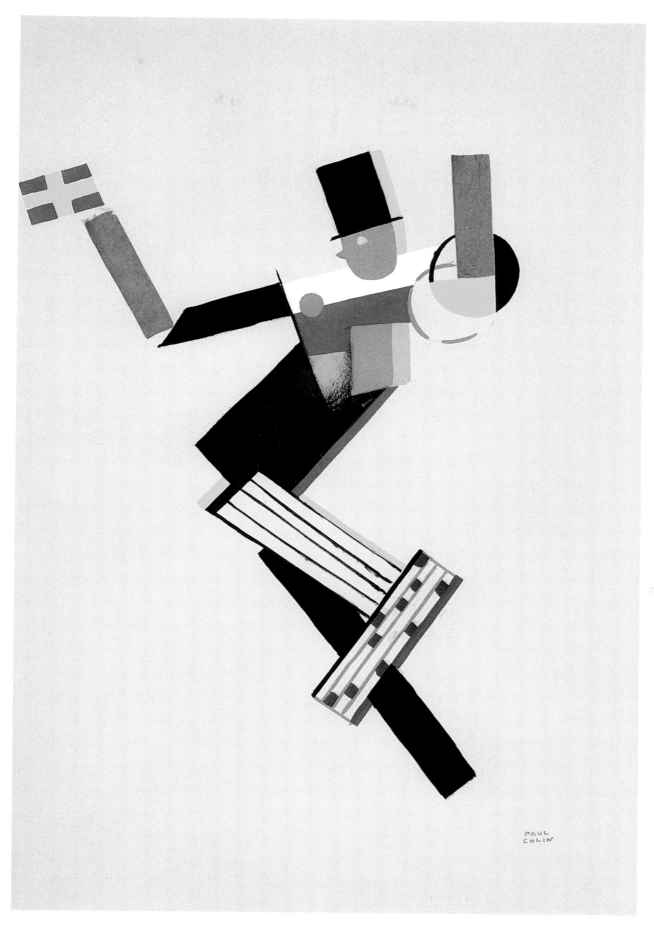

Paul Colin's Art Deco portrait of Jean Börlin,
the star and choreographer for the Ballets Suedois,
which was backed by his sugar daddy Rolf de
Maré, who also underwrote La Revue Nègre.

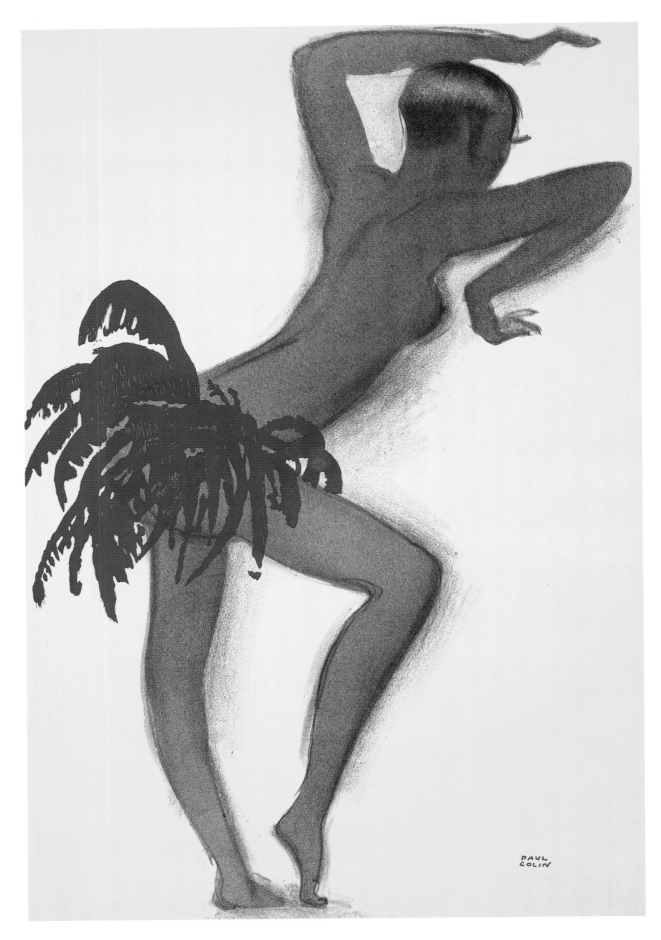

Josephine Baker in her "Danse Sauvage," an erotic pas de deux to jazz accompaniment which she performed topless, as captured by Paul Colin, who became a member of the theater publicity staff after his posters of Baker made him the new Toulouse-Lautrec.

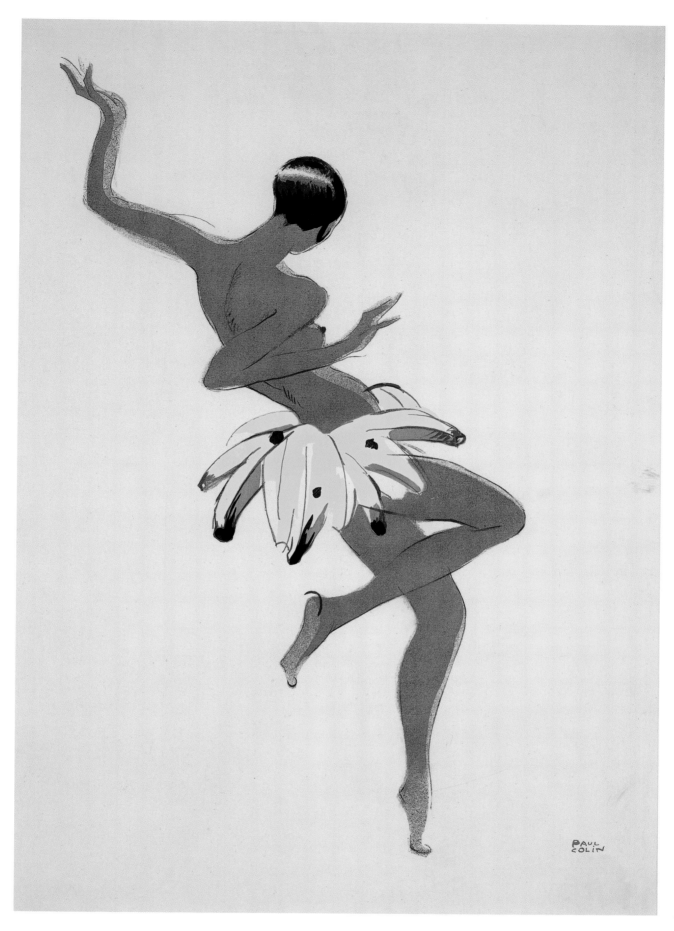

A friend of Paul Colin's at the Théâtre des Champs-Elysées, where La Revue Nègre made its debut, commissioned him to create the poster that made Josephine Baker famous across Paris and launched his high-profile career.

the beach were the basis for *Luxe, Calme et Volupté*, completed in 1905, as well as *Bonheur de Vivre*, which he began in 1905 and finished the year later.

A favorite theme of cultural and aesthetic historians is the return to the primitive in art and music, and that certainly plays its part in this story not merely in terms of Picasso and Stravinsky but as one interpretation of the role of the Americans in the French art scene. As Twain masterfully portrays them, Americans abroad play the innocents — it is part of their attraction for jaded Europeans. It can also be an artistic virtue in itself (the myth of the innocent eye, or innocent ear, has been a cog in modern art). Léger exuberantly embraced the American habits of enthusiastic risk-taking. He also detected an overall "rebarbarization" of art and culture — he had a right to after enduring the grievous initiation of the trenches of World War I. Boldly graphic paintings, sharply rhythmic music, violent dance, expletives on the printed page (Hemingway, Dos Passos, and Cummings fought bitterly against their editors and publishers for cleaning up their copy, and Cole Porter caught no end of grief for including "cocaine" in one of his most celebrated songs), and severely angular buildings and furniture all gave edge to the shock of the new.

For all that rough-and-ready brashness, there was also refinement. Some Americans, and certainly many Russians, were in France to cultivate their courtly side, and "high society" fueled by piles of money satisfied a yearning for sophisticated tastes that didn't play in Peoria (or Peru, Indiana, Cole Porter's hometown). The Americans had the best of both worlds. Art in exile is compelling — no story more aptly illustrates that than the example of Joyce, losing his sight and recalling Dublin street by

street from his Paris lodgings. MacLeish felt that the period was marked by "the isolation of the American artist," a statement we might contest with the collaborative ballets Porter, Murphy, the French, and the Swedes put on, or the fact that almost all the Americans had European teachers — Fernand Léger, André Lhote, Natalia Goncharova, Nadia Boulanger, Maurice Ravel, Leonid Massine, Michel Fokine, George Balanchine, Blaise Cendrars, and André Salmon. For all the well-documented nights wasted in the Dingo bar, there were afternoons in the Louvre we rarely read about during which all the painters, including Alberto Giacometti and Georges Braque, Murphy and Stuart Davis, Goncharova and Pavel Tchelitchew, learned their trade from the masters, forging the connections art historically that were the counterpoint to the obligatory alienation of the avant-garde, the isolation of the exile.

The real expatriates, of course, were involuntarily in Paris or on the Côte d'Azur — rootless white Russians, victims of censorship like Joyce, Jews from all over Europe who were along the coast from Nice to Marseilles. The Murphys, Fitzgeralds, Hemingways, MacLeishes, and Porters were not in that category by any means. They had family and society back home ready for their return at any time, and all of them did go back to the States, even if under duress. Still, they were not on a lark, as Murphy once observed: "There was a sort of unconscious discontent about life in America, but that wasn't all of it. Everybody who went, of the people we knew, were writing, or painting or composing, or interested in the arts, and they were young couples with children, so they all had, in a sense, settled down there. We were not tourists, not just people on a spree."

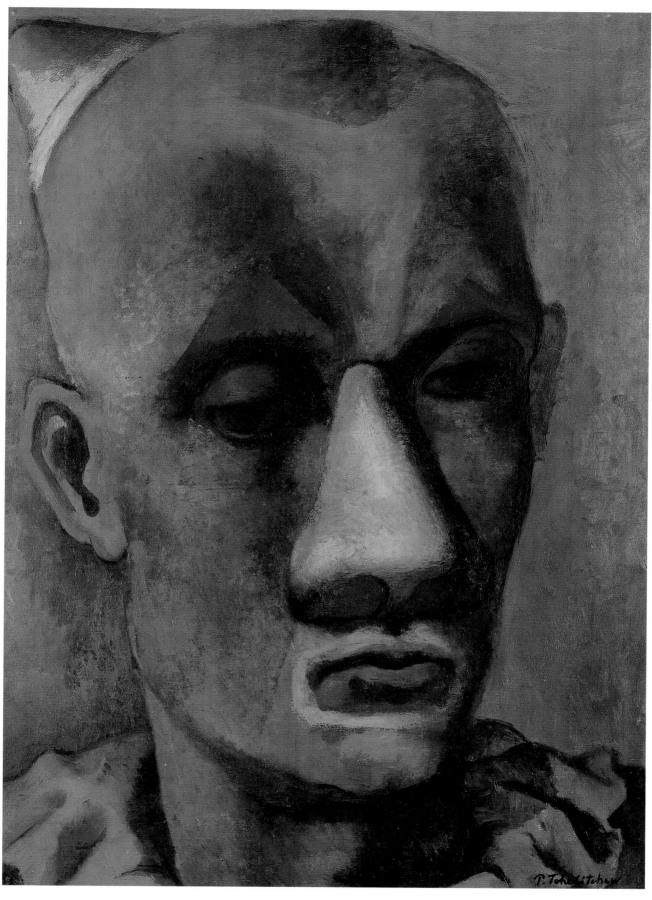

Among the great Russian expatriate artists of the
Jazz Age was Pavel Tchelitchew, whose *Pierrot* (1930)
captures one of the central Parisian literary and
artistic archetypes of the age.

DINNER-FLOWERS-GALA

Gerald and Sara Murphy

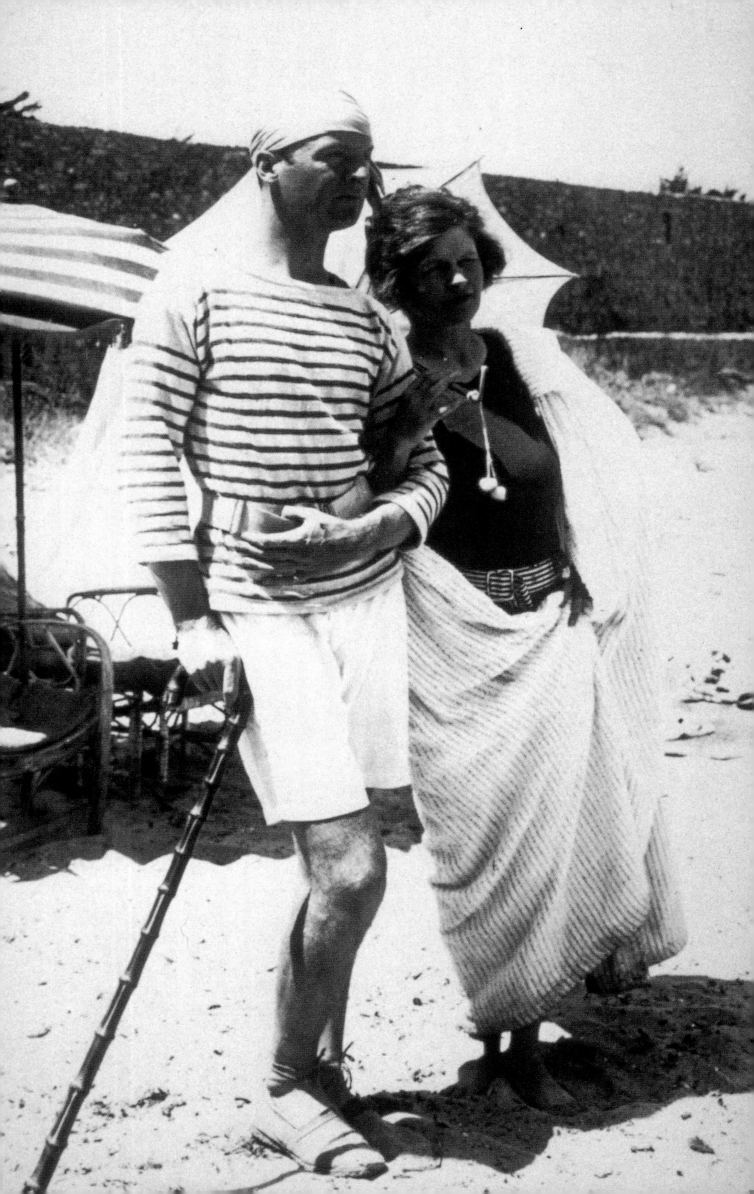

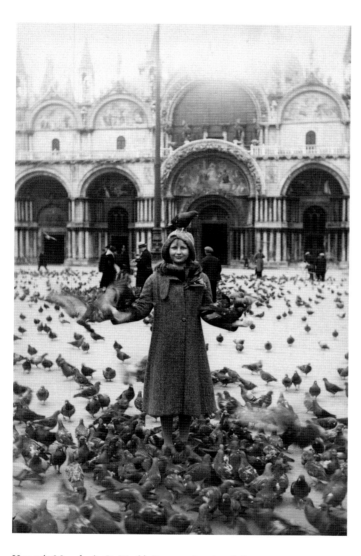

Honoria Murphy in St. Mark's Square when her father
was visiting Cole Porter in Venice in 1924.

Gerald and Sara Murphy in Antibes during the
magical summer of 1923.

Gerald and Sara Murphy arrived in Paris in
September of 1921, accomplices in a romantic
adventure that aimed at breaking free of the
prescribed pattern for young marrieds of their
class. They ended up setting a trend of their
own. Gerald and Sara were givers rather than
takers, avant-garde in many aesthetic matters
but classicists in others, and, in their fidelity
and their insistence on etiquette, positively
retro. Magnetic in their graceful cultivation
of enjoyment and intellectual stimulus, the
Murphys attracted the best of the best to their
lovely villa in Antibes. Theirs is a thrice-told
tale that borders on being a fable for the artis-
tically ambitious and, when oversimplified,
hedonistically inclined. Calvin Tomkins
profiled them in *The New Yorker* series that
became *Living Well Is the Best Revenge*, and
Amanda Vaill compiled a hefty tome that
exhaustively yet enchantingly re-creates their
whole lives and times in formidable detail
(*Everybody Was So Young*), while their daugh-
ter Honoria compiled the most intimate and,
in its way, soulful biography (*Sara and Gerald*).

It helped that they were good looking,
superbly educated, vivacious, and relatively
rich. Although her family fortune was made
in Cincinnati, headquarters of the Ault and
Wiborg Company, an ink manufacturer (for
which Toulouse-Lautrec had created an adver-
tising poster), Sara grew up stylishly in Europe
and New York, spending her summers in a vast
East Hampton residence. When Sara stayed at
the Plaza Hotel in Manhattan, her view was
of the brilliant golden sculpture St. Gaudens
had made of William Tecumseh Sherman, her
great uncle on her mother's side. Here was a
beauty who had been presented at the Court of
St. James in 1914, the year before her marriage,
who had danced at the junior prom at Yale in
1911 not only with Gerald, who brought her,
but (as her dance card records) with J. Biddle,
J. Spaulding, R. Auchincloss, and A. Harriman
(yes, Averill). Her income from interest ("Never
touch capital" is the class motto) was about
$7,000 a year, but the elegance of her enter-
taining as well as the eagerness with which
she and Gerald helped their fellow artists,
including Hemingway, Fitzgerald, and Léger,
fostered the impression that they had far
deeper pockets, comparable to those of their
close friends Cole Porter or Winaretta Singer,

heiress to the sewing machine millions, who had married the flamboyant Prince de Polignac. Even if they were not the richest Americans in France, they enjoyed the richest lives.

Gerald was the sensitive, artistically inclined son of a retail genius who had transformed Mark Cross from a saddlery in Boston to a Fifth Avenue luxury goods showcase. Today's wildly successful deluxe retail empires, such as Louis Vuitton, Gucci, Fendi, and Coach (which recently bought up the Mark Cross patents), are the descendants of Patrick Murphy's breakthroughs in marketing upscale editions of everyday objects. In addition to making the wristwatch a household item (taking his cue from an invention of convenience for World War I soldiers on the front), Gerald's father very nearly made his fortune on the patent for the disposable razor, but was beaten to the punch by King Gillette by a mere month. Two of Gerald's best-known paintings are *Watch* and *Razor*.

A child of privilege, Gerald was sent to Hotchkiss, where he was genuinely miserable, if superbly trained for Yale. On one holiday from prep school he was in East Hampton and daily visited the increasingly famous Wiborg girls. He and Sara, eight years his elder, began a correspondence that laced them together over the course of his Yale years. To her family's dismay and his parents' shock (he was barely out of Yale), he married her and swept her off to Europe. The corner office at Mark Cross went to his younger brother, Frank. Gerald was determined to become an artist.

As satisfying as Murphy's paintings are, the collaborative masterpiece of Gerald and Sara Murphy was the Villa America, an example of Modernist architecture and interior design so ahead of its time that it rivals Charles Rennie

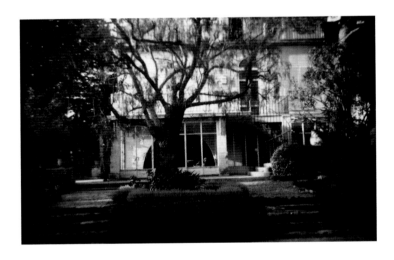

In its heyday, the Murphys' Villa America in Antibes was the playground of the world's greatest artists, writers, composers, and performers. The children would stage plays and ballets in the gardens. John Dos Passos often wrote and Fernand Léger painted at La Ferme des Oranges, the cottage on the property (the entrance is pictured above), which Robert Benchley jokingly called "La Ferme Derangée."

Mackintosh's Hill House in anticipating major developments to come (notably, Purism and Minimalism). When they bought it, it was called the Chalet des Nielles. It had a little under two acres of property atop a steep cliff, fourteen rooms, a donkey stable, and, probably the deal maker in Gerald's eyes, a separate building that could be turned into a studio. Having studied landscape architecture, he was also excited by the garden, which had extraordinary exotic specimen trees and plants collected from all over the world by a seafaring former owner. The view was incomparable: straight out across bands of blue Mediterranean as far as the horizon, to the north toward the point of Juan-les-Pins, where Picasso lived, and to the south toward Cap d'Antibes and farther on to Cannes on a clear day. They picked up the villa for 350,000 francs, well under $20,000, and hired a pair of Americans, Hale Walker and Harold Hellier, to remodel in a style that took into account the contemporary passion for Art Deco and yet achieved an effect more spare and contemplative. The Murphys pioneered the "horizontal" look that, just around the coastline at Cap Martin, Le Corbusier was simultaneously and brilliantly pushing to its extreme in his chalet by the water's edge. One major structural change the Murphys made was the addition of a third-story flat Moroccan roof for sunning and viewing. The broad, flagged terrace, upon which so many of the fabled dinner parties were held, was Sara's stage.

One of the many in jokes of the Villa America was the phrase "dinner-flowers-gala," lifted from an invitation to the captain's table aboard ship on one of the Murphys' crossings. It was generally reserved for the intimate, lovingly prepared dinners for eight or ten guests for which they were renowned. (These were not wild extravaganzas of Gatsbyesque proportions, with the exception of one quite famous post-theater banquet for the Ballets Russes on a barge on the Seine.) Guests surrounded a table worthy of Brancusi in its austerity, set with heavy, monochromatic earthenware. They sat on iron café chairs transformed by Gerald into High Modern statements with silver radiator paint — even arch-Minimalist Donald Judd would have approved.

Inside, the stark symphony of contrasts continued. Brilliant white walls met black tile floors in crisp, uninterrupted lines before which the least possible amount of furniture was precisely sited. Visitors to the dining room drew in their breath at the sight of a brilliant blue tablecloth upon which opalescent glasses and boldly colored local ceramics played chromatic complementaries to the hilt. Stainless-

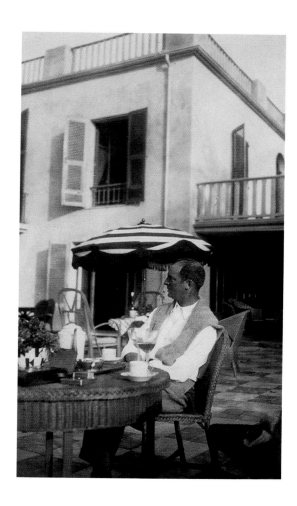

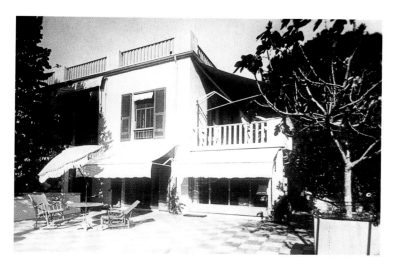

The Fitzgeralds, Hemingways, MacLeishes, Porters, and so many others dined under the linden tree on the famous terrace at the Villa America, where Gerald Murphy enjoyed a quiet moment in 1924 (top).

steel furniture, straight and pure and upholstered in white, was the Murphys' answer to French ornamental decadence. The pristine surfaces of the walls were rarely interrupted for mirrors, and certainly not for Gerald's paintings, which did not hang in the Murphys' home until late in their lives, when he put them along a corridor in the Hamptons estate that had been the Wiborgs'. Late in their time at the Villa America, the Murphys commissioned a mural from Léger, but it ended up in the home of another collector after their son Patrick was diagnosed with tuberculosis and they recognized they would be spending less and less time in Antibes. Even the sign for the Villa America was an early Modernist coup that drew in part upon Gerald's keen eye for American folk art. A crisply painted enamel "flag" combining French and American elements in Murphy's idiom, with five stars representing the family (Gerald, Sara, Patrick, his brother, Baoth, and their little sister, Honoria), it spent decades lodged in a glass-fronted alcove in a pillar at the end of the drive until, too valuable to be left there, it was bought by a collector outbidding the Whitney Museum. The sign has made its way into several textbooks on American Modernism as a pure example of the bold style that Stuart Davis, Charles Sheeler, and others championed in the thirties and forties. William Rubin percipiently focused upon it in his catalogue essay for the 1974 Museum of Modern Art retrospective of Murphy's paintings. In Rubin's eyes, Gerald was a Baudelairean (i.e., "heroic") dandy of transcendent individualism:

The life that Murphy invented for himself and his family, especially once they left Paris for Antibes, was a private vision of paradise, imbued with warmth, beauty, intellect, and taste. His concern for detail rarely succumbed to the conventional "good taste" that is measured against received values. Rather, Murphy was an inventor of taste, a maker of manners. The sunny, well-ordered world of the Murphys' life at Antibes constituted an "America" of their own making, symbolized by the "abstract design" of an American flag that Gerald had affixed to a wall near the gate of Villa America.

A house so full of life has its own rhythms. There was little or no lolling about at the Villa America, where Gerald oversaw each day's activities. His marvelous, bold painting of a Mark Cross watch, now at the Dallas Museum, reminds us of his ordered sense of a summer regimen, including swimming and calisthenics on the beach, which he raked daily to clear the seaweed. Mornings were given to the sacrosanct studio hour for painting and the lessons from tutors for the children (who were essentially home-schooled). In the afternoons they went down to the beach for long swims and to luxuriantly sunbathe for hours — Sara even sunned her strands of pearls, wearing them down her back in what became a signature fashion statement for her. For the adults, sunset signaled the ritual cocktail hour. Invitations were regularly issued for dinner-flowers-gala, an important feature of the weekly round. The Murphys also organized outings aboard their

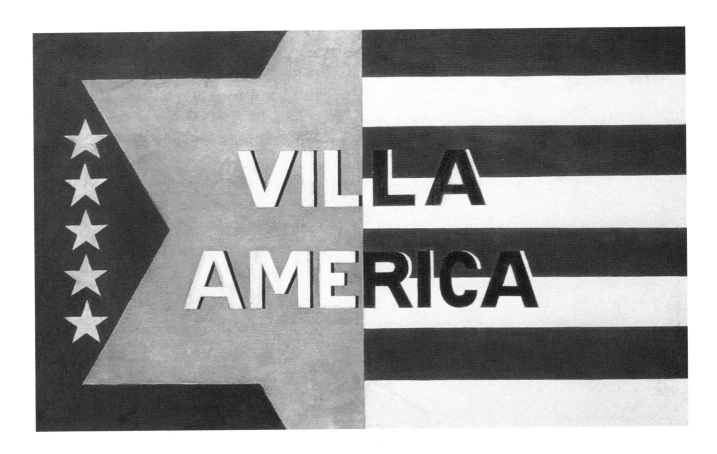

The autobiographical resonance of Murphy's early painting *Watch*, finished in 1925, stems as much from Murphy's own punctuality as it does from the fortune his father made with the wristwatch he designed for his leather-goods firm, Mark Cross.

Gerald Murphy's folk-inspired sign for the Villa America, which he painted in 1925, combines elements of the French and U.S. flags, with five white stars for Baoth, Patrick, Honoria, Sara, and Gerald.

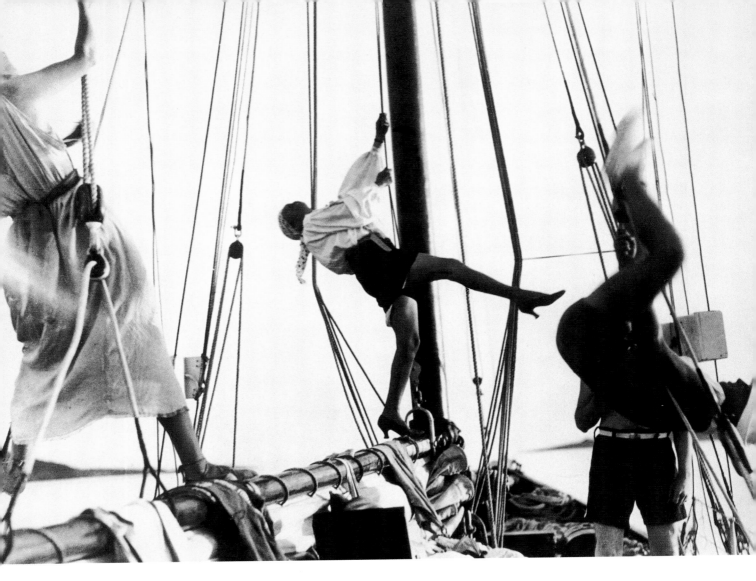

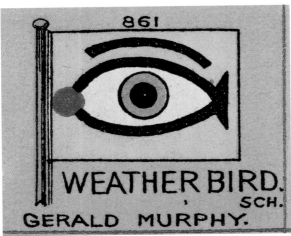

Ellen Barry, Sara Murphy, and playwright Philip Barry acting out an early version of the Peter Pan fantasy in the *Weatherbird*'s rigging, with Gerald Murphy in the stern. Gerald designed the ship's registry flag (left) so that it would wink as it flapped in the breeze, much to Picasso's delight. Fanny Myers Brennan, daughter of the Murphys' close friends, created this tiny but evocative painting of the *Weatherbird* (below left). It is published here at its actual size.

sailboats, including the *Weatherbird,* a custom-built schooner that was a splurge in 1930. She was named for a King Oliver song of that title, and a Louis Armstrong and Earl "Fatha" Hines recording of it was sealed into her keel. One of the most touching stories about Gerald's untiring efforts to keep up the spirits of all around him even in bad times tells of him tracing a full-size outline of the boat on the lawn outside Patrick's window at the Swiss sanitarium where he was unsuccessfully battling TB. Murphy's ingenious design for her official pennant was of a sun with an eye that appeared to wink as the fabric flapped in the breeze. Picasso loved it. A painting of the *Weatherbird* by Richard and Alice Lee Myers' daughter, Fanny, shows her sleek lines, while a pair of watercolor portraits of the Murphys aboard the yacht is one of the most lovely of Léger's gifts to them. Despite being almost abstract, avoiding faces and particulars of gesture, the twinned portraits are among the most evocative images we have of the couple, elegantly distilling their distinctively calm, radiant health and serenity.

The Villa America guestbook is a *Who's Who* of the arts, from the Fitzgeralds and Hemingways to Fernand Léger, Pablo Picasso, John Dos Passos, Gertrude Stein, Sergei Diaghilev, Igor Stravinsky, Dorothy Parker, Robert Benchley, Monty Woolley, Phillip and Ellen Barry, and so many others. Benchley and Parker, whose wit would keep laughter ringing through *The New Yorker* hallways and at the Algonquin's fabled round table, were among the most loyal of the Murphy circle.

One of the unwritten chapters in the fascinating Murphy saga is the friendship they enjoyed with Dick and Alice Lee Myers, another artsy and delightful American couple whose lives entwined with theirs just as with the whole expat circle (including closer ties with Stephen Vincent Benét, Edna St. Vincent Millay, Radclyffe Hall, E. E. Cummings, and, in the thirties, John Gielgud, Peter Ustinov, and Julia Child). If the Murphys had not existed, Calvin Tomkins could have written *Living Well Is the Best Revenge* about the Myers. Their open house, open hearts, and open wallet offered similar unconditional buttressing for struggling artists, and the trajectory of their lives through the twenties was parallel. They were close to the Murphys for all the obvious

reasons, and pillars of support during the difficult years when the Murphys themselves were in need of bucking up, having performed that office so often for others.

Richard Edwin Myers was a Chicago boy who went to the University of Chicago for his undergraduate degree. Setting aside his considerable talent and aspirations as a pianist and songwriter, he took a job in the shipping department of the American Radiator Company in St. Paul after graduation in 1911. The theater bug hit, and in 1917 he moved to New York to work on Tin Pan Alley. He enlisted in the Army soon after and landed in France as part of the American Expeditionary Force. Returning to Chicago long enough to marry his college sweetheart (she had majored in English, and had also been in France and Germany as a Red Cross volunteer), he was back in Paris as advertising manager for American Express from 1921 until 1928, followed by a stint as associate editor in the Paris offices of *Ladies' Home Journal.* Alice Lee Myers brought up her three bilingual, multitalented children, Fanny (who, partly under Gerald Murphy's direction, became a well-known artist with regular exhibitions at Betty Parsons and Salander O'Reilly), Dicky, and "Boo" (Alice Lee). Somehow she found the time to manage a dress shop where Russian émigrés could consign their embroidery. She also filed a regular fashion column for the *Chicago Daily News* and was one of the most popular hostesses in Paris. Their elegantly appointed apartment was a gathering place for diplomats, playwrights, musicians, artists, and writers. Richard Myers at the piano (a student of Nadia Boulanger's, he was much more than an accomplished amateur) was an asset to any gathering.

Alice Lee Myers also served, thanks to Gerald Murphy, as a buyer for Mark Cross in Paris, while Richard's job with M. Lehmann (later, Sherry-Lehmann), the wine importer, frequently took him back and forth between New York and France. He later became an associate editor and wine expert for *Gourmet* magazine and a regular contributor to *Town & Country* as well as a pillar of New York musical philanthropy, serving on the board of directors of both the New York Philharmonic and the Metropolitan Opera Guild. Myers the composer did make it to the stage, providing

Picasso was not the only painter to celebrate Sara's
stately beauty. Here is Fernand Léger's portrait of her
as they sailed the *Weatherbird*. His watercolor of
Gerald, also aboard the yacht, conveys something of
the austere dignity of its subject.

Top, from left: Ellen Barry, Sara Murphy, and Pauline Hemingway taking a stroll at the Cap d'Antibes. Above: Robert Benchley took time off from *The New Yorker* to live it up with the Murphys; the playwright Philip Barry, snapped here by Gerald or Sara at the beach at La Garoupe, stole one-liners delivered at Villa America soirees for his Broadway plays; and Ellen Barry, who was a lifelong member of the Murphy inner circle. Right: Archie and Ada MacLeish were living out their artistic dreams in Paris in the twenties. She sang at the Paris Opera. He later became a White House staff member and eventually Librarian of Congress.

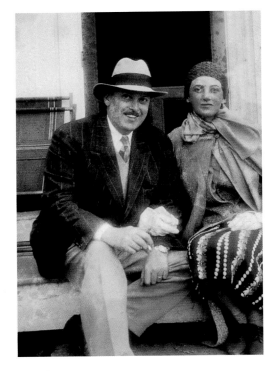

Dorothy Parker, Robert Benchley, Honoria Murphy, and Gerald Murphy on the beach at Antibes, where Gerald and Pablo Picasso mugged for the camera, probably held by Sara, in 1923 (right).

Dick and Alice Lee Myers were talented Chicagoans — he, a composer and she, a journalist and fashionista — who also collected artists and writers. Their daughter Fanny posed in her Poiret gown (right).

The Myers' Paris apartment was a showcase of modern design married to traditional Parisian elegance.

the piano score for Archibald MacLeish's play *Alien* as well as the incidental music for Philip Barry's *Without Love*. In 1949, he was decorated for service to French music in the United States, receiving the Cross of the French Legion of Honor. The Yale library now holds the Myers family papers, including a trove of intimate letters and postcards between the Murphys and the Myers that offer an enchanting taste of the belletristic style of the era. There is banter about the "American Expeditionary Farce" mixed with tender feelings and philosophy. Here is Gerald thanking Dick for sending him a record: "One thousand French thanks direct from factory to you for that music. It does my heart good to have it — and already the blood courses more swiftly in the veins. There's no use my posing any longer as an intellectual or trying to found a salon, for in my secret heart it is such as 'I have to laugh when I think how I danced with tears in my eyes over you.' That is my spiritual food and drink. If every Spring didn't bring forth some such song I doubt if I could go on."

Either together or individually, Gerald and Sara were the direct inspiration not only for three very strong biographical studies in our time, but for an astonishingly broad portfolio of works in the twenties, from a formidable series of Picasso paintings and drawings (of Sara, but of Gerald's face, too, as the noted Picasso biographer John Richardson recently suggested) through Fitzgerald's *Tender Is the Night*, Dos Passos' *U.S.A.*, Philip Barry's *Holiday* and *The Man of Taste*, and Archibald MacLeish's play *J.B.* and stunning long lyric portrait of Sara. As is often the case with modern art, many of these works had an edge. The most painful was probably the section devoted to Murphy in *A Moveable Feast*, Hemingway's readable if not believable revisionary look at the Paris years. The most prominent of the literary portraits is found in the early chapters of *Tender Is the Night*. The novel in its final form troubled Sara especially because, as Hemingway pointed out to Fitzgerald, it began as a warm and straightforward portrait of the Murphys and then veered into a self-portrait of Scott and

Zelda and their crumbling marriage. Fitzgerald called it "my novel of disintegration" and it signaled a number of other books and essays through which he tracked his decline and fall. The Murphys faced their own crises and certainly knew the brink of disintegration well, however gamely they avoided plunging over it. Fitzgerald's novel was published in 1934, just as a devastating series of events beset the Murphys. Sara struggled to forgive Scott for this, while Gerald grudgingly admitted the narrative if not historic truth of what the novel accomplished. The opening pages, however, are a splendid evocation of all that we still find irresistible about the Murphy circle. From the "dewy" ingenue Rosemary's perspective, the magic of Gerald (Dick Diver in the novel) was his ability to enchant the assembled company. Along with what Fitzgerald described as "the diffused magic of the hot sweet South," he momentarily establishes, like Prospero, a charmed circle of Americans (note the brief wave to "that country well left behind"):

There were fireflies riding on the dark air and a dog baying on some low and far-away ledge of the cliff. The table seemed to have risen a little toward the sky like a mechanical dancing plat-form, giving the people around it a sense of being alone with each other in the dark universe, nourished by its only food, warmed by its only lights. And, as if a curious hushed laugh from Mrs. McKisco were a signal that such a detach-ment from the world had been attained, the two Divers began suddenly to warm and glow and expand, as if to make up to their guests, already so subtly assured of their importance, so flat-tered with politeness, for anything they might still miss from that country well left behind. Just for a moment they seemed to speak to every one at the table, singly and together, assuring them of their friendliness, their affection. And for a moment the faces turned up toward them were like the faces of poor children at a Christmas tree. Then abruptly the table broke up — the moment when the guests had been daringly lifted above conviviality into the rarer atmosphere of sentiment was over before it could be irrever-ently breathed, before they had half realized it was there.

Those alfresco feasts under the linden tree at the Villa America were vital to Fitzgerald as he closed in on the final pages of *Gatsby* that summer of 1924. In this passage, Fitzgerald offers a nocturne worthy of the Keatsian poem from which he drew his title, with that erotic sense of the blending of beings "in the dark universe" before the spell is broken, or as Keats put it rather more morbidly, "to cease upon

the midnight with no pain…Fade far away and quite forget" the world around them. In the eyes of his wife in Fitzgerald's novel, Diver goes from the high spirits of the ritual of com-pany to a darker mood. On balance, however autocratic he may have been, Gerald comes off well in the early part of the novel, when his magic exerts its pull somewhat like that of a blue Riviera afternoon:

But to be included in Dick Diver's world for a while was a remarkable experience: people believed he made special reservations about them, recognizing the proud uniqueness of their destinies, buried under the compromises of how many years. He won everyone quickly with an exquisite consideration and a politeness that moved so fast and intuitively that it could be examined only in its effect. Then, without cau-tion, lest the first bloom of the relation wither, he opened the gate to his amusing world. So long as they subscribed to it completely, their happiness was his preoccupation, but at the first flicker of doubt as to its all-inclusiveness he evaporated before their eyes, leaving little com-municable memory of what he had said or done.

This evanescent quality is perhaps a bit unfair to the historical Murphy, a spectacularly loyal friend to Fitzgerald in particular, who, well into his Hollywood years, sponged off Gerald without shame, both financially and emotionally. Gerald never turned down a request for emergency funds, from Fitzgerald, Léger, Hemingway, Dos Passos, or any of the other formidable artists for whom he was a source of support and encouragement. With every check came a letter of such gentle encouragement that it completely assuaged the sting of a handout while affirming what appears in our own day of social-climbing philanthropy to be an utterly anachronistic commitment of a privileged lover of the arts to the artists and their work. With Gerald, there was no quid pro quo. He took no pleas-ure in collecting on his "investment" because he was not greedy for either the object or the attention, and he was not so unsure of his place in society that he needed to exploit his artistic connections for entrée he already had. As he once wrote to Dick Myers, "Really we must not let these little accruals take on such moment that all the pleasure of receiving them vanishes in a vortex of whatever vortexes are made of. Life is very piddling."

The one time that the Murphys materially received from what they had given came when Léger had an exhibition at New York's Museum of Modern Art. Unaware that the Murphys had lost both their sons in the space of one year,

Léger had written asking for about $2,000 to help him make the trip to the opening. Without blinking, the Murphys sent him the money, and at the show — which was from the start a massive success, pulling in ten thousand viewers in only twenty days — Léger coyly told them that there was a painting there for them, if they could spot it. The Murphys took him up on the challenge and, as they reached the bottom of a stairway, spotted a work that not only used an un-Légeresque brown, a color Murphy adored, but seemed to depict the giant aloes they had had in the garden at the Villa America. They were standing in front of *Composition à un Profil* when Léger came up behind them and said, "I see you've found it." Other than that, the cash advances and little gifts to Hemingway as he was breaking up with Hadley, to Dos Passos as he struggled with medical bills, to various wacky Russian ballet masters and con artists, and to Fitzgerald as he drank his way into a state in which he was unemployable by producers and magazine editors were all acts of a seemingly boundless, utterly natural instinct for the charitable.

While Gerald was an easier mark for satire, Sara was a born muse. Hemingway, Fitzgerald, MacLeish, Dos Passos, Picasso, and any number of lesser mortals were in love with her. Here she is as the besotted Fitzgerald saw her, in a passage from the beginning of chapter six of *Tender Is the Night*:

Feeling good from the rosy wine at lunch, Nicole Diver folded her arms high enough for the artificial camellia on her shoulder to touch her cheek, and went out into her lovely grassless garden. . . . Knotted at her throat she wore a lilac scarf that even in the achromatic sunshine cast its color up to her face and down around her moving feet in a lilac shadow. Her face was hard, almost stern, save for the soft gleam of piteous doubt that looked from her green eyes. Her once fair hair had darkened, but she was lovelier now at twenty-four than she had been at eighteen, when her hair was brighter than she.

Later, Fitzgerald explores Nicole's inner world, and it becomes increasingly difficult to separate the author's construction from its inspiration. The counterpoint between Sara's outer activity and inner stillness in real life drove Fitzgerald to distraction, especially if the two shared a late-evening tête-à-tête at that stage in a soiree when dinner partners either abandon one another or cross over into more personal conversation. Scott often pushed his impertinent line of questioning (he thought of it as research for the fiction) too far as he sought to break through the dignified outer perimeter. Elsewhere he described her as a "Viking madonna," and others, including the American publisher and bon vivant Harry Crosby, compared her to the Sphinx. Of the fictive Nicole, Fitzgerald wrote:

She walked rather quickly; she liked to be active, though at times she gave an impression of repose that was at once static and evocative. This was because she knew few words and believed in none, and in the world she was rather silent, contributing just her share of urbane humor with a precision that approached meagerness. But at the moment when strangers tended to grow uncomfortable in the presence of this economy she would seize the topic and rush off with it, feverishly surprised with herself — then bring it back and relinquish it abruptly, almost timidly, like an obedient retriever, having been adequate and something more.

Biographies of Fitzgerald tend to dwell on the courteous acquiescence with which the Murphys greeted the publication of the book. If I had been Gerald and read this passage, full of left-handed compliments and what, by our standards today, would be construed as sexist slams (golden retrievers not being renowned for their intelligence), I'd have taken a swing at Fitzgerald.

Others were more flattering. Archibald MacLeish captured her in his poem "Sketch for a Portrait of Mme. G—M—," kinder than Scott's yet not entirely dissimilar. It opens with an empty room in her Paris apartment:

"Her room," you'd say — and wonder why you'd called it
Hers, as though she hadn't seven others
Not counting the reception room beside
The front door in red paper with a view
Of Paris in a bottle and real snow
Made out of something else and through the window
The railroad cutting where the trains went by
To Marly-le-château-du-roy: but somehow
Whether you came to dinner or to see
The last Picasso or because the sun
Blazed on her windows as you passed or just
Because you came, and whether she was there
Or down below in the garden or gone out
Or not come in yet, somehow when you came
You always crossed the hall and turned the doorknob
And went in; — "her room" — as though the room
Itself were nearer her: as though the room
Were something she had left for you to see

The domestic scene offers the embodied sense of a serene and yet radiant muse. She is pensive, in control, at once absent and present. The room is not hers by family deed or money, but because she has invested it with an "attitude of gratified compliance," the phrase MacLeish deploys a few lines on. As Picasso used the body language of crossed arms to signify the distance of one who dwells apart, MacLeish captures the space between with words like "reticence" and "reserved" in a late reprise of the opening thought:

And yet you'd say, "her room," as though
you'd said
Her voice, Her manner, meaning something else
Than that she owned it; knowing it was not
A room to be possessed of, not a room
To give itself to people, not the kind
Of room you'd sit in and forget about,
Or sit in and look out from. It reserved
something that in a woman you would call
Her reticence by which you'd mean her power
Of feeling what she had not put in words

Much is made in the literature devoted to the Murphys of the brilliant series of works Picasso dedicated to Sara, and at least two of the leading experts on the life and work of the artist have strongly suggested there was a sexual relationship between them. The paintings themselves are not only powerful but fascinating to consider within the context of the Catalan's masterful oeuvre, so often scrutinized for the pitiless cruelty toward women that has become part of the Picasso legend. These are adoring, even downright reverential. Although they were painted at the same time as his beefy neoclassical nudes — the masterpiece *Three Women at the Spring* dates from exactly this period — they are not as distorted as later returns to the Cubist paradigm. There is a muscular nuance to the paintings, however, reflecting the physical and ethical strength that all those who knew Sara recall, the formidable character and unshakable virtue that biographers suggest Picasso found irresistibly provocative. Most accounts conclude that he never surmounted her defenses, despite an earnest effort during the summer of 1923 when the two were often together on the beach at La Garoupe and Gerald was away with Cole Porter in Venice. There is an immensely attractive and absorbing pensive quality to the works of this period. Two gestures dominate: the arms folded across her chest, and the upward glance.

Connoisseurs of body language are welcome to dissect them as they please. In terms of Picasso's depiction of women, although the portraits of Sara are similar in style to those of Olga, created at virtually the same period, the crossed arms are unique to Sara. It is amusing to flip through a Picasso book and watch the movement of hands in similar portraits — while Sara's arms are crossed, later Picasso entwines the fingers of his sitters in their laps, places the hands behind the head in the classic nude attitude, pulls them down to hold a book, or, late in his career, shows them firmly resting on the knees in an almost Dutch manner. By giving Sara her signature gesture, and by painting her as faithfully as he did his wife Olga, Picasso was imbuing the work with the type of respect for a woman posterity does not generally grant him. Those especially inclined to view the artist as a monstrous misogynist must concede that the woman who provoked such tributes was extraordinary.

Picasso uses the muscular proportions of his neoclassical style where MacLeish capitalizes "Her." Both connote what MacLeish makes explicit in "her power." Picasso's *Woman in White*, one of the most beloved works in the Metropolitan Museum's permanent collection, remains an enigma — a blank — in the otherwise nearly exhaustive catalogue of his works, and it is not entirely clear to even the leading experts whether it is a portrait of Sara or Olga — hovering by the beach at Antibes at that time — or a rendering of a statue of Juno in the Farnese Collection of marbles at Naples, which the artist had visited in 1917. Only recently was Sara spotlighted as the probable subject, amid tittering over related nude drawings and speculation that the artist and his model were lovers. But let us keep our eyes on the painting. As with the heavy robustness of the more famous Gertrude Stein seated portrait, or the massive *Three Women at the Spring*, the *Woman in White* has a gravity belied by its light tonality and almost transparent use of light washes of color to build up the veil-like drapery and floating hair. Her firmly delineated profile and heavily drawn eyes pull the painting into focus even as they emphasize Sara's distracted air. Distance is conveyed not only by the folded arms but by the upward angle of the nose and that far-off stare that Fitzgerald also captured so adroitly.

Remarkably, Gerald Murphy never painted his wife's portrait. His genre was the still life. His evolution as a painter can be traced from undergraduate days at Harvard, when he attended lectures by John Singer Sargent at the Museum of Fine Arts in Boston and met Sargent's great patron, Isabella Stewart Gardner, at her Fenway Court residence — now one of the world's most idiosyncratic and rewarding private museums. At Harvard, he was attending graduate school in landscape architecture,

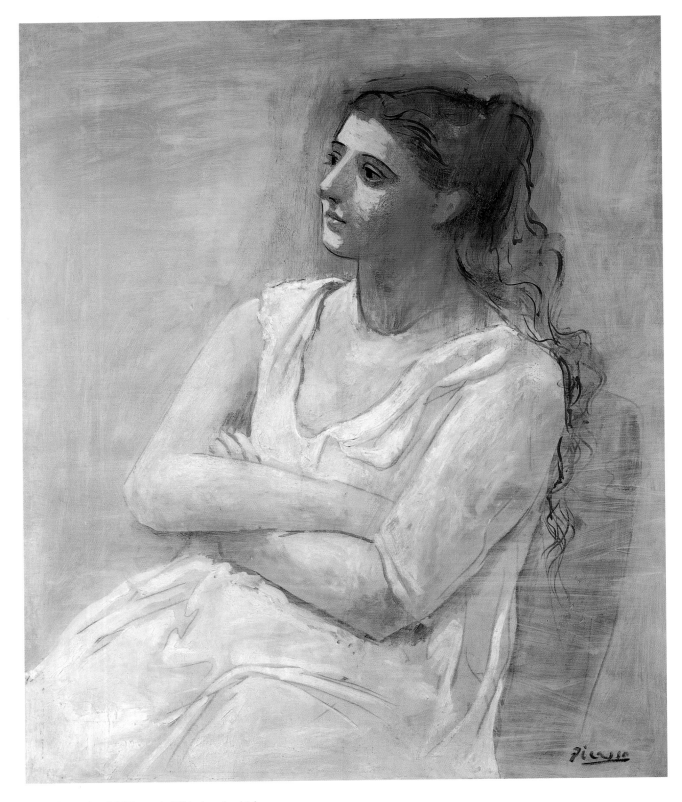

Picasso's magisterial *Woman in White* (1923), which
many experts suggest is a portrait of Sara Murphy,
is one of the highlights of the permanent collection at
the Metropolitan Museum of Art, New York.

where accurate and precise draftsmanship was a requirement. He went to New York during the first month of the Armory Show to see what all the fuss was about (in later years he admitted that Sara was more excited and nearly collected some of the more advanced paintings but caved in to the hue and cry of conservatives). Whether it was art, music (especially jazz, but he also cultivated a remarkably advanced devotion to "Negro spirituals"), design, or gardening, he was au courant in aesthetic matters well before the move to Paris in 1921. He also had his art-historical favorites, including Piero della Francesca, which makes great sense when one compares Murphy's painting with the "scientific" precision of the early Renaissance master's studio practice.

High society is not always synonymous with high art, but in Murphy's case connections opened studio and salon doors that were spectacularly useful to his artistic ambitions. Thanks to his sophisticated (and chilly) sister-in-law Hoytie, he had entrée in Paris to the circles of the Count de Beaumont (where he met Proust at a New Year's party in 1922, the year of the author's death) and the grande dame and archetypal muse Misia Sert as well as other art world insiders. He met his teacher, Natalia Goncharova, at one of these gatherings. A seminal moment was a walk down the rue la Boetie, in the center of one of the gallery neighborhoods in October 1921 when he saw

Whenever he was on the beach at La Garoupe with the Murphy coterie, as on this day in 1923 (above), Picasso was the center of attention. He also held court during a summer picnic at La Garoupe, during which *beaucoup de vin* has clearly been consumed.

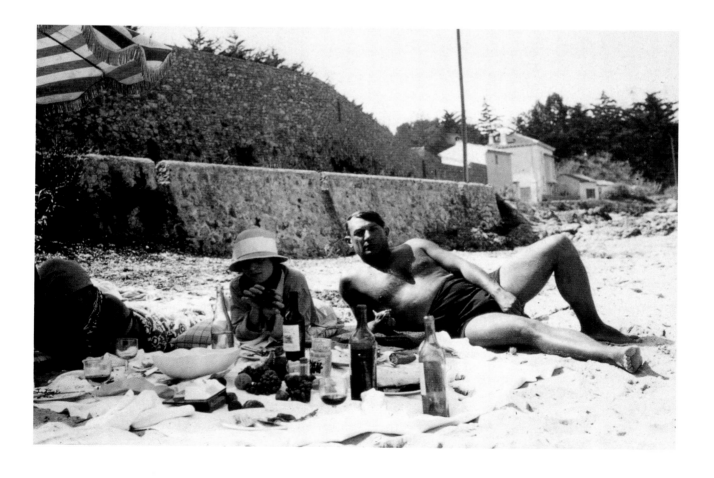

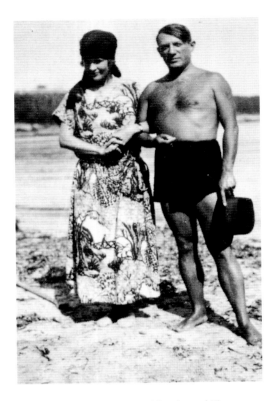

The artist and his muse: Sara Murphy and Picasso held long tête-à-têtes on the beach at La Garoupe.

paintings by Derain, Braque, Gris, Léger, and the star, Picasso, in the window (he could not recall for his biographers which ones) and declared that evening to Sara, "If that's painting, that's the kind of painting that I would like to do." Later he recalled the shock of recognition, which somehow in that time and place reached him as it had not when looking at similarly challenging works in the Armory Show on Lexington Avenue eight years earlier: "I was astounded. My reaction to the color and form was immediate. To me there was something in these paintings that was instantly sympathetic and comprehensible."

He enlisted Goncharova, a descendant of Pushkin's wife and the painter of big, bold, action-packed High Modernist works, who instructed him in her studio on the rue de Seine. Her straightforward, highly conceptual method was characterized by a rationality that Murphy found attractive. The painter subdivides the canvas into abstract (termed "nonfigurative") forms. Reversing the traditional strategy for the addition of color to form, she pushed Murphy to use a strong, advancing color for weak or insignificant areas in order to even the plane of the picture. The result was to push the whole work toward abstraction, or as Murphy told *Art in America* in 1963 on the occasion of his gift to the Dallas Museum of some important paintings, of treating "objects in a world of abstraction."

Inside Murphy's studio, either in Paris or in Antibes, all was order. He liked to paint on airplane linen stretched on three-ply veneer panels, much as it was used in the wings and fuselage of aircraft in those early days. The vast expanse of many of his earliest works was directly facilitated by his volunteer work in the theater. Goncharova was involved in designing scenery for Diaghilev, who had recently lost many of his sets and much of the decor for *Le Coq d'Or* and *Les Noces* in a warehouse fire, so the Murphys signed up, turning in long days in the hot studio in suburban Belleville, pushing huge squeegees of paint across the flats. Another of the emergency volunteers that summer was Dos Passos. Braque, Derain, and Picasso stopped by to cheer the troops and check on their own designs, as did Cocteau. Painting flats for the theater takes big gestures, an eye for how forms will read from a distance, and a sure sense of handling color in quantities that forces an artist-in-training to learn how expanses of a tone affect its behavior in a composition. It may be interesting to note that the work is done on the floor, especially given the importance of painting on the floor to the art to come (Pollock comes to mind, but so do many other artists of Abstract Expressionism, including Helen Frankenthaler).

Murphy learned to think big. As he later said in a revealing statement about his work, "I seem to see in miniature detail but in great scale." Modernism made a cult of objectivity and the impersonality of the work, whether through Eliot's doctrine of the "objective correlative" or the visual distance that Cubism and Precisionism imposed. Murphy was a devotee of the principle, but was betrayed in many ways by his choice of subject matter. As William Rubin observed in the catalogue essay accompanying the landmark 1974 retrospective at the Museum of Modern Art just after Murphy's death, "When he started painting in Goncharova's atelier, Gerald had wanted to represent real objects as abstractions; but what had begun as an exercise in formalism had become a means to put distance between himself and images that carried a heavy load of personal connotation."

The trajectory of Gerald Murphy's career as an artist was anything but typical, for the twenties or for our own time. He was thirty-three when he completed his first painting (*Engine Room*, 1922), had three children and was (temporarily, it turned out) fending off family pressures to step up and fulfill his duties as the heir to the Mark Cross company. Many of the marketing tricks he had picked up at the company's Fifth Avenue offices came in handy when it came to color and design, even window displays and the selection of materials or designs. He later developed, when he returned to the family business, a knack for seizing on clever designs in inexpensive materials and translating them into the leather and silver creations for which the firm was eventually to become famous.

Many of Murphy's earliest projects were more examples of design than of art. For example, he was invited to create the American booth for the Bal des Artistes Russes, a major benefit for a relief charity held in February 1923. There was plenty of competition — Picasso, Gris, Delaunay, Goncharova, Foujita (who recreated the Kabuki theater) all created booths — but Murphy wowed them with a cityscape replete with skyscrapers and the razzmatazz of Broadway, complete with blinking lights. It was the must-see attraction and the talk of the hall on opening night.

It was a short hop from the hit at the fair to the commission to create the scenario and decor for a jazz ballet called *Within the Quota* (the allusion is to immigration laws in the States) to be performed by the Ballets Suedois in Paris. Murphy pushed for his friend Cole Porter to write the music for an eighteen-minute curtain raiser about a young Swede "on the town" in Manhattan. Porter and

Gerald was not the only Murphy who picked up a paintbrush. This is Sara's portrait in oils of him.

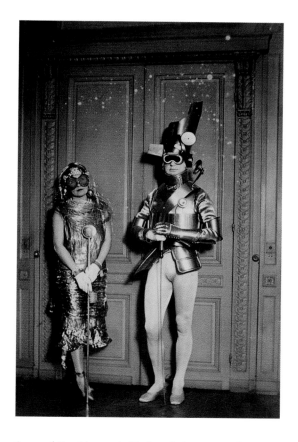

Sara and Gerald were clad in futuristic costumes for the Count Etienne de Beaumont's 1924 "automotive ball" at Montmartre's Théâtre de la Cigale.

Gerald Murphy's first exhibited painting was *Boatdeck*, which was the talk of the 1924 Salon des Indépendants. Now lost, it was eighteen feet tall and twelve feet wide, a sore point for the other artists and a target for reviewers. "If they think my picture is too big, I think the other pictures are too small. After all, it is the Grand Palais," Murphy told the *Herald* critic at the opening.

Gerald Murphy and Cole Porter with the characters in costume before the backdrop to *Within the Quota*, the innovative jazz ballet that had its debut in 1923.

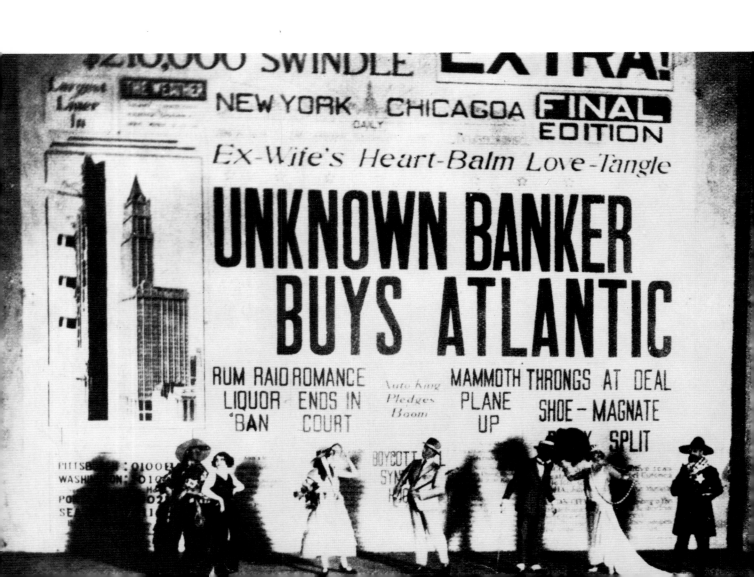

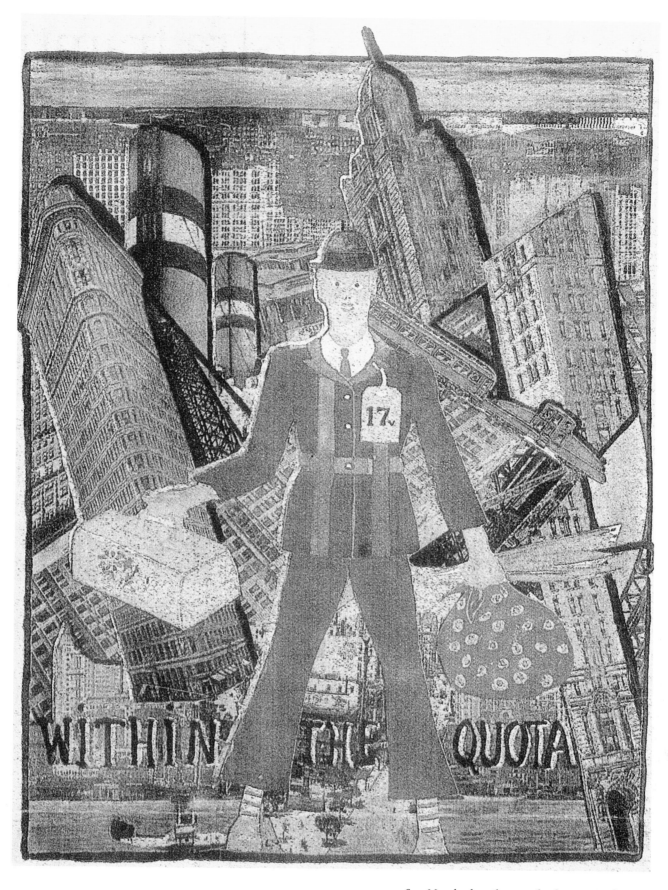

Sara Murphy drew the cover for the program for *Within the Quota*. She also designed the original costumes.

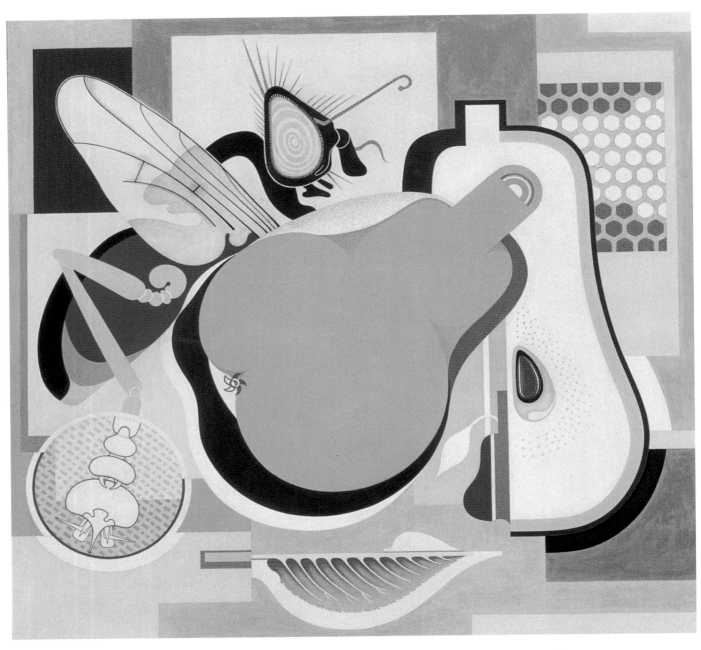

Murphy's *Wasp and Pear*, painted in 1927, was acquired by Archibald MacLeish and is now a main attraction in the permanent collection of the Museum of Modern Art in New York.

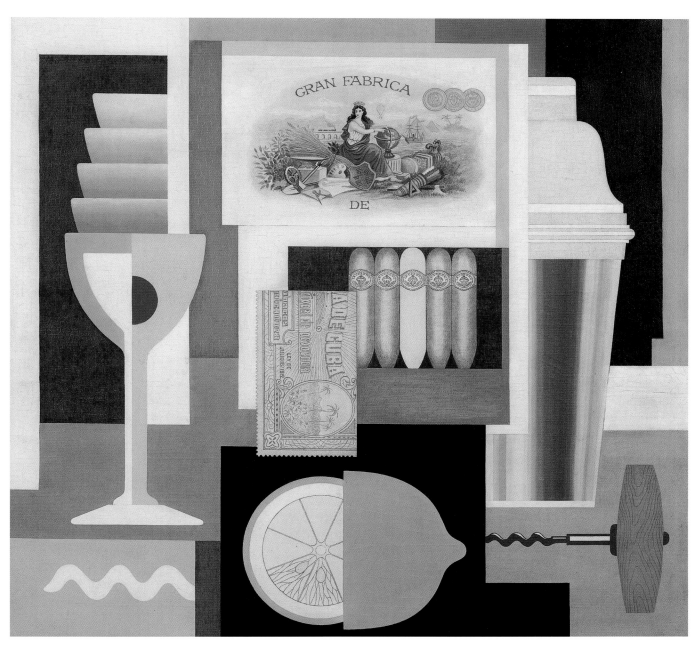

Gerald Murphy's most important and best-known painting is *Cocktail*, capturing the Villa America evening ritual along with a memory of the artist's father in one intricate work.

Murphy repaired to the current Porter palazzo in Venice for three mad weeks and pulled together what dance historians recognize as the first jazz ballet. It was choreographed by Jean Börlin, the star of the Ballets Suedois and inamorato of its wealthy proprietor, Rolf de Maré, who had created the company to give Diaghilev a run for his money and to showcase Borlin. Murphy used the sets and costumes (Sara had designed the costumes in watercolor) to extend his cityscape idea — particularly in the backdrop, which parodied the front page of a typical American newspaper. Rubin compared its massive black-and-white display type and graphics to Pop masterworks by Andy Warhol from the early 1960s that similarly created a trompe l'oeil representation of the banner and tabloid layout, including sans-serif headline fonts and grainy photos. Murphy's headlines were over the top: "Unknown Banker Buys Atlantic" is the main item, along with "Largest Liner In" and "Boycott All Syndicate Hootch." When Picasso saw the backdrop he declared, "*C'est beau, ça*" ("That's lovely").

This comic confection made even the most jaded theater audiences laugh from its debut at the Théâtre des Champs-Elysées on October 25, 1923, all the way through a decent run in the States afterward, including Washington, Philadelphia, Boston, Buffalo, Allentown, Scranton, Wilkes-Barre, Altoona, Rochester, Batavia, Utica, Lima, and Columbus. A full-fledged Modernist work, both visually and aurally, it gave an American accent to the smart picaresques set to jaunty scores that were the contemporary staples of Cocteau and Satie. While the ballet had been conceived as an opener for a work that has become an important fixture in the Modernist canon — Darius Milhaud's *La Création du Monde* — at the last minute, on Léger's advice, their order was switched to avoid the appearance that Porter's music, which had been tweaked by a professional orchestrator, Charles Koechlin, "who made Debussy out of it," was a parody of Milhaud's. Murphy's scenario is a parade of types who take turns seducing the young Swede:

A millionairess, bedecked with immense strings of pearls, ensnares him; but a reformer frightens her away. Then a Colored Gentleman appears and does a vaudeville dance. He is driven away by a "dry agent" who immediately thereupon takes a nip from his private flask and disappears, to the immigrant's increasing astonishment. The Jazz Baby, who dances a shimmy in an enticing manner, is also quickly torn from him. A magnificent cowboy and a sheriff appear, bringing in the element of Western melodrama. At last the European is greeted and kissed by "America's Sweetheart," and while this scene is being immortalized by a movie camera, the dancing of the couples present sweeps all troubles away.

The arts crowd A list, including Rudolph Valentino and wife, John Barrymore, and Elsie de Wolfe, turned up for the premiere. The French and American critics lapped it up. Gilbert Seldes, reviewing for the *Paris Journal,* heralded it as a landmark, "an American ballet, the first in which popular American music exclusively has been used in connection with an American theme." The success was good for Murphy's spirits. By 1927, he was gaining confidence before the easel. "Before I die I'm going to do one picture which will be hitched up to the universe at some point. I feel it now and can work quietly," he declared.

That was the year of his first one-man show at the Galerie Georges Bernheim (not Bernheim Jeune, as some accounts have mistakenly suggested). He did not have the swift, virtuosic modus operandi of the Parisians, and two paintings a year was his usual pace. The painting that stakes its claim to posterity is *Cocktail,* a highlight of the Whitney Museum's permanent collection and a favorite of artists and art historians, who admire its boldness and its craft. This painting, too, has its autobiographical story to tell. As with *Watch, Razor,* and *Bibliothèque,* there is a subtle reference to Gerald's father — he painted his father's bar tray from memory, tightened into a more orderly arrangement in the painting. The oval image on the lid of the Edwardian cigar box (still in the Murphy family collection) was painstakingly reproduced over the course of four months. To pull it off, Gerald used a two-haired brush. Many of the elements refer to Murphy's passions, including the palette, the globe (recalling *Bibliothèque)*, the flywheel (an allusion to both *Watch* and a lost painting, *Engine Room*), the yacht, and the compass.

Murphy's most famous painting is an homage to one of the signature moments of Murphy's Villa America: cocktail hour. When the sun was over the yardarm, Gerald presided over an elaborate process that ended in the concoctions (limit, two per guest despite all the hoopla associated with the Fitzgeralds over drunken debauchery) that were his "specials." According to firsthand sources, Gerald's repertoire included frequently varied combinations of brandy, liqueur, and lemon juice, shaken in a silver "chalice" not unlike the one in the painting. The playwright Philip Barry once remarked during the proceedings, "Gerald, you look as though you're saying mass." The

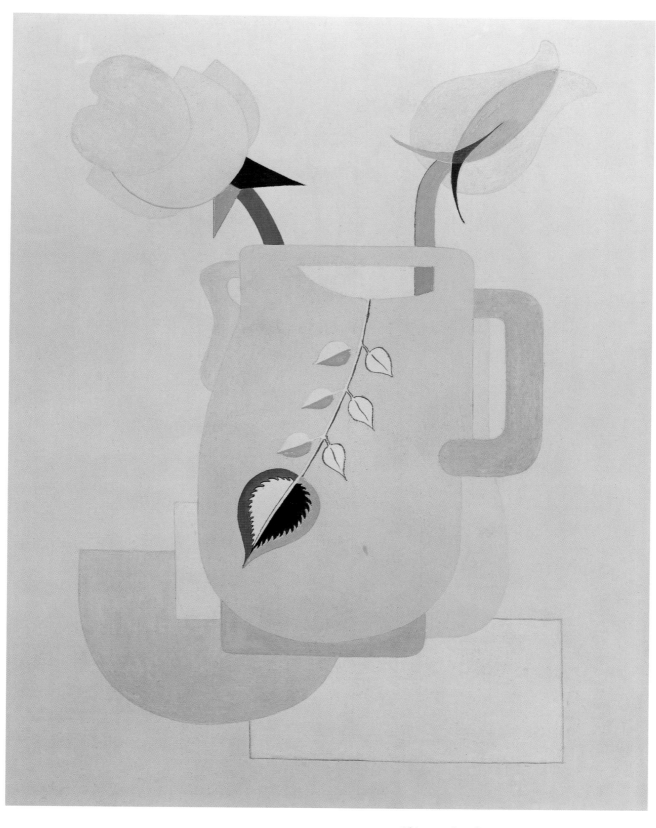

This recently rediscovered gouache by Gerald Murphy, *Still Life with Flowers* (1925–26), has a lightness of tone and touch that is distinctive even in his small oeuvre, and yet the meticulous attention to detail is pure Gerald.

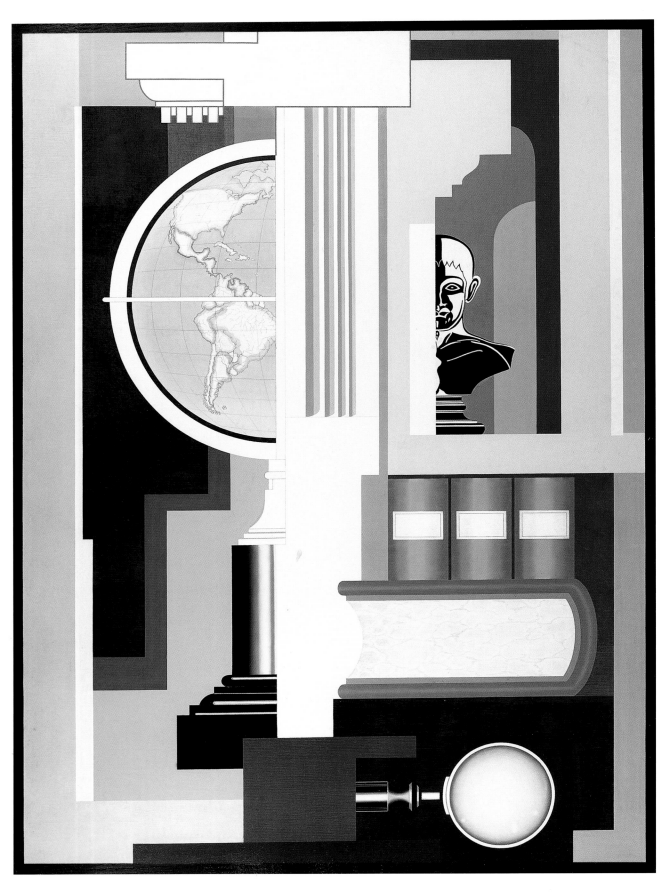

An unknown painting by Gerald Murphy that only
recently surfaced when it was discovered rolled up
in an East Hampton attic, *Bibliothèque* is based on
memories of his father's Manhattan library. The
portrait bust is of Ralph Waldo Emerson.

host's reply made it into Barry's play *Holiday*:
"Just the juices of a few flowers." In a typical
Murphy gesture, the painting was loaned to
Ellen Barry at a time when she was feeling a
bit low, in the hope that it might cheer her,
and she had it in her collection until it went to
the Whitney Museum.

The Murphys and their entourage at Villa
America represent the Jazz Age at its height.
Without the art, however, the story would pale
in significance. As Archibald MacLeish wrote
in the preface to the MoMA catalogue: "To
any artist, and to a painter above all, the best
revenge upon life, or more precisely upon death,
is not living either well or badly but creating
works of art, and Gerald Murphy, whatever he
may have said upon the subject, knew it." One
of the most provocative things Gerald Murphy
himself ever said about their extraordinary
journey was a remark he made to Fitzgerald:
"For me only the invented parts of our life had
any real meaning."

Gerald Murphy may not have been the richest of the
Americans in Paris, but he was arguably the most
stylish. Just look at the razor-sharp crease in that hat!

ANYTHING GOES

Cole and Linda Porter

"Why oh why do I love Paris?"
—Cole Porter

When the Murphys arrived in France in 1921, Gerald's Yale schoolmate Cole Porter was already there. You could almost say that Cole Porter was brought up to live on the Riviera, which was hardly true of the other children in Peru, Indiana. His doting mother made sure he was tutored in French from age six, when he was also practicing two hours daily at the piano. The combined fortunes of his father and mother, consisting of brewery, coal mining, and drugstore interests, guaranteed a life of privilege. By eleven he had written an operetta, *The Song of the Birds*, the waltz from which his mother had privately published in Chicago. His prodigious verbal ability stemmed in part from his father reading Browning, Keats, Shelley, and other poets to him. He was the Little Lord Fauntleroy of Peru, a show-off who took a turn as pianist at the local nickelodeon (he was kicked off the stool when he started improvising). He arrived at Worcester Academy, a prep school in the Massachusetts Berkshire Hills, with sculpture, framed paintings, and an upright piano — as eyebrow-raising in 1905 as it would be now. Faculty wives loved his playing at their teas, and he immediately became involved in school theatricals, especially Gilbert and Sullivan productions, and wrote songs. Upon graduation, he sat for the Yale entrance exam. When he passed, his grandfather said he could have anything he wanted. He chose Paris.

He stayed with a Parisian family for two months, sharpening his conversational French, and then toured Switzerland and Germany. Back at Yale, Cole was a darling of the "rich rich set" (during his freshman year Vanderbilt Webb invited him to his midtown Manhattan mansion for a holiday). On the Yale campus only Leonard Hanna, Jr., scion of a Cleveland industrialist, had a higher allowance than Cole's. Both were known for their smart cufflinks, gold cigarette cases, mink-lined stadium coats, and colorful shirts and bow ties, as well as a generous habit of running a tab for class-

mates in local eateries. His sartorial splendor as well as his wit at the keyboard drew the notice of two other campus dandies, Big Men on Campus Gerald Murphy ("best dressed man" of the class of 1912) and Edgar Montillion Woolley, both active in the Psi chapter of Delta Kappa Epsilon. Porter was "tapped" by Murphy, who risked his considerable popularity at the house to admit Porter, who was considered eccentric. A decade later, the irrepressible trio of Woolley, Murphy, and Porter would take their college act on the road, delighting the drawing rooms of Paris society while hatching the new Broadway musical.

Porter married "the most beautiful woman in the world" (a mantle bestowed upon her by the tabloids): the icy Mrs. Linda Lee Thomas. The story of how they met in 1918 is engraved in the social history of the twenties with all the indelibility of a brass plaque on a building. The scene was the Paris Ritz. Porter gravitated to the piano during the reception for the wedding of Ethel Harriman and Henry Russell. The expat crème de la crème gathered round, including Mimi Scott, a singer just brash enough, once the champagne had taken effect, to pull off Porter's racier numbers. One of the delighted guests was a towering blonde stunner. At thirty-six, eight years older than the recent Yale graduate, Linda was a tale. She was the toast of post-Wharton Americans abroad despite having recently been divorced from financier Ned Thomas, a speed demon who was reputedly the first driver in the United States to kill someone with a car. He was a theater angel and a speculator, and he had a limp and a weakness for other people's wives. He ponied up $1 million for the divorce settlement after his indiscretions hit the headlines, and married again ten days later. Barred by law from remarrying in New York State, Linda came to Paris, allowed herself to be courted by dukes and counts, and gained a place in fashion history as the first to wear the "little black dress," usually with an extraordinary accent

Cole Porter hamming it up as a matador for a postcard.

"The most beautiful woman in the world": Linda Lee Porter in a portrait by Edward Steichen and in the Riviera sunlight outside her Château de la Garoupe.

of jewelry. A close friend joked that she did not know how to open a door and would leave a cigarette between her lips forever if a gentleman were not around to light it.

But getting back to the party at the Ritz. Linda Lee Thomas knew exactly whom to turn to when social strings were to be pulled — master marionetteer Schuyler Livingston Parsons, bachelor scion of several distinguished New York lines, bon vivant, and arguably the most connected man in Paris. Where did Charles Lindbergh stay when he returned to the States after his epic flight? Parsons' home. On whose piano did George Gershwin try out the first notes of *Rhapsody in Blue?* The Parsons Steinway. Where did Gertrude Lawrence and Beatrice Lillie spend their first evening in New York? The Parsons apartment. Linda gave Parsons marching orders: to book Cole Porter for an encore performance of his songs, rendered by Miss Scott at the Thomas apartment. The two were a bit put off by the command performance invitation, and to get back a little of their own, they concocted a plan. They costumed themselves as vaudevillians of the Belle Epoque, she in a beaded-jet dress and a silly hat, he in tails, high collar, and slicked-down hair parted silent-movie style in the middle. Linda was clearly amused, as were the guests, even though Porter and Scott lost a bit of their nerve and entered apologetically. It was clear from that evening on that he was completely taken with Linda.

Most of his friends — including Gerald Murphy, who viewed him as a younger brother — felt Cole was walking right into it. Sara later observed, "Cole was a natural-born hedonist, which is fine. People like hedonists. But Cole had so much more. He always liked beautiful, expensive things. Not that he thought about money. He never noticed it. He thought everyone had it, because he never had to bother. But he wanted to live like a king — which is all right too. Unless it stops you from working. That's what we were afraid of. Of course, he wanted to marry a very beautiful woman — which he did. Even I had to admit that. She was dull as anything, but she was very beautiful."

Beautiful and expensive. Even before Cole and his wallet showed up, Linda binged on antiques and art. She was partial to Chinese paintings, Louis XIV furniture, porcelain, first editions. After they were married in 1919 (at the mayor's office) it was easy to spot their open Rolls-Royce limousine — it was the one with the seven dachshunds in the seat beside the chauffeur.

But it was the baubles, bangles, and beads that most remember. She returned the Hope Diamond for fear of the curse, but other rubies and sapphires and diamonds bedazzled onlookers. One night at a café-concert a young couple from the States danced by her table several times until the young woman finally got up the gumption to ask: "Are those real?" Linda, hard as her diamonds, countered: "Real what?" (Of course, in our day that question no longer refers solely to gemstones.)

From an apartment at the Ritz they eventually moved to one of the most famous in Paris's long history of such addresses. The decor of 13, rue de Monsieur was as far ahead of its

The Porters' Rolls-Royce was easy to spot in Paris or on the Côte d'Azur — it was the one with the seven dachshunds in the front seat by the chauffeur.

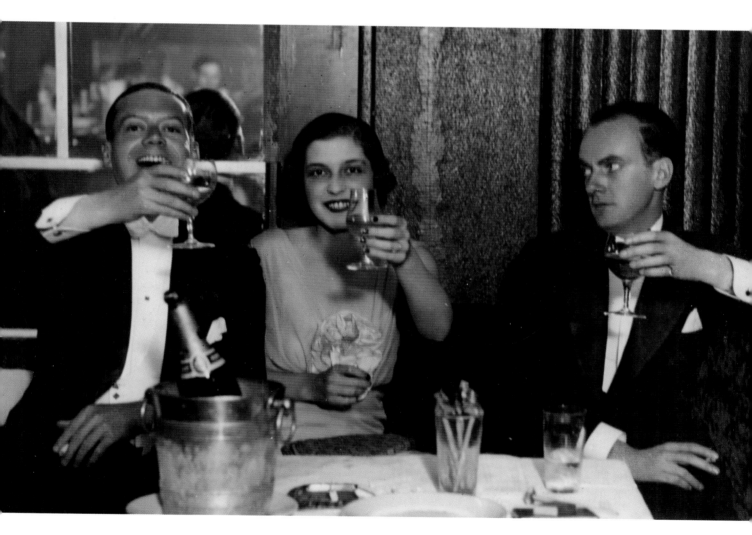

Our type: An evening on the town with Cole Porter often started at the Ritz for cocktails and included many of the café-concerts where he always had reserved tables by the dance floor.

time as Cole's lyrics. It had zebra-hide rugs and red lacquer chairs upholstered in white kid. One room's walls were clad in platinum wallpaper. The extraordinary study was an exercise in Minimalism *avant la lettre:* a brilliant white all round, with a white piano and white working table on which 100 sharp white pencils were arranged, as well as a crisply unadorned fireplace and no paintings or drawings on the walls. It stunned Diana Vreeland, who wrote about it in *Vogue.* Like the Murphys' Villa America, the apartment was an influential showcase for new ideas in interior design. These highlights of High Modern were not the whole story, however. Billy Baldwin, the interior designer, used more sumptuous furniture and arrangements in the sitting room, breaking the ascetic mood and creating a counterpoint of past and present that was forgotten by many historians who fixated on the platinum walls and zebra rugs.

The Porters were far from homebodies, of course — "There's No Cure Like Travel" — and their orbit included his beloved Venice, Rome, Monte Carlo, London, Biarritz, Seville, Morocco (where he started "Night and Day"), Newport (where he finished it), Berlin, and of course Manhattan. They were always attended by her maid, his valet, a chauffeur, and moochers and hangers-on of various levels of distinction. Trendsetters in Paris, they also led the way in redefining the Riviera lifestyle. Along with the soprano Mary Garden, they preceded everybody else, including the Murphys, in discovering the charms of the off-season at Antibes. Garden and the Porters broke with custom in 1922 and simply stayed on after the season had ended and everyone else had gone home. Anyone who lives year-round by the water knows the delicious satisfaction of seeing the taillights of the crowds disappear into the sunset. It means having the whole beach to one's self, returning to conversational tones in quiet restaurants, finding a place to anchor in a deserted harbor once crowded with boats, sharing the empty roads only with locals.

As was George Gershwin, Porter was a serious amateur painter, somewhat in the vein of Winston Churchill both philosophically and stylistically. When Porter's grandfather died in 1922 and left his mother half a million dollars, which she immediately split with

A view of Cole Porter's fabulous apartment at the rue
Monsieur, designed by Billy Baldwin, and shot for
a *Vogue* lifestyle piece by Diana Vreeland. The study
where he wrote was all in white, down to the pencils,
while the salons had all the opulence that Linda's
antique collecting demanded.

Cole, he fulfilled a childhood ambition to live in a palazzo in Venice. The one he bought had once been Isabella Stewart Gardner's. He spent his days at the easel, which mixed the brashness of the amateur with the ever-expanding sophistication of the American abroad who was imbibing art history in great gulps throughout Italy and France. His nights were passed in a constant round of high-level entertaining. The lucky beneficiaries of his largesse included the eminent theater critic George Jean Nathan, rival Tin Pan Alley star Irving Berlin, Ira and George Gershwin, John Barrymore, and, from the upper echelons at least artistically, Arthur Rubinstein, Sergei Diaghilev, and Serge Lifar, who persuaded Cole to host a ballet evening.

The Porters never did anything by halves. The affair, of which the ballet was only one part, required three barges of stage sets, including massive statues on loan from a local museum (insurance and loan policies were evidently a bit different in that era). The whole was lit by nothing less than 225,000 candles. This was the first of his annual Red and White balls, an invitation so sought after in Venice that a full hundred percent of those asked would come,

and a hundred more gate crashers somehow would sneak in for a night of splendid debauchery. The evening was crowned, at midnight, by the cessation of dancing long enough for the guests to enter the large salon, where there were piles of red crepe-paper costumes — pants, capes, skirts, sashes — for them to don before continuing to dance under colored lights, with acrobats performing overhead on high wires.

With fellow Midwesterner and rising society hostess Elsa Maxwell at his elbow urging him to test out his material professionally, Porter started a *galleggiante* (floating private club) and eventually joined forces with jazz diva Bricktop, whose eponymous club opened in Paris in 1925 and who often sang at the rue Monsieur apartment. Still smarting from the failure of his first Broadway musical, *See America First*, and blithely oblivious to the need for money, Porter had avoided serious writing until Murphy turned up with the irresistible commission from the Ballets Suedois. *The New York Sun and Globe* called their rollicking *Within the Quota* "a satirical touchdown," and the opening-night audience was equally enthusiastic. Suddenly, Porter felt the urge to reenter the theater business.

Cole and Linda Lee Porter entertained lavishly at the Château de la Garoupe near Antibes.

In Venice and on the Riviera, Cole often had his watercolors out to capture beach scenes like this one, which Linda pasted on the final page of one of their photo albums.

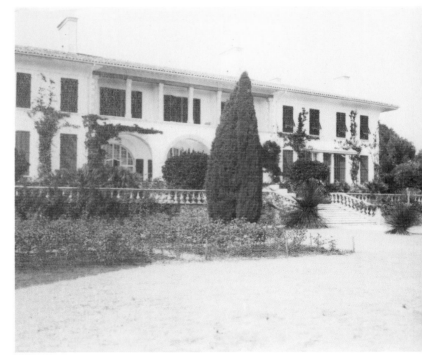

Right on the downbeat, Edmond Sayag, who owned the Café des Ambassadeurs, commissioned him to do an American revue. The music was top-tier, played by Fred Waring's orchestra with guest singer Frances Gershwin, George and Ira's sister, and the obligatory complement of chorus girls. The aim was simple: Put on a Yale smoker for a Paris crowd. The opening number was "Keep Moving," an all-aboard that urges:

Keep moving, keep moving, and cover ground.
If you meet disaster,
Step lively, get past her,
Go faster and faster
And put a bit more pep in your step.
All aboard for over-there
All aboard for God-knows-where
All aboard, goodbye, Uncle Sam
Give our love to the family Ford.

Porter swiftly tossed off two dozen other songs in this vein, making it look easy. The opening was attended by royalty, William Randolph Hearst threw the after-party, and Linda made all the papers wearing a new Cartier scarab set with immense diamonds. For Cole, it was the end of high society — bopping around from Paris to Biarritz, Morocco, and Manhattan, and noodling at the piano during parties — and the beginning of "High Society." Like an athlete turning pro, he made the transition from private entertainments to big-budget productions.

The touchdowns started coming quickly, including songs for a Paramount film, *Battle of Paris*, that starred Gertrude Lawrence; the score for *Wake Up and Dream*, which ran in London and New York; and, *allegro vivace*, the scores for *Fifty Million Frenchmen*, *The New Yorkers*, and *The Gay Divorcee*. The breakthrough was *Fifty Million Frenchmen*, because Cole for once was not a collaborator, but the

Elsa Maxwell pushed Cole Porter to become a professional songwriter. He immortalized her in one of his tunes: "I'm dining with Elsa/And her ninety-nine most intimate friends. . . ."

Gerald Murphy and Cole Porter worked on their groundbreaking jazz ballet *Within the Quota* at Porter's palazzo in Venice.

"If I can get into a bottle where all the bubbles are":
The cover for Porter's wildly popular 1929 Broadway
musical *Fifty Million Frenchmen.*

unifying genius. The work was directed by old Yale pal Monty Woolley. Its elaborate sets required seven railroad cars to make it to Boston for an out-of-town tryout, and then were too big for the New York theater. It opened on November 27, 1929 — smack in the middle of the Wall Street collapse. For a while, *Fifty Million Frenchmen* and *Wake Up and Dream* ran simultaneously on both sides of the Atlantic.

The titles and quicksilver lyrics of these early revue numbers run like a color commentary on the times. The anthems of a generation? Call them the fight songs for the team, the "Boola Boola" of the partygoers. From "Anything Goes" to "Ev'ry Day a Holiday," from "Let's Fly Away" to "Somebody's Going to Throw a Big Party," they stoked the burners for the revelers who crossed the Atlantic. From the 200-plus ballads, dance tunes, and astonishingly sophisticated (particularly by comparison with the meager drivel or savage pathology of today's pop and rap) comic songs Porter wrote before 1928, his compatriots learned to love Paris, to "get into a bottle where the bubbles are" ("Paree, What Did You Do to Me?"), to give themselves up to "just one of those crazy flings." Just reading the words makes you feel as welcome to the club as a snifter of Armagnac, magically capturing the intimacy of the privileged circles of which the Porters were the center. You're invited, whether it's sitting with "the upper supper set to sup" ("Somebody's Going to Throw a Big Party"), taking a regular table at Bricktop's club in Paris ("The Happy Heaven of Harlem"), or joining the other Eli, including Murphy, Woolley, and Archie MacLeish at the Ritz bar. Like Cocteau's backstage notes, the behind-the-scenes glimpse of ambition in "Another Op'nin' Another Show" is palpable: "Another job that you hope, at last/Will make your future forget your past." You're present in the ballroom for "A Toast to Volstead" and its punchline, "Here's long life to Volstead/And I hope he dies of thirst." In "Please Don't Make Me Be Good," the slightly naughty but never tasteless tone implores, "I'm getting so bored,/With virtue's reward,/So please don't make me be good." The fun and games are in the lines of this song written for one of Elsa Maxwell's famed parties in the late twenties, during most of which Maxwell, to the annoyance of Mrs.

Porter who had long since begun to find the hostess tiresome, promoted the songwriter's talents to *tout* Paris:

I'm dining with Elsa, with Elsa, supreme
I'm going to meet princesses
Wearing Coco Chanel dresses
Going wild over strawberries and cream.
I've got Bromo Seltzer
To take when dinner ends,
For I'm dining with Elsa
And her ninety-nine most intimate friends.

Porter celebrated "our type" and the pleasures of tagging along with the fun group. Betty Compton and Jack Thomson gave "Down With Everybody But Us" its preview in the Boston production of *Fifty Million Frenchmen*. Its lines go right to the point: "Down with the folks who bore us/Up with the Anvil Chorus/Down with ev'rybody but us." Porter flirted with the prevailing boundaries in a way that is reminiscent of Hemingway's manner of testing old man Scribner with unprintable words in an early draft of a novel. Notably, "some get a kick from cocaine," the line that made theater owners wince in "I Get a Kick Out of You." Although Ethel Merman sang it as Porter wrote it in its debut, its published (whitewashed) variants in later, tamer productions included "Some like the perfumes of Spain" or "Some like a bop-type refrain." He raised eyebrows, similarly, with "Do It Again" and with "Love for Sale," which was banned from the radio for decades after its premiere in 1930.

During the twenties, Porter gave up both painting and serious jazz composition to get into gear as a popular songwriter. The future, of course, brought a parade of hits sung by the top stars of the next two decades. It also brought the dark day in Locust Valley at the Piping Rock Club, when he took a skittish colt out for a ride (against the groom's protests) and had both legs crushed after the horse reared. Left on the ground by his host Benjamin Moore, who went to the local fire department for an ambulance, Cole took out his pencil and notebook and finished the lyrics to the title song of "You Never Know." Linda was in Paris. To Elsa in the hospital he bravely quipped, "It just goes to show fifty million Frenchmen can't be wrong. They eat horses instead of ride them."

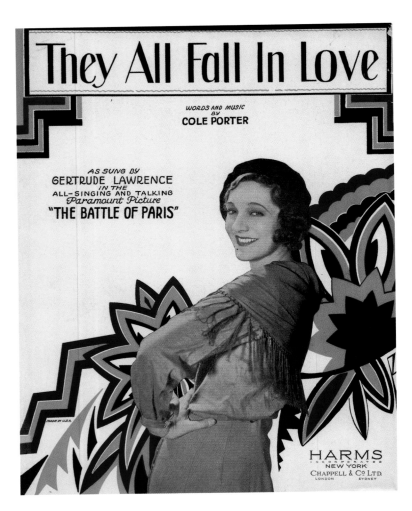

The cover for "They All Fall in Love," one of the many hits in the 1929 Broadway musical *The Battle of Paris*, words and music by Cole Porter.

In *Paris* (1927), Irene Bordoni was typecast as the sultry songbird Vivienne Rolland, who nearly seduces a young American millionaire with the risqué "Let's Do It (Let's Fall in Love)."

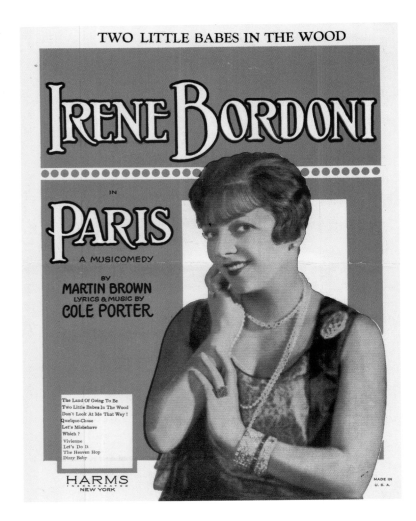

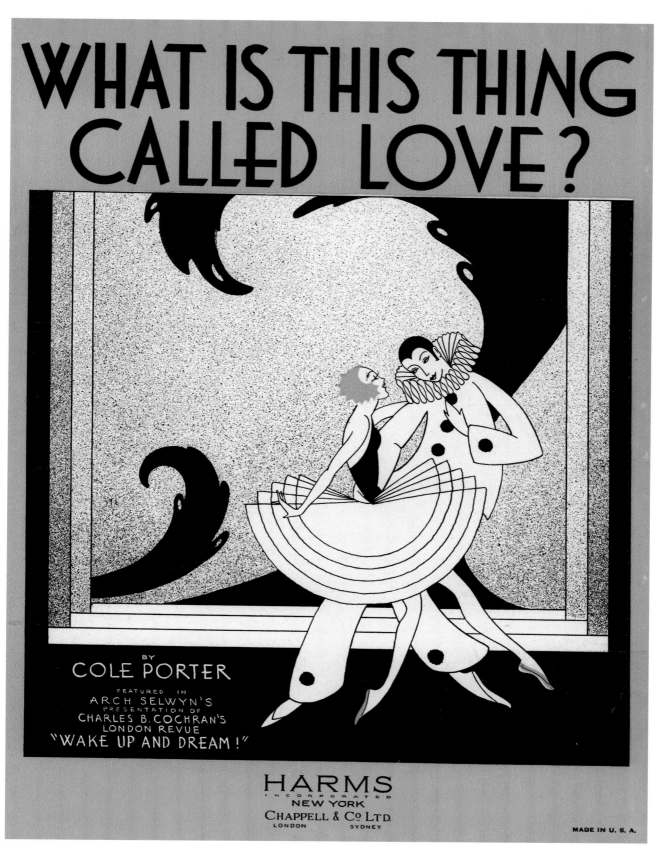

"What Is This Thing Called Love?" was one of
several Porter hits in 1929.

LIVE IT UP TO WRITE IT DOWN

F. Scott and Zelda Fitzgerald

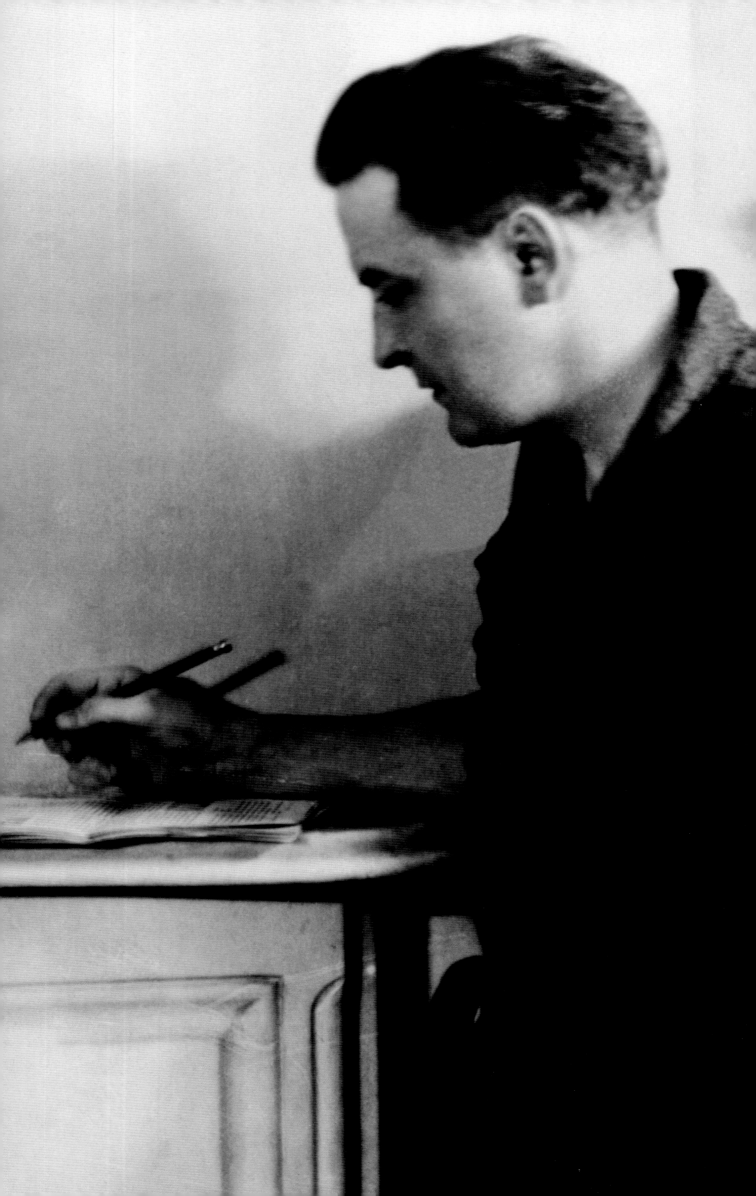

> *"Out there the hot light clipped close her shadow and she retreated – it was too bright to see."*
> —F. Scott Fitzgerald, *Tender Is the Night*

Once the stage had been set by the Murphys and the Porters, all was ready for the star turn: Zelda and F. Scott Fitzgerald. They arrived on the Côte d'Azur for the summer of 1924, one that would make its mark on American literary history for the masterpiece it produced, *The Great Gatsby*, and the touching elegy for the decade it begat, *Tender Is the Night*. Although their first venture abroad in 1921 had been a disappointment, the Fitzgeralds' second trip was one for the books. Scott and Zelda had barnstormed through their considerable earnings with wild parties in town and at their "nifty little Babbitt house" (as she called it) in Great Neck, a suburb of New York City on the north shore of Long Island. Bored and forever bordering on broke until one of them could land a magazine assignment, they had fine-tuned party antennae, which caught the signals of the moveable feast across the pond. Scott's satiric account of their fiscal befuddlement was offered in a mock plea for sympathy that ran in *The Saturday Evening Post*, "How to Live on $36,000 a Year," in which the spendthrift author mused, "I wanted to find out where the $36,000 had gone. Thirty-six-thousand is not very wealthy — not yacht-and-Palm-Beach wealthy — but it sounds to me as though it should buy a roomy house full of furniture, a trip to Europe once a year, and a bond or two besides. But our $36,000 had bought nothing at all." Just as their inability to balance a budget that started with nearly forty grand was outrageous, here is an extraordinary fact about Scott and Zelda, celebrity couple: They never owned their own home, either in the States or in Europe. The house on Long Island, and the several villas they were heading off to occupy, were all rentals.

According to Scott, the plan was simple: "I will take the Long Island atmosphere that I had familiarly breathed and naturalize it beneath unfamiliar skies." The logistics of the move were not that challenging. All they had to do was follow the lead of the other Ivy League, Manhattan smart set (the Porters, Dos Passos,

Cummings, Murphys, MacLeishes), the first wave having already secured the beach at Antibes. On April 15, 1924 they did the math and decided to head for the Riviera. They had managed to hang on to $7,000 in savings to stake them. Properly managed, this could go a long way in France. A dollar would get them nineteen francs at a time when three francs was sufficient for a decent dinner with wine. Scott could bear down on his third novel, the working title of which was *Among Ash Heaps and Millionaires,* although his devoted and brilliant editor Max Perkins, who had shepherded *The Beautiful and the Damned* and *This Side of Paradise* through the press for Scribner's, wanted it to be called *The Great Gatsby*. They chose the *Minnewaska*, a "dry" ship, for the voyage, and embarked with their seventeen pieces of luggage and a set of the *Encyclopaedia Britannica*. Scott was serious about staying sharp for his writing. Never exactly cover material for *Parenting* magazine, they made a priority of finding an English nanny for Scottie for only $26 a month in Paris. (It is a shame her diaries do not survive.) After nine days there — during which Scott made a backslapping celebratory tour of the Ritz bar, Left Bank cafés such as the Dôme, and then the Right Bank and Montmartre — they decamped to the south. They stayed at first in a hotel in Hyères, then moved into the Villa Marie in Valescure and rented a Renault that would be immortalized in the hair-raising stories of wild, besotted late-night drives along the Corniche and other switchback roads of the coast that summer.

The Riviera cast its spell immediately upon the young Fitzgeralds. Writing to his buddy and fellow novelist Thomas Boyd, Scott waxed enthusiastic: "This is the loveliest piece of earth I've ever seen without excepting Oxford or Venice or Princeton or anywhere. Zelda and I are sitting in the cafe d'Universe writing letters (it is 10:30 PM) and the moon's an absolutely *au fait* Mediterranean moon with a blurred silver linen cap and we're both a little tight and

F. Scott Fitzgerald correcting the proofs of *Tender Is the Night,* his fictive portrait of Gerald and Sara Murphy (to whom it is dedicated).

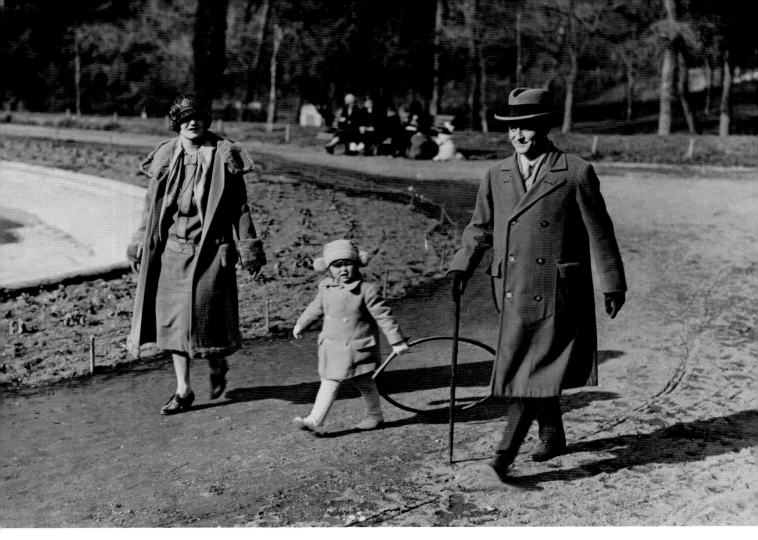

The Fitzgeralds take a stroll in a Paris park during their first summer in France in 1924. Newly famous and darlings of the magazines, everywhere they went they were recognized by Americans abroad.

very happily drunk if you can use that term for the less nervous, less violent reactions of this side."

Their arrival was a cause célèbre. It would be hard to conjure a literary "property" hotter than the Fitzgeralds in the spring of 1924. Bold-faced names in the gossip pages and cover-line-caliber writers for major magazines such as *The Saturday Evening Post* and *Esquire*, they brought the high gloss of celebrity to a literary scene quietly confined to small-press precios-ity and parties more like seminars. They made the scene — or made a scene — in Monte Carlo, Cannes, and Antibes, where it was only natural they would find themselves at the door of Gerald and Sara Murphy. Accounts vary with regard to when and how they actually met, but the bridges between them were many. Dos Passos knew both couples well and sent the Fitzgeralds to France with a letter of introduc-tion. Gerald's sister Esther knew the Fitzgeralds socially in New York and told them to look her brother up. Donald Ogden Stewart, another

mutual friend who was in Antibes that summer, may have done the honors, or it could have been Gilbert Seldes, the literary critic, who visited both couples in August of that year dur-ing his honeymoon; by that time Fitzgerald had logged the Murphys in his carefully kept ledger. While Gerald and Sara may have pre-ferred Zelda at first, they took on the Fitzgeralds as a project as soon as they arrived at the Murphys' suite of rooms at the Hôtel du Cap (the Villa America was undergoing its facelift that summer). The attraction was so strong that Scott and Zelda wanted to move to Antibes just to be closer.

That summer was far from distraction-free for a novelist on deadline. The twenty-four-year-old Zelda, neglected and bored as many writers' wives tend to be, was the willing object of a tall, handsome French aviator's devoted attention on the beach, and about half of their many biographies suggest she had an affair. Although Edouard Jozan (later a war hero and admiral) often zoomed just over the villa in

his plane, he later denied he had slept with Zelda. He did, however, admit that Zelda and Scott added a soupçon of cosmopolitan excitement to the summer: "Zelda and Scott were brimming over with life. Rich and free, they brought into our little provincial circle brilliance, imagination, and familiarity with a Parisian and international world to which we had no access." The novelist, oblivious through much of June, was tormented in July by the dalliance. He marked the ledger: "The Big crisis — 13th of July." The Murphys and others were nervously watching the beach soap opera unfold. Gerald described their modus operandi in tragicomically conspiratorial terms: "They would begin together in the evening; you would see some look come over them as though they had been drawn together — and then they were companions. Then they were inseparable. They would stay out all night. It was as though they were waiting for something to happen; they didn't want entertainment, or exotic food; they seemed to be looking forward to something fantastic. That's the only way I can put it; something had to happen, something

extravagant. It was that they were in search of, and they went for it alone." For the Murphys and other friends, the painful truth of Zelda's appetite for excess and what it was leading to was not a matter for immediate comment. Turning a blind eye was just part of the exercise routine on the Plage de la Garoupe — later Hemingway would show up with both his wife, Hadley, and his mistress and her good friend, Pauline Pfeiffer, and there were always Picasso's indiscretions to overlook. By August Zelda's threats of divorce had passed, but the drama continued with suicide attempts (hers), binge drinking (both), and wild fights. Some married couples — God knows how or why — thrive on a steady course of crisis. If the neighbors missed the late-night shouting, they would know the next morning that there had been an outburst because Zelda would have her bags packed and piled at the villa's gate.

A writer's capital often comes at the expense of those near and dear. Zelda used the turmoil in her novel *Save Me the Waltz*, which bombed after Scribner's published it. She lifted the title from a line in a Victor record catalogue.

Happy and healthy, the Fitzgeralds frolic in the water at Antibes.

The Fitzgerald family in the little Renault that Scott bought for Zelda to have a bit of independence while the family was on the Riviera. This image is from their scrapbook.

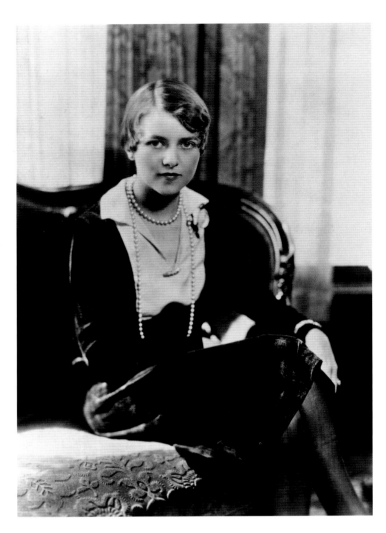

Zelda Sayre was the belle of the ball in Montgomery, Alabama, when she met Fitzgerald, stationed there for military training.

Alongside *Tender Is the Night*, which directly matches many of the same moments in its coverage of the era, Zelda's novel seems overheated and shoddy. She strikes many of the same keys as Scott, including the way she pits blue against yellow, the chromatic code of *The Great Gatsby*, in her symbolic system. Ironically, insofar as either of the Fitzgeralds is read at all on the undergraduate level these days, it is a triumph of political correctness that for every page of *Gatsby* assigned, teachers require at least one excerpt from Zelda's novel as a way of leveling the scale of their reputations, and feminists insinuate that he ripped her off both in a literary and an emotional way. *Save Me the Waltz*, like *Tender*, is in part a roman à clef, wherein Alabama is Zelda, Jacques is the aviator Jozan, and David is Scott. The languid, sensitive Alabama is teaching herself French by reading *Le Bal du Comte d'Orgel* with a copy of Larousse by her side. The sound of Jozan's propeller gives her palpitations in this scene that draws upon some of her fondest teenage memories from Montgomery, Alabama, where she lived by an air base and was susceptible to the old wing-dip trick of pilots hoping to land on her dance card in the evenings.

The beating, drumming whirr of an aeroplane sounded above the villa. The plane was so low that they could see the gold of Jacques' hair shining through the brown net above his head. The plane swooped malevolently as a bird of prey and soared off in a tense curve, high into the blue. Banking swiftly back, the wings glittering in the sun, it dropped in a breathless spiral, almost touching the tile roof. As the plane straightened itself, they saw Jacques wave with one hand and drop a small package in the garden.

"That damn fool will kill himself! It gives me heart failure," protested David.

"He must be terribly brave," said Alabama dreamily.

Since *Gatsby* was not delivered until October, the emotional havoc of all this low flying and billet dropping must have factored into its lateness and, perhaps, added a needed bitterness. Stimulus comes in many packages. Balancing Zelda's adrenaline-generating indiscretions was the always positive lift of being within the Murphy circle, so deftly captured in the early pages of *Tender Is the Night*. Later in life Scott would write of Gerald, "a fourth man had come to dictate my relations with other people when these relations were successful: how to do, what to say. How to make people at least momentarily happy.... This always confused me and made me want to go out and get

drunk, but this man had seen the game, analyzed it and beaten it, and his word was good enough for me."

When Fitzgerald looked up the Murphys, he could never have anticipated what an important connection he would be initiating. Fitzgerald was at a crossroads. He was an acclaimed if not yet comfortably off young literary star rising to the very zenith of his powers despite a mile-wide self-destructive streak. Nothing to come — not the acclaim of literary Manhattan or the money of Hollywood — would match the rhapsodic fulfillment of that first summer in Antibes. The friendships meant as much as the "output." As Gerald had played older brother to Cole Porter, so he was a guiding, fraternal influence on Scott, who was eight years younger. Sara reluctantly permitted herself to be the muse. Although the Murphys were more conservative, their similarities to the Fitzgeralds were more important than the differences. Let us take the keynote from an early working title for *Tender Is the Night*: "Our Type." It goes right to the heart of what made this group so special. The phrase accounts in part for the rapidity with which the bonds of camaraderie in the Murphy circle were solidified, as well as the intensity of the creative exhalations brought on by all that emotional excitement. All these ex–Ivy Leaguers, minor heirs and heiresses, veterans, dropouts from the law and business (think of them either as latecoming Belle Epoque bohemians or hippies *avant la lettre*) shared a code. The lingua franca included vaudeville gags, sly allusions to family expectations, nostalgia for the best nights ever at jazz clubs or most memorable tailgate parties on football Saturday afternoons, the enthusiasms and disappointments of French life. "Everybody was so young," recalled Sara Murphy in the 1960s (and Murphy biographer Amanda Vaill used it for the title of her magisterial account of the period). But it was not youth alone, nor snobbery, that held them together. The epoxy drew its strength from the ambitions that had brought them to France — take your best shot at becoming the poet, the painter, the composer, the bon vivant you had read and dreamed about. Nor were they sloppy amateurs, coupon-clipping *faux* artistes. The respect instilled by good work (recall the approval with which Picasso and Léger viewed Murphy's paintings, or the praise Hemingway heaped on Fitzgerald at the time, not just the late acrimony) weighed as heavily as the inherent acceptance people of similar class and backgrounds extend to one another, that willingness to include a stranger in the circle as long as his references check out. Quite a bit of the closeness also derived from a common

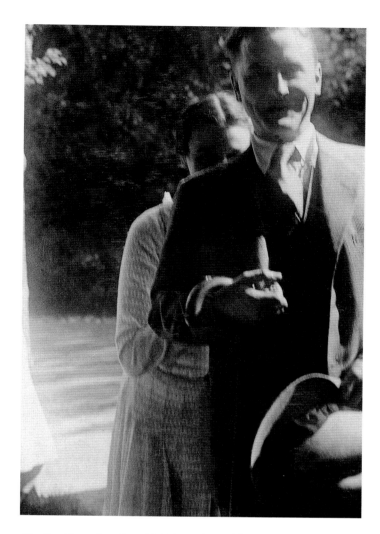

Alice Lee Myers clowning with F. Scott Fitzgerald in France.

intellectual parlance that meant allusions would be caught. They all got the joke.

The art each of them made was bolstered not only by mutual support but by the material the group proffered. The greatest beneficiary among them by far was Fitzgerald, who essentially built two of his best books on the repartee heard on the terrace of Villa America and, more admirably for being more substantive, upon the candor of introspection he learned from the Murphys. With their age difference, three children, and a lifestyle far more devoted to family, Gerald and Sara represented a different generation in certain respects. In fact, the Fitzgeralds (along with Dos Passos and Hemingway) called Murphy "Dow Dow" after his children's affectionate way of saying "dada," while Gerald addressed letters to the Hemingways, "My children" (so much for Papa). Without detracting from the sheer force of Fitzgerald's concentration and energy in those days, which drove him through the writing of a classic in a few short months, it seems clear that the love and support of the Murphys was essential to the mysterious mix that allowed *Gatsby* to be composed so quickly.

There were parallels aplenty within the Irish-American Fitzgerald-Murphy quadrangle. Gerald and Scott had been trainees but not combatants in the Great War. They were Ivy Leaguers and East Coast prep school graduates with no particular fondness for their school days, and they seemed to know all the same people on both sides of the pond. The party animal aspect of their days together is often stressed in accounts (the next year Scott referred to June and July as the summer of "1,000 parties and no work"), but in the summer of 1924 a block of each day was spent in the solitude of the studio, where Gerald meticulously painted and Scott crafted a stylistic masterpiece in *The Great Gatsby*, the undisputed peak of his career. Accounts of the working habits of writers and artists do not make lively copy, but the two would be nothing but socialites if it were not for what was made in those quiet hours.

The couples had interlacing interests. Sara and Scott shared the Midwest cultural background. Sara and Zelda were expat mothers, though of a decidedly different stripe. Gerald and Zelda were painters, and the Murphys shared her passion for the ballet. Music is a great binding agent, and they all took turns keeping Gerald's phonograph spinning with the latest jazz from the States. As Gerald wrote to Scott, "We four communicate by our presence rather than by any means. Currents race between us regardless: Scott will uncover for me values

in Sara, just as Sara has known them in Zelda through her affection for Scott."

Certain ideas were in the air, and the well-read Murphy circle would have had as conversational starters such notions as those propounded by Thorstein Veblen in his 1899 classic, *Theory of the Leisure Class*, or the pragmatism of John Dewey, the pessimism of Oswald Spengler, which was a bestseller in its English translation and frequently cited as a powerful influence on Fitzgerald's work. When Dewey proposed, "A bare event is no event at all; something happens. What that something is, is found out by actual study," he was launching an entire mode not only of philosophical inquiry but of writing in Fitzgerald and Hemingway's case, and painting in the work of Léger and Murphy. These were new and exciting ideas, and from the distance of France a wonderful way to intellectually amplify the drama of the break from America. In a March 14, 1925, letter from France, Archibald MacLeish beautifully articulated what they meant to him as a poet: "To write one must take the world apart and reconstruct it." He would later add, "Great poems are instruments of knowledge." Standing before a painting or reading a novel for the first time, we do not always know what the maker had in mind beyond the basics of narrative and character, or color and line. For that matter, we do not always care. However, the experience of the people who made the works is more available to us in the case of the so-called Lost Generation, partly because they did not live long ago and partly because the ideas are embodied in the work if we just choose to look for them. Murphy, MacLeish, Hemingway, Fitzgerald, and Léger were all attentive observers of the commonplace who circled their subjects with unblinking scrutiny, like expert boxers in the ring, then painstakingly rendered the details that, to use Dewey's term, make a pocket watch or a party into an "event." Every time Fitzgerald was jilted, for example, it made its way into a novel or a story.

The golden year 1924 was in many ways the annus mirabilis of Fitzgerald's career, not in the boring sense of how much money he made, but in terms of craft. Even as he was pulling together the tightly woven *Gatsby*, he was also writing numerous short stories and articles for American magazines. Because his smart-aleck voice was lucrative, he was too often tempted to drop into it. However, by 1926 and the initial stages of *Tender Is the Night*, he reversed the slide from substance into style by offering his own psyche up as content, courageously ripped from inside through an

analytic process he learned in part at the Murphys' table. It would later emerge in the extraordinary nonfiction volume, edited for him by Edmund Wilson, called *The Crack Up*, a forerunner of the disability memoir.

The Fitzgeralds became somewhat dependent on the Murphys not just for fun and games but for guidance. The older couple combined their fabled generosity and forgiveness with a moral rigor that did not countenance the rudest of Fitzgerald's destructive gestures. Sara and Gerald rebuked him when he needed it. After the notorious debacle at dinner at the Villa America when Fitzgerald, drunk, disgraced himself before the Princesse de Caraman-Chimay, and smashed three Venetian glasses by throwing them from the terrace, Sara banned him from the property for three weeks and gave him a dressing-down in a letter, concluding her harangue: "But you ought to know at your age that you can't have theories about friends." Another, similar night out ended abruptly when Fitzgerald sank to his knees on the dance floor of a restaurant, much to the astonishment of the gypsy band playing. He sobbed and pleaded with Gerald, "Don't go! Take me with you. Don't leave me here." Murphy's response is both patrician and helpful in a "tough love" way. "This is not Princeton, and I'm not your roommate," he said, dropping Fitzgerald's hands and leaving him to make his way on his own back to the villa in Antibes. It is always hard to pinpoint the moment of genesis for any work of art, but one can imagine that the cold sober light of day brought an impulse to start *Tender Is the Night*. Even through the haze of alcohol and ego that uncharitable critics and biographers have keyed on, Fitzgerald knew to seize on insights and use them redemptively in his fiction. The moral intelligence of *Tender Is the Night* is a credit in part to the Murphy influence.

The Fitzgeralds had the deepest psychological stake in returning year after year to the Riviera. Like a gambler who waits for his lucky seat at a roulette table where he won big years before, Scott would head south from Paris annually in the hope of tapping again the wellspring at which *Gatsby* had been drawn. After the novel was sent to Scribner's in late October 1924, Zelda dragged him off to Rome and Capri (she had just read Henry James's *Roderick Hudson*), where they were absolutely miserable. They returned to Paris in the spring of 1925, after *Gatsby* had its debut, and Scott was the toast of the town. By that time, his racy material was perceived as a cinch for Hollywood, though no one would guess it would take as long as it did for *Gatsby* to become a block-buster. Nor was he lacking in literary credentials. His hip pocket held a wad of letters filled with the kind of glowing praise that make alcohol seem superfluous, including plugs from Old Master Edith Wharton ("Let me say how much I like Gatsby, or rather His Book, and how great a leap I think you have taken"), gate-keeper Gertrude Stein ("You are creating the contemporary world much as Thackeray did his in *Pendennis* and *Vanity Fair* and this isn't a bad compliment"), Willa Cather, and the immensely influential T. S. Eliot, who after reading *Gatsby* three times declared, "In fact it seems to me to be the first step that American fiction has taken since Henry James."

Their time in France from 1924 to 1930 was split among comfortably appointed apartments and hotel suites and villas in the south. A clever piece titled "Show Mr. and Mrs. Fitzgerald to Room Number . . ." is a catalogue aria, year by year, of their hotel rooms, including this entry: "The Hotel du Cap at Antibes was almost deserted. The heat of day lingered on the blue and white blocks of the balcony and from the great canvas mats our friends had spread along the terrace we warmed our sunburned backs and invented new cocktails." The friends who supplied the mats, and most of the cocktails, were of course the Murphys.

The springtime of the friendship between Hemingway and Fitzgerald was also 1925, when the older writer was eager to persuade his editor, Maxwell Perkins, that Hemingway was worth signing. In Paris they met nearly daily, and literary historians have documented the genuinely splendid way in which Fitzgerald read Hemingway's manuscript of *The Sun Also Rises*, and their conversations on craft. Even in the mean-spirited *Moveable Feast* Hemingway said about Fitzgerald and the everlasting grace *Gatsby* had earned him: "When I had finished the book I knew that no matter what Scott did, nor how he behaved, I must know it was like a sickness and be of any help I could to him and try to be a good friend."

The giddy bliss of those days is reflected in one of Fitzgerald's most poignant admissions to Hemingway at decade's end. Although their friendship had been sorely tried, they were still tightly allied, craftsmen who were surprisingly generous to one another financially and collegially, and Fitzgerald confided the worry that he had spent himself during the great creative blitz of 1924: "All that time we were living at top speed in the gayest worlds we could find." Both Fitzgerald and Murphy were concerned about Hemingway during the divorce from Hadley in 1926, Murphy quietly depositing $400 in the writer's bank account, and

Fitzgerald also offering support both monetary and moral, including a letter that read in part, "I can't tell you how much your friendship has meant to me during this year and a half. It is the brightest thing in our trip to Europe for me."

The social scene in the south had cranked up to its full pitch during the summer of 1925. Fitzgerald was in a jocular mood one day at the end of the summer when he wrote to his dear friend from Princeton and literary mentor, John Peale Bishop: "There was no one at Antibes this summer except me, Zelda, the Valentinos, the Murphys, Mistinguet, Rex Ingram, Dos Passos, Alice Terry, the MacLeishes, Charles Bracket, Maude Kahn, Esther Murphy, Marguerite Namara, E. Phillips Oppenheim, Mannes the violinist, Floyd Dell, Max and Crystal Eastman, ex-Premier Orlando, Etienne de Beaumont — just a real place to rough it and escape from all the world. But we had a great time. I don't know when we're coming home — The Hemminways [sic] are coming to dinner so I close with best wishes Scott." Did Bishop feel the same twinge of envy we do as he read this?

Those who find Hemingway's A Moveable Feast dubious — and most who know the particulars of the time find it at least factually astray despite some accuracy in its characterizations — can turn to Fitzgerald's "Echoes of the Jazz Age" as a guide to the real story. Written in November of 1931, a scant two years after the period officially ended, according to its author, it first appeared in Scribner's Magazine. Fitzgerald's history is glib but remarkably comprehensive, bouncing briskly from politics to literature to gossip (movie stars, drinkers, and socialites, his stock-in-trade). "It was an age of miracles, it was an age of art, it was an age of excess, and it was an age of satire," he offers in parody of Dickens. To sell the piece, Fitzgerald devoted perhaps too much of the memoir to sex and its role in shaping the mores of the decade, suggesting that by 1922 the flappers and their lucky dance partners had taken "petting" and the casual kiss to an extreme. Given what we already know about the slightly older Murphys, and the way that Fitzgerald in turn played the elder statesman of the flapper era to comic effect in some of his other journalism, the next observation has a particular piquancy: "The sequel was like a children's party taken over by the elders, leaving the children puzzled and rather neglected and rather taken aback. By 1923 their elders, tired of watching the carnival with ill-concealed envy, had discovered that young liquor will take the place of young blood, and with a whoop the orgy began." He viewed the progression from the cocktail parties of 1921 to

the hedonism of the mid-decade headlong race, "served by great filling stations full of money," as inevitable. Unconvinced that the movies of the Jazz Age had done the damage (he viewed the "Hollywood hacks" as too "timid, behind the times and banal" to do much damage), he singled out jazz and bestsellers as the rum in the punch. In an ironic aside, he adds, "There were very few people left at the sober table." As society drifted toward Palm Beach or Deauville, Fitzgerald joined the "smaller" crowd and headed for the south: "One could get away with more on the summer Riviera, and whatever happened seemed to have something to do with art. From 1926 to 1929, the great years of Cap d'Antibes, this corner of France was dominated by a group quite distinct from that American society which is dominated by Europeans. Pretty much of anything went at Antibes — by 1929, at the most gorgeous paradise for swimmers on the Mediterranean no one swam any more, save for a short hangover dip at noon." But Fitzgerald noted another type of decline by mid-decade: "Americans were getting soft," and "neurosis" was evident. The names of Princeton buddies, contemporaries not yet past their thirties, began showing up in the alumni notes dead, either by murder, suicide, or heart attacks. Paris began attracting the wrong sort ("fantastic neanderthals who believed something, something vague, that you remembered from a very cheap novel" arrived by the boatload in 1928). "It ended two years ago, because the utter confidence which was its essential prop received an enormous jolt, and it didn't take long for the flimsy structure to settle earthward. . . . It was borrowed time anyhow — the whole upper tenth of a nation living with the insouciance of grand ducs and the casualness of chorus girls."

Fitzgerald's crash course in the sociology, psychopathology, literature, and philosophy of the twenties ends on a note of nostalgia, one long sentence full of Hemingwayesque conjunctions:

Sometimes, though, there is a ghostly rumble among the drums, an asthmatic whisper in the trombones that swings me back into the early twenties when we drank wood alcohol and every day in every way grew better and better, and there was a first abortive shortening of the skirts, and girls all looked alike in sweater dresses, and people you didn't want to know said 'Yes, we have no bananas,' and it seemed only a question of a few years before the older people would step aside and let the world be run by those who saw things as they were — and it all seems rosy and romantic to us who were young then, because we

will never feel quite so intensely about our surroundings any more.

Fitzgerald's fictive retrospective on the Jazz Age was darker. The story of the composition of *Tender Is the Night* is a saga unto itself — while he put off the ever-patient Perkins with a decade's worth of thinner and still thinner telegram excuses and promises of its imminent arrival, he destroyed page upon page of the manuscript. Even the "final" version was a writer's battlefield of cuts, questions, insertions, second guesses, and overall indecision. *Tender* was started twice — in 1926 and in 1932 — and everything from the cast of characters to the plot outline changed drastically. It was always a book about the Riviera, but in its later incarnation Fitzgerald precipitated that bizarre and friendship-threatening metamorphosis that took the Divers from being an accurate and entrancing dual portrait of the Murphys into a blurred but recognizable image of the Fitzgeralds. The Murphys were charitable, but Hemingway never forgave him for it.

As poignant as it is riveting, one of the most fascinating documents in the vast trove of Fitzgerald manuscripts and memorabilia stored in the vaults of the Princeton University Library's rare books division is the detailed movie treatment for *Tender*. Fitzgerald collaborated on it with Charles Marquis Warren, a young Baltimore freelancer, in 1934. Its first pages offer casting suggestions. Who should play the Murphys? Fitzgerald's wish list is fascinating, from Fredric March, Robert Montgomery, Douglas Fairbanks, Jr., and Ronald Colman to Leslie Howard (!), and, on Sara's side, Katharine Hepburn, Miriam Hopkins, and Helen Hayes. For the ingenue Rosemary Hoyt, who was modeled on a starlet of Fitzgerald's generation named Lois Moran, he wanted Marlene Dietrich, Myrna Loy, or Constance Bennett. Unlike the novel, when it is not just plain crude (car crash, riding accident, onscreen nervous breakdowns, both Divers skirting the brink of affairs, the utterly ridiculous denouement of Dick operating on his own wife's brain), it is generally pretty silly. At the opening, Dick Diver is at Nicole's bedside after she has been thrown by her horse, and signs of her mental illness are immediately present — unlike the deft way in which they insinuate themselves gradually through the novel. The ending is so lame that it is a blessing the film was never made.

However, there are insights offered by the treatment, which is interrupted midway by an interesting and rare aside by the author: "In the book, *Tender Is the Night*, there is much emphasis on the personal charm of the two Divers and on the charming manner in which they're able to live. In the book this was conveyed largely in description, 'fine writing,' poetic passages, etc." For the screen treatment Fitzgerald suggests music by his collaborator, Warren. There is much emphasis on "the atmosphere of luxury and good taste of intimate friends." The screenplay also reveals some of the interior motivation that the reader of the novel has to divine, notably the way Dick allows his wife's money to "overshadow" his medical vocation. It paints too deep a division between the dark sister, Baby Warren (Sara's sister Hoytie, to be played by Kay Francis or Ina Claire) and the Nicole/Sara character.

The real-life epilogue was similarly tenebrous. The summer of 1928 was mainly spent in Paris, where Zelda made a fool of herself trying to get on stage as a ballerina and Scott flipped back and forth between the art of *Tender* and the hack work of writing the lucrative Basil Duke Lee series of stories for *The Saturday Evening Post*, which brought him a cool $31,500. Foreshadowing the next phase in his life, Fitzgerald met King Vidor that summer and began planning his assault on Hollywood. He introduced Gerald Murphy to Vidor, and eventually Murphy and Vidor collaborated on a dreadful picture called *Hallelujah!* It was so bad that even Murphy, who had been musical advisor, was disgusted.

One of the great paradoxes of the Fitzgeralds was the violent dichotomy between the highs and lows of their exploits. A highlight of 1928 was James and Nora Joyce's dinner at the Fitzgerald's Paris apartment one July evening. It has gone down in literary history as one of the great encounters between European and American Modernism. Shakespeare and Company founder Sylvia Beach had introduced the Olympian Joyce to Fitzgerald, who admired the master's work regimen of eleven hours a day at the writing table. Beach arrived with Adrienne Monnier, who owned the bookstore La Maison des Amis des Livres, and André and Lucie Chamson, another writing couple on whose behalf Scott had written to Perkins. The Fitzgeralds ended up fighting, though, because Zelda was not as prostrate in her admiration of Joyce as Scott was.

One of the riddles that vexes biographers of all three writers stems from a conversation that occurred that year at Gertrude Stein's, with Hemingway and Fitzgerald present, in which the doyenne ambiguously suggested her preference for Fitzgerald's writing. Misinterpreted by Fitzgerald at the time (who thought she had chosen Ernest) it fell to Hemingway to set him straight and urge him not to consider writers as competitors. In "The Swimmers,"

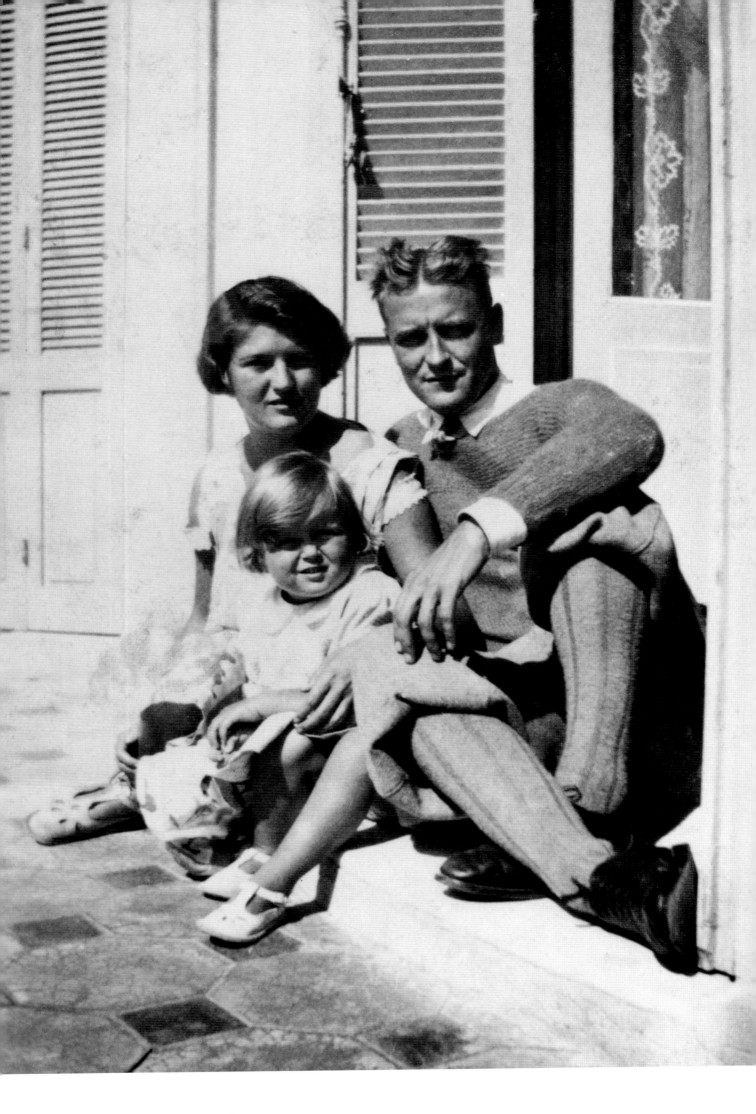

the best of Fitzgerald's writing that last year of the decade, he offered up an answer to Gertrude Stein's "Lost Generation" label:

There was a lost generation in the saddle at the moment, but it seemed to him that the men coming on, the men of the war, were better; and all his old feeling that America was a bizarre accident, a sort of historical sport, had gone forever. The best of America was the best of the world. . . . France was a land, England was a people, but America, having about it still that quality of the idea, was harder to utter — it was the graves at Shiloh and the tired, drawn, nervous faces of its great men, and the country boys dying in the Argonne for a phrase that was empty before their bodies withered. It was a willingness of heart.

This story appeared in *The Saturday Evening Post* of October 19, 1929 — the massive Wall Street collapse was just ten days away.

The denouement to the decade was brisk. In March of 1929 the Fitzgeralds checked into the Beau Rivage in Nice, then returned to Paris in April, as Zelda, who had nearly killed them driving off the road on the way, worked up some magazine pieces to pay for her all-consuming ballet lessons (which were setting her back $300 a month). By July they had moved to the Ville Fleur des Bois in Cannes, where Zelda's emotional ups and downs (she

was offered a solo role in the San Carlo Opera Ballet's production of *Aida* in Naples, but rejected it) and Scott's block were getting the best of them.

Fitzgerald, for all his fixation upon the past, was attuned to casual prophecies of chilling accuracy, including this line jotted in the twenties in the "Things Overheard" section of his notebooks amid the *Vanity Fair*–style paeans to youth, luxury, physical beauty, and wealth: "We can't just let our worlds crash around us like a lot of dropped trays." The direct blow of the Wall Street debacle spared the Fitzgeralds, who never dabbled in the market, but they were caught in the fallout. They attempted to outrun it all. In February 1930 they crossed to Algiers, but Zelda's emotional swings led to a speedy trip to Switzerland and confinement at Les Rives de Prangins, a clinic on Lac Leman in Nyon, between Geneva and Lausanne. The balance of the story is available in so many versions, ever sadder with the addition of detail that each new biography demands. Instead, the reflected sunlight of the Côte d'Azur is felt in John Peale Bishop's elegy for Scott, "The Hours":

Those hours which you and I have known —
Hours when youth like an insurgent sun
Showered ambition on an aimless air,
Hours foreboding disillusion,
Hours which now there is none to share.

When Scott, Zelda, and Scottie Fitzgerald first arrived in Antibes, the Murphys made sure they had all the comforts of home at their hotel.

RHAPSODY IN BLACK

Henry Ossawa Tanner, William H. Johnson, Hale Woodruff, and the African-American Expatriate Painters

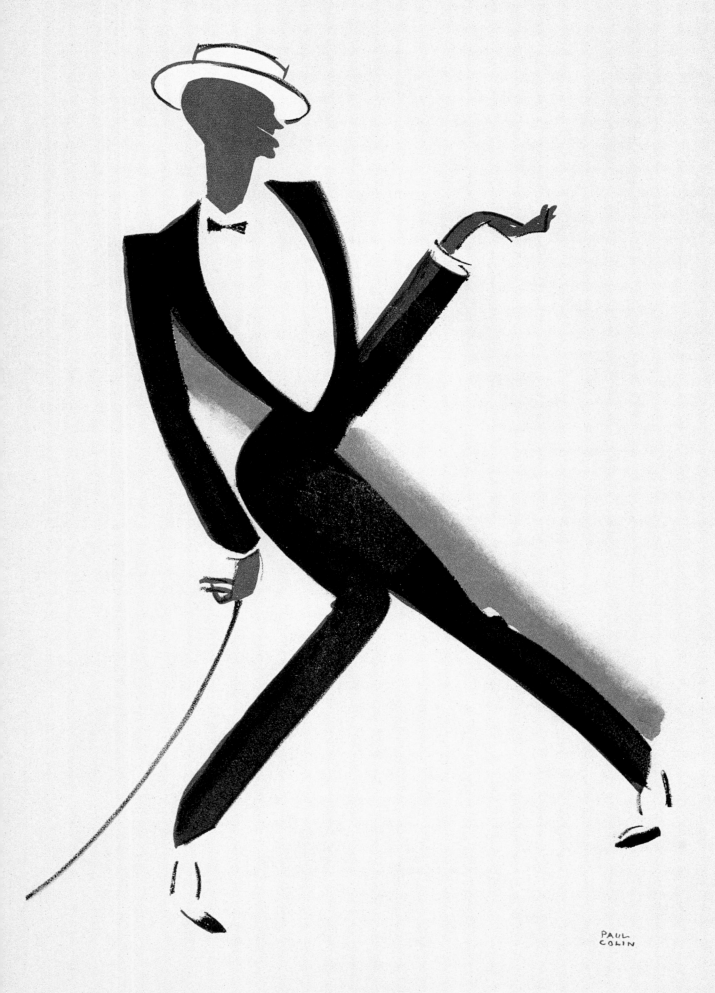

> *"In those years in Paris there were I can't tell you how many people who wanted to write, who wanted to paint and perform. . . . It was a beautiful, beautiful thing."*
> —Bricktop

Paris in the twenties was paradise for more than just the Ivy Leaguers. There was another group of American painters, sculptors, and entertainers who attracted far more attention on the art scene in France in their day than they have in the States in the eight decades since. Following in the footsteps of Henry Ossawa Tanner, a minister's son who so loved the French capital that he never went home, a stunning roster of African-American artists made their way to Montmartre in the twenties, including Gwendolyn Bennett, Aaron Douglas, William Thompson Goss, Palmer Hayden, William H. Johnson, Archibald J. Motley, Jr., Nancy Elizabeth Propher, Augusta Savage, Lara Wheeler Waring, and Hale Woodruff.

These artists followed a migratory pattern, coming out of the Midwest or up from the South to New York or Chicago for training, winning fellowships, continuing to Paris, and then, in some cases, heading down to the Riviera before returning to the States. They were a particularly talented, dynamic group, acquainted with many of the major figures and showing their work at some of the best galleries and at the annual Salon d'Automne, Salon du Printemps, and Salon de Paris. Landing a gallery show in Paris was no mean feat, but many of the black artists had exhibitions at the right addresses. One of the most important shows was held in 1927 at the Artists' Club on the boulevard Raspail. Palmer Hayden showed at Galerie Bernheim-Jeune, a top gallery that also represented Matisse and Rousseau. He was also part of the roster of artists at the Salon des Tuileries, while Woodruff was associated with the Galerie Jeune Peinture. Tanner's work, including at least one painting in the collection of the Louvre, earned him a place in the National Academy of Design in New York, the presidency of the Société Artistique de Picardie, and the distinction of being named a chevalier of the Légion d'Honneur. Another chevalier of the Légion was William Edouard Scott. William H. Johnson's work drew the attention of both the eccentric American col-lector Dr. Alfred Barnes, and the Smithsonian Institution, which now holds a core collection of many of his paintings. Thanks to a dedicated group of collectors in our time, including Bill Cosby and Whoopi Goldberg, as well as President Clinton while he was in office, the work of these little-known African-American artists is getting a well-deserved second look. As these pages show, there were fine painters among them.

The dynamics of their movement are more complex, sociologically, than those of the other Americans in Paris, whose presence can be explained by the favorable conversion rate, the excitement of being in Paris among the world's artistic elite, even the old joke of just trying to get a legal drink. Without exception, the autobiographical texts and histories of the African-American painters in France, who, being in their thirties, were mostly older than the party-going white writers we have met so far, cite the degree of acceptance afforded by Paris by contrast to the insults still to be endured Stateside. Tolerance, teachers, inspi-ration, a ready market for one's work, access to private collections and major works for study, beautiful models, and seductive landscapes — it was a heady cocktail not to be resisted. Being welcome was enough. Both Sylvia Beach and Gertrude Stein offered their salons as havens to some (Bennett in particular attended regu-larly). French artists, especially Matisse, were generous in tendering invitations for studio visits. Rodin opened his studio in Meudon to take on as a student Meta Vaux Warrick Fuller (1877–1968), a fellow Pennsylvanian friend of Tanner's. The leading art schools, notably the Ecole des Beaux-Arts, and the Académies Moderne, Scandinave, Julian, and de la Grande Chaumière, were similarly warm in their embrace of the African-Americans. The musical scene was also nurturing. George Antheil and Woodruff were friends, in a circle that included Kay Boyle, master of the short story. The salons of Les Six were proud of including black artists. Many of the most popular works they produced

Fascinated by Le Tumulte Noir, Colin produced a number of images of Baker and her nimble backup dancers.

Mixed company: A pochoir print by Léon Benigni from *Filatures Prouvost,* an album showcasing the spring fashion collections in Paris for 1929.

for sale to tourists were nightclub scenes from the Bal Musette and Montmartre, or American hangouts like the Café l'Avenue and Jockey Club. Some of the artists headed south to the Côte d'Azur, less often to Antibes than to Cagnes-sur-Mer, a veritable artist's colony that Chaim Soutine had "discovered," where Johnson painted some of his best seascapes. Palmer Hayden traveled throughout Brittany, capturing the town of Concarneau in a series of drawings and seascapes.

The American expatriates took a great interest in black art and music. Gerald Murphy not only supported the work but became something of an expert in "Negro spirituals," eventually traveling to Hollywood to be the music consultant for the movie *Hallelujah!* His record collection included not only the latest Louis Armstrong albums but an extensive collection of spirituals as well. Josephine Baker and Bricktop were among the more conspicuous ambassadors in Paris in the twenties. Baker regularly sold out the biggest theaters with her risqué hoochy-koochy act. The day of her funeral (April 15, 1975), an estimated seven thousand French admirers escorted her casket past the fancy shops of the eighth arrondissement to the twenty-foot iron doors of the massive Church of the Madeleine, which had to be shut against the overflow crowd hoping to attend the funeral. Bricktop was twelve years Baker's senior. Her club, where the Charleston was introduced to Europe, was a massive success for the young proprietor from Alderson, West Virginia, whose real name was Ada Beatrice Queen Victoria Virginia Louisa Smith. It was a long way from Le Grand Duc, a down-market gangsters' club where she made her debut as a dancer in 1924, and where Langston Hughes was a waiter. She was hired by Cole Porter to use his mirrored basement room as a studio where the Prince of Wales (later the Duke of Windsor), the Aga Khan, Elsa Maxwell, and the Porters, as well as other friends learned how to Charleston. Porter wrote "Miss Otis Regrets" for her. He also escorted her to the Opera Ball, having outfitted her at Captain Edward Molyneux's salon, one of the palaces of couture where Linda Lee had her dresses made. They broke a longstanding rule and made a double of the dress worn by Princess Marina of Greece. The dress and Bricktop were the sensation of the ball, which infuriated the stodgier members of society.

Gertrude Stein's story "Melanctha," the third in her groundbreaking work of fiction *Three Lives*, was a portrait of an African-American girl, and she and Virgil Thomson daringly cast their opera *Four Saints in Three Acts* entirely with black singers. She understood why

African-Americans might thrive among Parisians, who had greater respect for artists than had been found at home: "But really what they do do is to respect art and letters, if you are a writer you have privileges, if you are a painter you have privileges and it is pleasant having those privileges."

Stein's point is well taken, especially for the painters. There was a significant gap between their prospects in New York and in Paris. The historical context for the strong showing these artists made in France is defined in part by the Harlem Renaissance and the "New Negro" movement, codified in 1925 by the publication of an anthology of that title edited by the philosopher Alain Locke, a stunning literary collection that included Art Deco graphics by Aaron Douglas. The movement established a circle of support in New York, focusing on the literary and music scenes, although publications including *The Crisis* (1910–the present), *The Messenger* (1917–28), *Opportunity* (1923–49), *Negro World* (1918–33), and some newspapers were also patrons of the visual arts. The editors hired Douglas, William Edouard Scott, Albert Alexander Smith, Bruce Nugent, and Romare Bearden for illustrations and graphic design. The literary and musical elite of that generation are well known, including writers Claude McKay, W. E. B. DuBois, Countee Cullen, Langston Hughes, and Jessie Fauret, the stately baritone Paul Robeson, and soprano Florence Embry Jones. The history of jazz could not be written without Louis Armstrong, King Oliver, Duke Ellington, Sydney Bechet, and hundreds of others. But the fine artists were left out.

Paris was far friendlier to them. It still is — one indelible example was the splendid figure cut by Jessye Norman at the Arc de Triomphe as she sang the *Marseillaise* for the celebration of the Republic's bicentennial on Bastille Day 1989. The biblical saying, "A prophet is not without honor, save in his own country," is so often true of artists in general, but was particularly apt with regard to the African-Americans of the day, who could not make a living or even find an audience willing to look past their color to appraise their work. Today the situation in the United States is different but far from ideal. Thinly disguised attitudes and backward policies, including political correctness, continue to dishonor artists because they relegate many commissions and exhibitions to tokenism. The artists explored in this chapter were strong painters who earned the attention they received in Paris then and deserve it now on the basis of the work, not on the basis of their color or by dint of some condescending form of art historical affirmative action. The exhibition history of this material even today

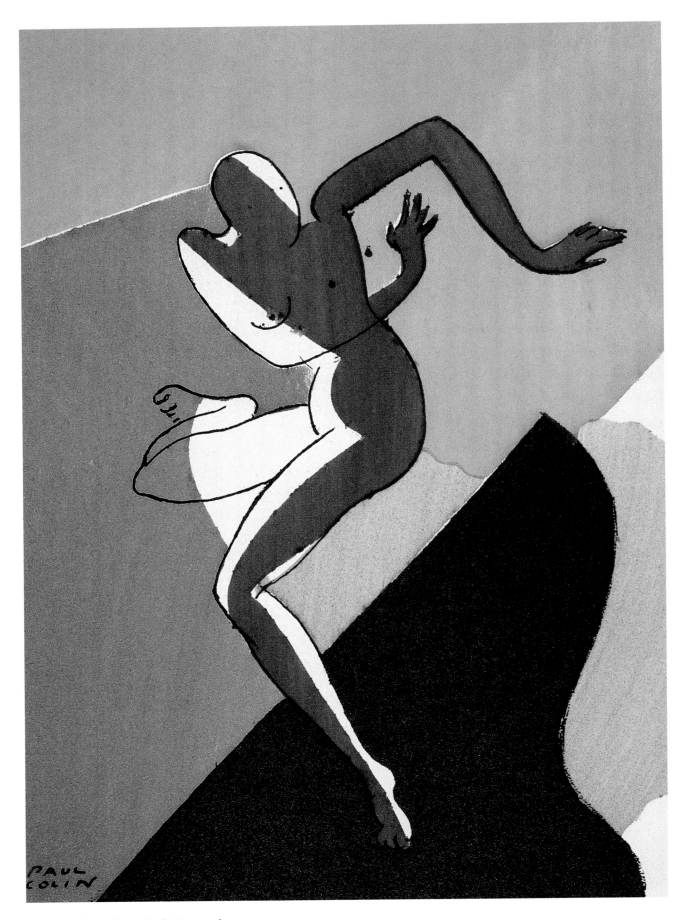

When Josephine Baker arrived in France, she was
introduced to an aspiring young graphic artist named
Paul Colin. The night she arrived at his studio to pose
for a poster they became lovers, and soon after were
the talk of the town.

is vexed by the question of whether an "all-black" show, or any exhibition organized along racial lines, is segregationist. In 1921, according to a helpful chronology compiled by art dealer and Modern American art specialist Michael Rosenfeld (whose 57th Street gallery has devoted a decade of major exhibitions as well as an ambitious publishing project to many of these artists), the New York Public Library organized the first major show of African-American artists in Harlem back in 1921. The Art Institute of Chicago held its "Negro in Art Week" in 1927, and in 1928 the Harmon Foundation held the first of its historically important exhibitions and competitions which, in the 1920s, would include touring shows. After the thirties, however, there was a steep drop toward obscurity.

Another tender topic is primitivism. Picasso's passion for tribal masks, the contemporary popularity of Henri Rousseau, and the influence of "tribal" music on modern dance as well as on Stravinsky and others are all well-known instances of primitive influences on Modernism. A few of the painters included in this chapter had thoughts on primitivism of their own, including the complex Johnson, who once said, long after his Parisian period during which he discovered the appeal of rural scenes painted in a folksy style, "I myself felt like a primitive man, like one who is at the same time both a primitive and a cultured painter." However, the works and the artists chosen for this volume do not, at least in my opinion, exemplify the so-called power of primitivism in early Modern painting, partly because I feel that would be akin to setting a snare for racist associations and, more important, because it is their elegance and mastery of the medium that interests me. Few of them adopted Cubism or Surrealism. Woodruff wrote, "If one should attempt to keep pace with all the different movements that are now evident in Paris, there would be little time for anything else." He did note, however, that

Archibald Motley, a graduate of the Art Institute of Chicago, gained early recognition for his spirited scenes, such as *Cocktails* (c. 1926). He once observed, "In all my paintings where you see a group of people you'll notice that they're all a little different color. They're not all the same color, they're not all black, they're not all, as they used to say years ago, high yellow, they're not all brown. I try to give each one of them character as individuals."

Picasso's *Les Demoiselles d'Avignon* helped make clear the relationship between contemporary and African art, which was a collecting passion he shared with not only Picasso but Alain Locke, who exhorted African-Americans to take greater pride in their heritage. On the whole, however, the group did not subscribe to the tenets of primitivism as they had been adopted by Rousseau or Picasso. Like idiomatic French, the delicate chromatic and impasto effects of Parisian painting in the 1920s were the goal of many an American student, and those works chosen for inclusion here captured the accent superbly.

The timing of the exodus to Paris was tied to the rise of important philanthropies. The most notable of these was the William E. Harmon Foundation, a New York–based institution, funded by real estate holdings, that started in 1922 by making modest grants to build playgrounds and sports fields in the low-income areas of small cities. By the twenties, however, it had become the premier support organization for visual artists of color. Until 1933, when it was suspended (the terminus as well of the "New Negro" movement with which it was closely allied), it offered a standard yet substantial $400 dollar grant to students. A formidable roll call of African-Americans headed to France on a Harmon, and returned from their studies under such distinguished teachers as André Lhote and Fernand Léger or at first-tier schools such as the Académie Julian and the Académie de la Grande Chaumière with hundreds of first-rate paintings.

Nor was the Harmon Foundation the only angel. The Julius Rosenwald Foundation (from the money behind Sears), the Carnegie Corporation, and the just-incorporated Guggenheim Foundation also issued checks. Note the founding dates. The Harmon Foundation started in 1922. The Howard University Gallery of Art opened in 1928 (it was initially located in the chapel basement), the Hampton Institute (renamed Hampton University) started its collection in 1911, and Fisk University did so in the 1930s.

Every movement needs its trailblazer, and the undisputed pioneer of the black American painters in Paris was Henry Ossawa Tanner, who had already been in Paris for thirty years when the big wave of artists from Harlem started to arrive. Tanner's life story is as prismatic as his painting, multifaceted and brilliant, and far from the dark, grim tale of bohemian privation and obscurity some might expect. He could have been a preacher, like his father (a bishop of the African Methodist Episcopal church), or a painter. When he was growing up in a solidly middle-class home in Pittsburgh, his father objected to his choice of art as a career, but talent will out. He was accepted at the Pennsylvania Academy of Fine Arts and became a student of Thomas Eakins, the master of the gesture and controversial apostle of a new frankness in figure painting. It is remarkable to realize that Tanner headed to Paris as early as 1891, age thirty-two, and almost immediately found an appreciative audience for his work. Despite a number of appearances in group exhibitions back home, it took until 1908 for him to have a one-man show in the United States, at the American Art Galleries in New York.

Henry Ossawa Tanner passed along the technical secrets of his teacher, Thomas Eakins, to the next generation of African-American painters in Paris.

The old master of African-American painters
working in Paris (where he'd lived since 1891), Henry
Ossawa Tanner was a consummate technician, as we
see in *Coastal Landscape, France* (c. 1912).

The precursor to Tanner's deeply religious later
paintings is this view of the *Birthplace of Joan of Arc
at Domremy-la-Pucelle* (1918).

An important part of an American artist's success in
Paris was capturing familiar scenes, as William
Edouard Scott does in *Along the Seine, Paris* (1914).

By the time the twenties rolled around,
he was the benevolent mentor of the African-
American artists in Paris, and his fame is in
part due to his legacy of fine students. Now
known primarily as a painter of religious sub-
jects in narrative scenes reminiscent of the
Nazarenes or Pre-Raphaelites — at least in
terms of composition — the earlier Tanner
works have that Post-Impressionist luxury of
paint, the flourishes of a fast brush, the creamy
impasto and mingled lavender and white
that read as mother-of-pearl from a distance.
Tanner's signature aquamarine atmosphere is
the dominant chromatic note of his highly
atmospheric painting of the house of Joan of
Arc in Domrémy, painted in 1918, with its
brightly lit doorway in counterpoint to the
crepuscular blanket of blues. It is a carefully
constructed painting, using a Cézannesque
mingling of blue and green and Maurice
Denis-like contours for the trees. Leslie King-
Hammond, an expert on Tanner who teaches
at the Maryland Institute College of Art calls
it a great example of his "hallmark warm blue-
green glazed surfaces and soft glowing inner

radiating light." As William Edouard Scott,
one of Tanner's prize pupils, observed, Tanner
was "painstaking, conscientious, and a real
genius." Scott was one of the many African-
American Harmon winners who made the
obligatory trip to Tanner's atelier at 86, rue
Notre-Dame-des-Champs, near Montparnasse.

Tanner died in 1937. A postscript that
might come in handy on *Jeopardy* one day: In
1995, one of his landscapes was acquired by
President Clinton, making Tanner the first
African-American artist to be included in the
White House collection.

Tanner's influence on other African-
American artists was technical as well as inspi-
rational. One glance at William Edouard Scott's
Along the Seine (1914) affirms the teacher-
student bond. The thick blue-lavender curtain
of sky behind the slightly darker blue of the
cathedral towers, the commingling of greens
and that sliver of gold and white (dawn or
sunset?) are all straight from the Tanner reper-
toire. Scott pushes his human figures away a bit,
by comparison, and the more overt theology
of Tanner's painting is absent, but otherwise the

idiom is very similar. Scott was a Midwesterner who left his home in Indianapolis to attend the School of the Art Institute of Chicago in 1904, where he spent five years. During that time he was commissioned to paint murals in local schools, reportedly the earliest public works of art in the U.S. depicting the black experience. He headed to Paris in 1909 and became one of Tanner's students, then studied at the Académie Julian and the Académie Colarossi. When he returned to the States in 1914, his work changed dramatically and he became a renowned documentarian of African-American culture. In 1931 he headed to Haiti on a Julius Rosenwald Fellowship and his style took on an expressive quality using the bright colors of Haitian painting.

Another of Tanner's protégés was Hale Woodruff, the youngster in the group, like Scott a child of the heartland. He left Cairo, Illinois, for classes at the Art Institute of Chicago and then the school of the Fogg Art Museum at Harvard. Woodruff was extraordinarily versatile, venturing into a wide spectrum of mediums and styles. He won his Harmon fellowship for bronze sculpture. In Paris he studied not only with Tanner but at the Académie Scandinave and the Académie Moderne. The golden hills of his early watercolor *The Peasant's House, France* are reminiscent of the mounded forms of Brueghel's haystacks, while the interlocking shapes of a winter landscape painted in 1928 use the cloisonnist style that some of the Fauves had employed, although the palette has been cooled to an austere medley of greens, grays, and blues. He spent the summer of 1936 in Mexico studying mural technique with Diego Rivera. Woodruff and Charles Alston completed the Golden State Mutual Life Insurance Company murals in Los Angeles in 1948, and he later painted *Art of the Negro*, a mural series in the library at Atlanta University.

In the sixties he was a founder of the New York–based, politically active Spiral Group, which included fellow artists Romare Bearden and Charles Alston. He died in 1979 in New York.

William H. Johnson was another of the Southerners, born in Florence, South Carolina. He studied in Harlem and then at the National Academy of Design (1921–25) as well as at the Cape Cod School of Art in 1925 under George Luks, one of the prominent members of The Eight (poetically known as the Ashcan School). Sometimes the most valuable education a young artist can obtain is the "opportunity" to carry out menial tasks literally at the feet of the master (just ask Brice Marden, who left Yale to clean brushes for Robert Rauschenberg, only to equal or surpass his mentor in our time). Johnson was caretaker and porter in the Luks studio, where he picked up studio technique and pointers. His other teacher was Charles Hawthorne, an academic painter now almost completely unknown, but who in his day had been Whistler's studio-mate. Hawthorne advised him to take the boat to France.

When Johnson arrived in Paris in 1926, he repaired straight to Tanner's studio for advice and encouragement. Just glancing at his work reveals his passions: Paul Gauguin, Chaim Soutine, and Edvard Munch, not merely for the glowing colors but for the sinuous line and unapologetic expressiveness. Johnson in Cagnes-sur-Mer was as lit up as the white housefronts he lovingly rendered in the village and street scenes of the late twenties: "I am painting the old villages, buildings, and streets," he wrote in the summer of 1929 to Hawthorne. "I have a big space to select from that gives me all the freedom that I need. Here the sun is everything. . . . I am not afraid to exaggerate a contour, a form, or anything that gives more character and movement to the canvas." After three years in France, mainly in

A regular at the Jockey Club in Paris during his years there, Hale Woodruff returned to become a protégé of Diego Rivera and one of the most important muralists in the States.

Throughout his career, including *Art of the Negro,* the monumental mural in California for which he is best known, Hale Woodruff used the dynamic crowding of forms we find in this painting, *Medieval Chartres* (c. 1928).

Woodruff's *The Peasant's House, France* (c. 1928) was painted on one of his many trips to the countryside, often to visit Henry Ossawa Tanner.

Woodruff's excursions to Normandy gave him material for a number of landscape works, such as this light-filled study of 1928.

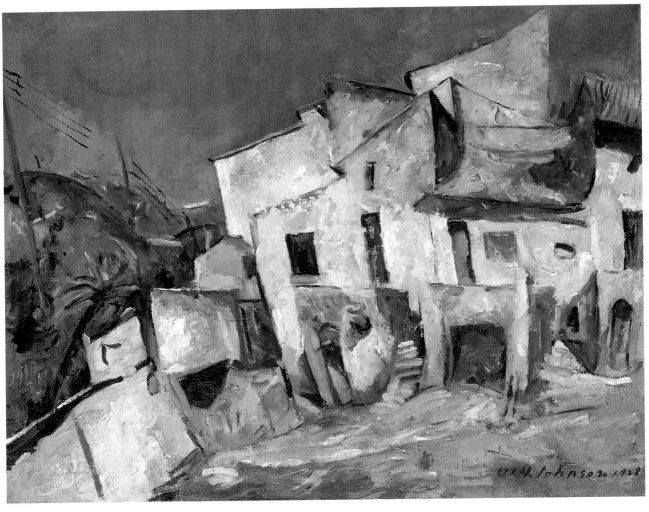

Johnson followed Chaim Soutine to the coast where he painted *Cagnes-sur-Mer* (1928).

William H. Johnson was one of Tanner's most renowned pupils.

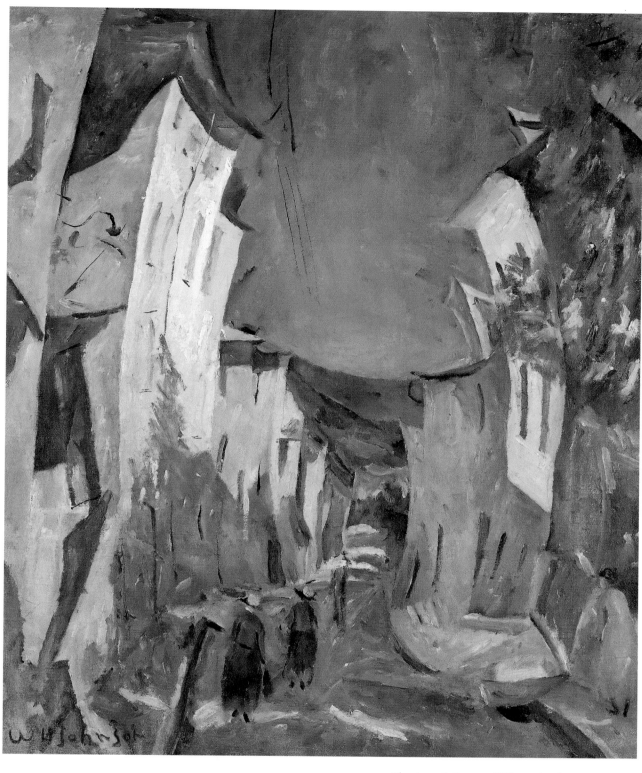

The strong influence of Cézanne's palette on
William H. Johnson's *Village Street, Cagnes-sur-Mer*
(c. 1928–29) joins forces with the Cubist compositions
he had studied in Paris.

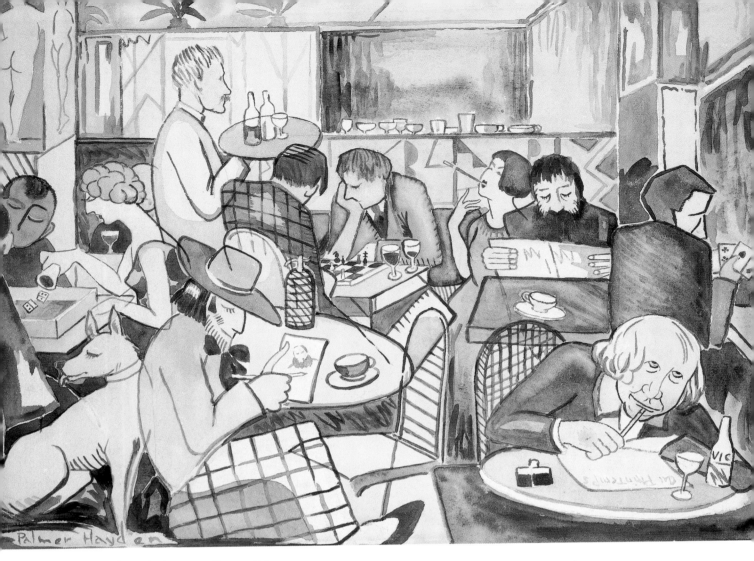

The Parisian café interior is a genre of its own. Palmer Hayden's *A Corner in La Coupole* (c. 1935) was drawn in one of the most popular of Left Bank haunts for writers and artists. Note the mingling of the races, including an Asian.

Cagnes-sur-Mer, he returned to New York, winning the Harmon Foundation Gold Medal in the Fine Arts in 1929. He was soon back in Europe, this time Scandinavia. He traveled and showed in Norway, Sweden, and Denmark. He met and married a weaver in Denmark, Holcha Krake, and at the outbreak of World War II in 1939 returned to the States, where his style changed drastically. Spike Lee might say, with humor, that he had discovered his "negritude" — his palette turned to primary colors, naive figural painting, rural settings. He had a steady paycheck until 1943 with the WPA as an art teacher at the Harlem Community Arts Center. Johnson was committed to a hospital for the mentally ill on Long Island in 1947, remaining there until his death in 1970.

If you like Pissarro, then Palmer Hayden's *Harbor Scene* (1929) is bound to intrigue you, with its broadly pulled white and pink strokes for sails, upswept clouds on a field of blue, and zigging blue strokes for the reflection of the masts in the water. Hayden was born in

Widewater, Virginia, ran off to join the Ringling Brothers Circus when it visited Washington, and then enlisted in the 10th Cavalry in 1912. Originally Peyton Cole Hedgeman, he changed his name because his (white) sergeant could not pronounce the real name correctly. After being discharged in 1920, he began studying at the Cooper Union in New York under Victor Perard and at the Boothbay Art Colony in Maine (1925). He won his Harmon in 1926 (the title of his prizewinning work was *Schooners*) and headed to Paris to study at the Ecole des Beaux-Arts the next year. Late and early Hayden are like night and day from a technical point of view. His paintings of black life in the 1940s became Bentonesque — boldly drawn and saturated with bright reds and yellows.

There are so many stories yet to be told about the dynamic young artists of African-American background who gained respect and mastery of their craft in France between the wars. As many of them returned they formed the nucleus not only of a movement but of a

teaching corps as well in many of the universities (nine of the group taught at historically black colleges) and art schools in the States, where other African-Americans garnered the benefits of the experience abroad. As Theresa Leininger, an expert in the movement, notes, "In the tradition of explorers who have consciously or unconsciously linked travel with the search for the self, both the expatriates and those who returned to the United States gained a broader sense of themselves and the world from their sojourns. Paris was the proving ground for African-Americans of the pre–World War II era whose success there greatly contributed to their artistic careers in the United States. Going abroad gave them the distance to better understand what DuBois called their 'double consciousness,' their dual identity as Americans and as persons of African descent." This fascinating ability to dwell in two worlds is a source of strength. The movement not only traveled well, but had resonance. A tradition that had begun with the first African-American transatlantic visitors to France in the 1830s (mainly from New Orleans) spanned the arc of the Jazz Age and has continued, wave upon wave, through the post–World War II generations to the present.

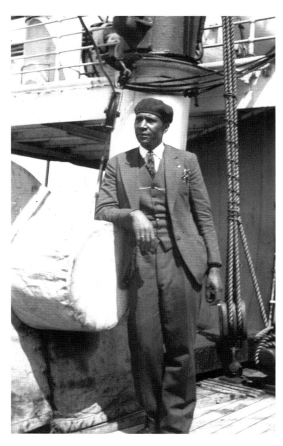

During his five years in Paris, Palmer Hayden, fascinated by boats and seascapes, often found himself on the coast.

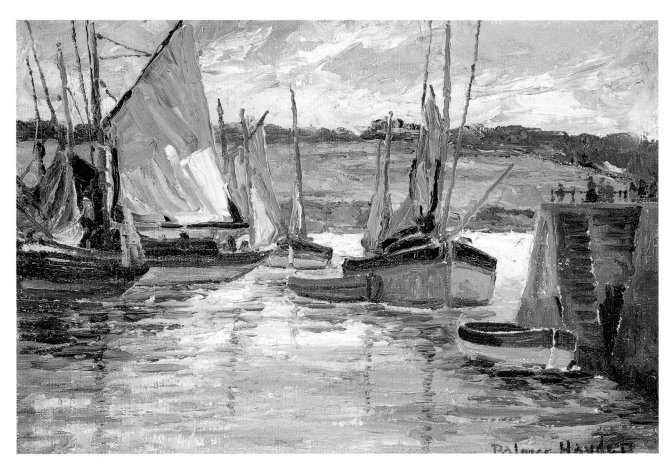

Palmer Hayden's lyrical *Harbor Scene, France* (c. 1929) draws on Impressionist composition and brush technique.

THREE SOLDIERS

Hemingway, Dos Passos, and Cummings

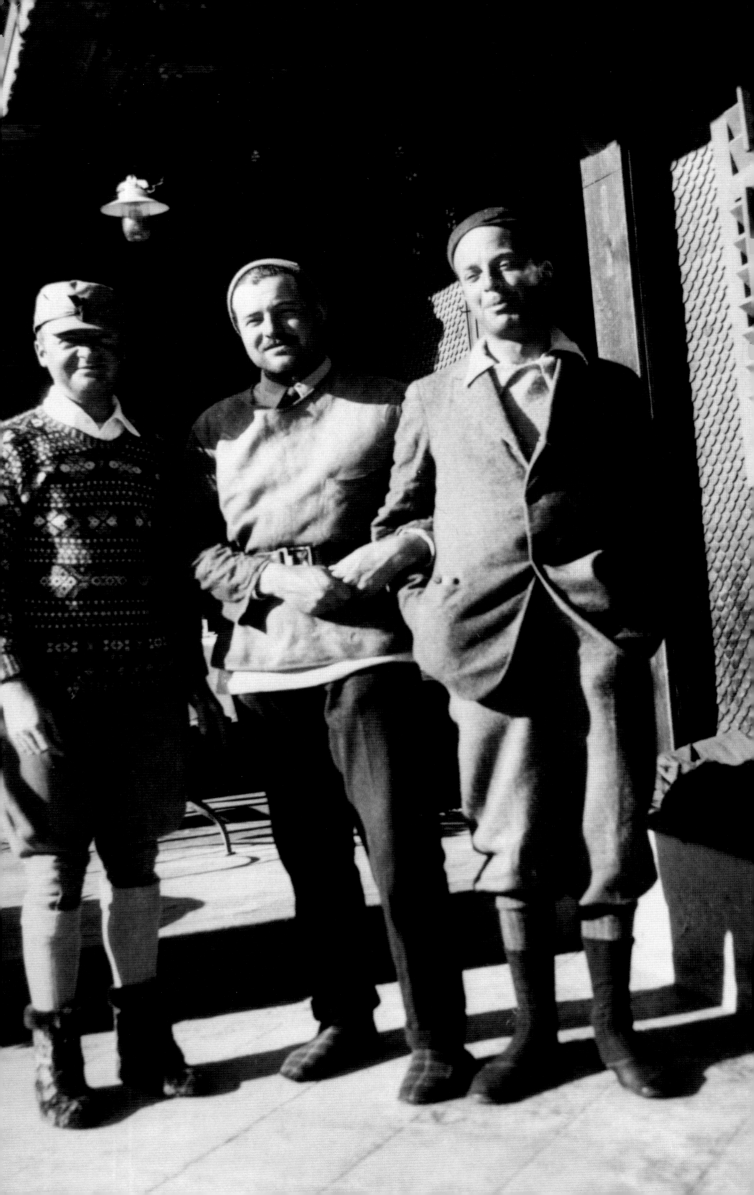

"May in Paris is the most of all most everyanywhere."
—E. E. Cummings

Among the extraordinary characters who followed the Murphys, Porters, and Fitzgeralds across the Atlantic during the Jazz Age, the most colorful trio may well have been Ernest Hemingway, E. E. Cummings, and John Dos Passos. They were macho men who had driven ambulances at the front during the Great War. Their amorous exploits were every bit as renowned as their war escapades and early literary forays. They cut a broad swath through the cafés of Montparnasse. The bohemian rhapsodies on the Paris party scene that they filed for newspapers and magazines back home made them tourist attractions in themselves for their wide-eyed compatriots who arrived in later waves.

The legends have grown to such towering heights that they distort the true features of the men. Reading between the lines of the many biographies, we can easily grasp the bonhomie they enjoyed during that time, twenty-somethings released from the grip of war to get drunk on the pleasures of the world's cultural capital. One could not ask for tighter friendships than theirs. Superbly loyal comrades-in-arms, they promoted and defended one another's work against acerbic critics and censorious editors. A less familiar aspect of their lives is that all three were mainstays of the contemporary art scene, Hemingway as a connoisseur, Dos Passos and Cummings as dedicated avant-garde painters.

Could there possibly be any secrets left in the Hemingway saga? Yards of shelf space in any respectable college library are devoted to the life and letters. Next in line after the endless curiosity regarding Papa's sex life and suicide, his lion slaying and left hook, his five wives and scores of drinking buddies, comes a slew of critical studies of the stories and novels, drawing heavily upon the rich vein of his own observations on the writer's life and the meticulous way in which he honed his style with daily habits now imitated by journalists who would be novelists worldwide. Where the documentary trail leads, most scholars will generally follow. We know all about the

Hemingway in Paris who played tennis most afternoons with Ezra Pound, boxed with Morley Callaghan, revised his typescripts at the Closerie des Lilas café, bet on the horses at Longchamps, and banged away on a dilapidated Corona typewriter night after night in the room without electricity or plumbing above the sawmill, assiduously trying to put together the slim debut volume of sketches that appeared as *In Our Time*.

Too little attention has been paid to his fascinating role in the art world. The Ernest Hemingway–Norman Mailer comparison may be the most popular pairing with a writer in our own time (particularly according to Mr. Mailer), but in terms of his engagement with the artists of Paris in particular, he was more like a hardy John Updike. Both put in their time visiting artists' studios and were regulars at openings. What writers do to procrastinate in front of their deadlines can be revealing. While James Joyce may have been more connected to the classical music (specifically opera) world of Paris, no doubt in part because of his failing eyesight, and Fitzgerald was more aware of the theater and ballet through his wife and the Murphys, Hemingway was a devoted gallery-goer. The inviting early pages of *A Moveable Feast* give a strong hint of the powerful role the visual arts played in his life and thought during the period (December 1921 to the market crash in 1929), when he cycled through Paris regularly, living there more than most expatriates identified with the Lost Generation. Thanks to Sherwood Anderson, who had packed him off to Paris from Chicago with generous letters of introduction, doors flew open. Behind many of them were paintings he loved:

If I walked down by different streets to the Jardin du Luxembourg in the afternoon I could walk through the gardens and then go to the Musée du Luxembourg where the great paintings were that have now mostly been transferred to the Louvre and the Jeu de Paume. I went there nearly every day for the Cézannes and to

"The last unalloyed good time": Gerald Murphy, Ernest Hemingway, and John Dos Passos après-ski in the Alps in 1929.

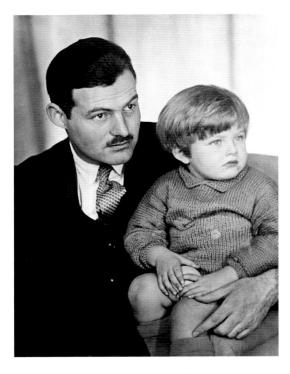

Hemingway with his young son, Jack, known as "Bumby," in Paris.

see the Manets and the Monets and the other Impressionists that I had first come to know about in the Art Institute at Chicago. I was learning something from the painting of Cézanne that made writing simple true sentences far from enough to make the stories have the dimensions I was trying to put in them. I was learning very much from him but I was not articulate enough to explain it to anyone. Besides it was a secret. But if the light was gone in the Luxembourg I would walk up through the gardens and stop in at the studio apartment where Gertrude Stein lived at 27 rue de Fleurus.

Once across the Stein threshold, he was treated to the hum of a hive of opinion and a glorious array of masterpieces stacked salon-style on the walls, extensive as the spectrum of liqueurs he and his wife, Hadley, enjoyed there. Hemingway's detailed account of the conversation concentrates on Gertrude's literary opinions and advice, as well as his own retorts, but most reports of the salon dwell on the art talk. Open house was held on Saturdays, and the mix of artists, writers, and collectors was formidable. To eavesdrop thoroughly it would have helped to speak not only French

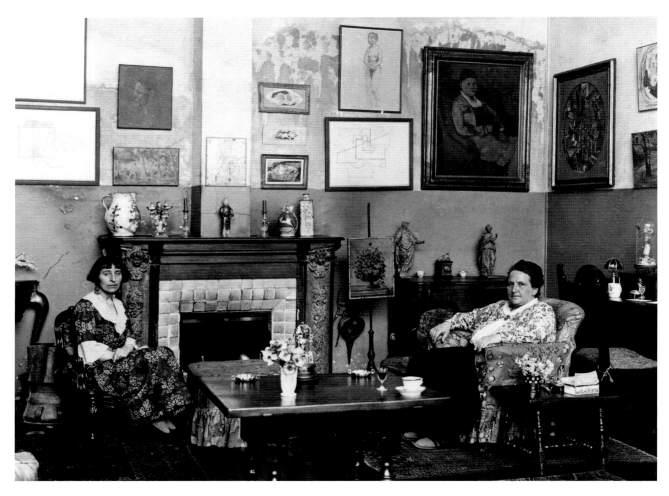

"Paris was where the twentieth century was," noted Gertrude Stein, photographed here by Man Ray along with Alice B. Toklas and masterpieces by Picasso, Braque, Matisse, and Cézanne.

but Russian, Polish, Hungarian, German, even Japanese. Hadley and Ernest paid their first visit on March 8, 1922. He immediately wrote to Sherwood Anderson, slightly exaggerating: "Gertrude Stein and me are just like brothers, and we see a lot of her."

If you were standing, tipsy from pastis, in a corner of the Stein apartment at 27, rue de Fleurus, you'd have an eyeful. On the wall by her famous, now iconic Picasso portrait, below which Gertrude generally took her place, there was an ever-changing array of drawings and paintings, some massive and now prizes in museums from Moscow to Manhattan, including a study for Matisse's *Music*, Picasso's *Woman in a Hood, Young Acrobat on a Ball,* the *Standing Female Nude Along with Violin,* Cézanne's portrait of his wife and *Landscape with Spring House, Bathers,* and textbook masterpieces by Gauguin, Renoir, and Manet. The friendly competition-duet of Picasso and Matisse was scarcely invented by curators in our time — their works sparred throughout the Stein apartment.

Indeed, with so many real-life rivals in one place, the atmosphere was far from relaxed. As in the nineteenth-century salons upon which it was modeled, or the contemporary dinner parties in which Proust found material for his biting satires, competition for the *bon mot* or at least the final *mot* was fierce. Just keeping up with the latest from the hostess, week by week, was hard work. Hemingway was a good guest, arranging for Stein's work to be published in the literary magazine the *Transatlantic Review*, for which he served as associate editor under the English novelist Ford Madox Ford. In return, he was brought up to speed by Gertrude's brother Leo, who offered disquisitions on new acquisitions as part of a campaign to spread the message of pre-Cubist Picasso and Matisse beyond Paris. In 1913 they had split the collection, Leo taking his paintings to his villa in the Italian town of Settignano while Gertrude kept the apartment. Among the works that disappeared that day were paintings and watercolors by Cézanne and sixteen Renoirs, but not a single Picasso (Leo had not bought a Picasso since 1910). The bitterness in a letter written the day before he departed was undisguised: "The general situation of painting here is loathsome with its cubico-futuristic tommy-rotting. I don't believe it can last very long, however, as its effectiveness is soon seen through and when no longer curious it becomes a bore. It is, even on the part of the most distinguished representative, nothing better than an exploitation of ingenuity."

It is never easy to remain au courant. Movements congeal into schools; betrayals and defections are not uncommon. Rival factions launch attacks upon suddenly rigid orthodoxies, and hard feelings drive apart former supporters. The Surrealists in particular were sticklers for the principles laid down in their many manifestos. Hemingway strode into the Stein salon when the excitement over Modernism was at its height, and his own writing rapidly became ammunition in the cause. He was a great one for penetrating circles, from the newspaper bullpen to the bullring, the boxing ring to the tipsters at the paddock.

Hemingway, by grace of Gertrude and his acquisition of a major Miró in 1926, was on the inside. Well before the star-studded crowd of Surrealists began appearing at the Galerie Pierre for Miró's opening on June 12, 1926, the centerpiece of the show, *The Farm*, was extremely well known in Parisian art circles. Monumental, autobiographical, rigorous, the painting represented ten months' work and had already been shopped around since its completion in 1922, to Léonce Rosenberg and Pierre Loeb, at the Salon d'Automne, and at the Caméléon. It was seen by all the major critics at his rue Blomet studio, but at one point Miró's precarious finances nearly drove him to cut it into four pieces to make it easier to sell. The catalogue (which Hadley asked other attendees at the opening to sign, with Max Ernst, Louis Aragon, and André Breton all obliging), indicated that the star painting was on hold for Evan Shipman, one of Hemingway's dearest friends in Paris, who had agreed on a price of 5,000 francs, but had not yet paid a *centime*. At the opening, Hemingway, already feeling guilty about affairs into which he was drifting, decided to present it to Hadley for her thirty-fourth birthday on November 9. He was feeling flush that evening because Horace Liveright had sent him a $200 (4,000 franc) advance on the rights to *In Our Time*, but friends who knew the Hemingways were on a tight budget and spending Hadley's trust fund income were taken aback when they learned of the plan. He confided his hope to give Hadley the picture to Shipman, who offered to roll the dice for the chance to own the painting. Hemingway won and went back to the gallery the next day to put down a 500-franc deposit. It took him until September to raise the other 4,500, which is where Dos, who could ask his dad to wire him the money, came in.

This was not a minor painting in 1926, and since then it has only bloomed in art historical significance. For Miró it was the pushing-off point for a career, directly analogous in its way to Hemingway's *The Sun Also Rises*. Well known in its time among artists and connoisseurs, thanks in part to an essay by Hemingway,

Sylvia Beach's Shakespeare and Company bookshop was a lifeline for the young Ernest Hemingway during his first year in Paris. Eventually, his photo joined its gallery of masters.

it plays a central role in the evolution of a style of painting that was practiced by several at work in that era, including not only Miró and Léger, but Stuart Davis, Marsden Hartley, and Gerald Murphy. They share a passion for detail and the tendency to paint in tight lines and flat color areas. Examine *The Farm* side by side with Murphy's *Watch*, completed two years later, and a family resemblance emerges, not only in the crisp rectilinear organization, square within square, but in the contrapuntal central sphere around which other curves orbit (in Murphy's painting the gears and winding stem, in Miró's the full moon and dark ellipses of the cistern and buckets). The calligraphic precision of the leaves on Miró's tree is answered by Murphy's meticulously rendered gear teeth. Most striking, however, is the way in which both turn the inner to the outer. In Miró's painting, the red frame around a patio seems an interior opened to the air, a glimpse not only inside the courtyard but inside the walls of the home itself. Murphy, too, is taking us inside the workings of the watch, investing the anatomy of its movement with a dynamic dialogue of straight lines and curves, shadows and light. In both cases, the delicacy of the observation is coupled with imperceptible transparency. Sly bits of symbolism emerge, from the Old Master–style allusiveness of a tipped bucket or sheaf of corn, the thin tree and ladder to heaven in Miró's packed iconography, to the yin and yang division of the light and dark body of the watch. Today this textbook example of analytic High Modernism is one of the stars of the permanent collection of the Museum of Modern Art in New York.

Hemingway purchased respect in the art community when he bought *The Farm*. The serious literary camp in Paris was another elite, however, and distinct from the journalists and freelancers he readily joined at the bar. The literary answer to the Stein salon was Shakespeare and Company. It had been one of Hemingway's first stops in Paris (he opened his lending account just seven days after arriving in Paris). Sylvia Beach, a dear friend of Gertrude's, was the hub of the writers' gossip and gatekeeper to the inner circle. It was a proud moment when Hemingway's photo took its place on her wall of fame beside those of Joyce, Pound, Conrad, and Lawrence. Hemingway was a good customer — with a twelve-franc monthly subscription that allowed him to take home two volumes at a time. Hadley, who had been to Bryn Mawr, used her own card to introduce Hemingway to the work of Henry James.

They read together in their cozy apartment near the wine co-op on the rue Mouffetard,

where a decent *vin du pays* could be bought for a song. That is where the poet Archibald MacLeish found them. Even after his years in Washington as Undersecretary of State and speechwriter in the White House, and all his encounters with players on the world stage, MacLeish viewed Hemingway as exceptional. "He was one of the most human and spiritually powerful creatures I have ever known. The only other man who seemed to me to be as much *present* in a room as Ernest was FDR, and I am not excepting Churchill," he recalled. MacLeish painted Hemingway's verbal portrait in an enduring poem similar to the lyric he dedicated to Sara Murphy:

The lad in the Rue de Nôtre Dame des Champs
At the Carpenter's loft on the left-hand side
 going down —
The lad with the supple look like a sleepy
 panther —
And what became of him? Fame became of him.
Veteran out of the wars before he was twenty:
Famous at twenty-five; thirty a master —
Whittled a style for his time from a walnut stick
In a carpenter's loft in a street of that April city.

When you're "famous at twenty-five" and immensely good-looking, you attract an entourage. A fashionable, rich pair of sisters (heiresses to perfume and Arkansas farm fortunes), Pauline and Virginia Pfeiffer, were often in the company of the Murphys, MacLeishes, and Hemingways beginning in the spring of 1925. Hemingway, bored with fatherhood and marriage, became the target of Pauline, a petite, sharp-witted *Vogue* correspondent, then thirty, who had first turned up at the Hemingway apartment to visit Hadley. When they were out of Paris, Pauline would write almost daily to one or the other of the Hemingways (a biographer, noting Pauline's bisexual experiences, suggested she may have been more interested in Hadley at first). Pauline even traveled with the Hemingways to Austria, cozying up to their newborn son, Bumby, and plying the writer with praise. By the winter of 1926, when Hadley was away Pauline and Ernest had taken their affair to a more physical level. Hemingway in hindsight diagrammed the situation in this way: "An unmarried young woman becomes the temporary best friend of another young woman who is married, goes to live with the husband and wife and then unknowingly, innocently and unrelentingly sets out to marry the husband…. The husband has two attractive girls around when he has finished work. One is new and strange and if he has bad luck he gets to love them both." Dos told him to become a

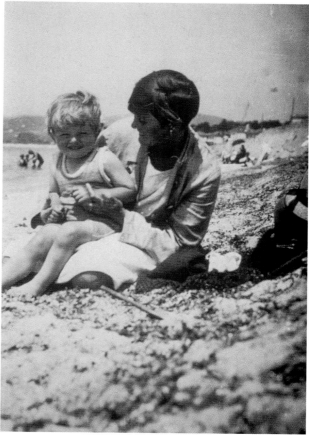

Journalist and socialite Pauline Pfeiffer followed Papa from Paris to Antibes to Austria and beyond in her quest to be the new Mrs. Hemingway.

Hadley Hemingway, Ernest's first wife, with their son, Bumby, on the beach at La Garoupe, 1924.

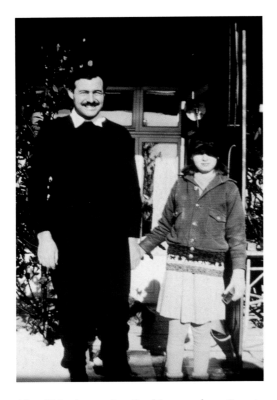

A loyal friend even when the chips were down, Ernest Hemingway did his best to keep up the spirits of Honoria Murphy at Montana-Vermala, Switzerland, in 1929, while her brother was treated for tuberculosis.

The tension is palpable in this group shot of (from left) Gerald and Sara Murphy, Pauline Pfeiffer, and Ernest and Hadley Hemingway, with friends, taken at Pamplona during the summer of 1926. "Pfeiff" was moving in on Hadley's territory and was soon to become the next Mrs. Hemingway.

Mormon. In any event, that was how things stood when in March the Murphys invited the Hemingways to stay at the Villa America and enjoy a Mediterranean sail.

The party was already in full swing by the time Ernest arrived on May 28. Three weeks earlier, Hadley had brought her maid, Marie Cocotte, and Bumby, who had whooping cough, and moved into the small guesthouse at Villa America. Sara was a bit worried that her own children would become infected, so the Fitzgeralds, who were moving to a larger villa nearer the casino, surrendered their villa in Juan-les-Pins. Pauline, who had arrived on her own by train, wrote that she had had whooping cough in childhood and was not afraid of catching it again. The day Ernest arrived, there she was at the station, alongside the Murphys and Hadley. To celebrate the young literary lion, Gerald staged a memorable champagne and caviar party at the casino, which was marred by a drunk and thoroughly jealous Scott Fitzgerald.

The remainder of the holiday was tense. The Hemingways, with Pauline in tow, moved down the street to the Hôtel de la Pinède in Juan-les-Pins after the Fitzgeralds' lease ran out on the villa. The group went to the beach each morning, Bumby had his first sunburn, Pauline attempted to teach Hadley how to dive, the three adults toured the hills by bicycle or joined the Murphys for long car rides as far as La Napoule, took lunch in the garden of the hotel, and headed to the Murphys for cocktail hour. Pauline was making inroads. "I'm going to get a bicycle and ride in the Bois. I am going to get a saddle, too. I am going to get everything I want," she wrote the Hemingways

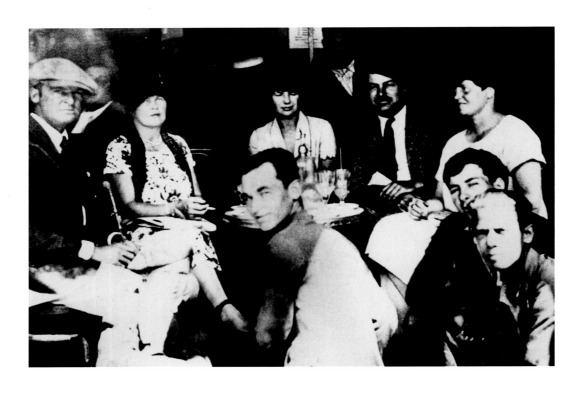

Playwright, filmmaker, painter, and novelist John
Dos Passos spent most of his childhood in Brussels
and Paris and, unlike many of the Americans, was
fluent in French.

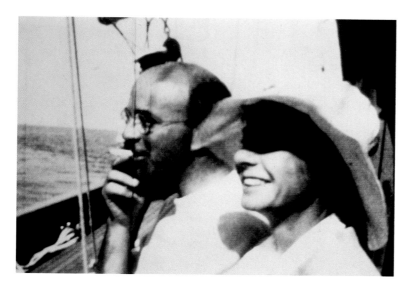

John and Katy Dos Passos enjoying a sail aboard
the Murphys' yacht, the *Weatherbird*.

after they had all gone to Pamplona for the running of the bulls and then broken up for the summer.

By the following August, when the Hemingways turned up at Villa America for the start of another holiday, their marriage was predictably in its final stages, and they solemnly told Gerald and Sara they were planning to seek a divorce. Hadley put on paper that if Papa and Pauline could stay out of each other's beds for one hundred days and nights and remain in love, the divorce would be granted. Pauline headed back to the States, and Hemingway to Paris.

He did what recently separated men so often do — he bonded with the boys. Gerald Murphy was a sport, loaning him his studio on the rue Froidevaux (opposite the Montparnasse cemetery) and quietly depositing $400 in Hemingway's account at the Paris branch of the Guaranty Trust. Archibald MacLeish went biking with him. Among the most supportive of the drinking buddies were Cummings and Dos Passos, fast friends, Harvard grads, assailants upon English punctuation and manuals of style. What had they been doing all this time?

Like Hemingway, they had arrived in France to drive ambulances in 1916, eager to be in the thick of the war, although not as combatants. Both had serious reservations about the hostilities, which were to cost Cummings three months in a French prison camp. Dos, as he once wrote to Cummings' family, narrowly escaped the same fate (he had his brush with the law during a protest on behalf of Sacco and Vanzetti in Boston some years later). Both Hem and Dos were newspapermen and freelance feature writers building up their novelistic muscles writing under the discipline of deadlines. They were also immersing themselves in the cultural bounty of the moment. As Dos would later write, "We were hardly out of uniform before we were hearing the music of Stravinsky, looking at the paintings of Picasso and Juan Gris, standing in line for opening nights of Diaghilev's Ballets Russes. *Ulysses* had just been printed by Shakespeare and Company. Performances like *Noces* and *Sacre du Printemps* or Cocteau's *Mariés de la Tour Eiffel* were giving us a fresh notion of what might go on the stage."

Hemingway, who did not go to college, was uncomfortable among all the Yalies, Cantabs, and Tigers, but Dos was far from the typical Harvard man. His grandfather had fled Madeira after being involved in a stabbing. His father was a dapper Chicago attorney who took advantage of his wife's aversion to travel to have an affair with a Washington widow who was descended from one of the first families of Virginia. Their son John was eventually "made legitimate"

when the wife back in Chicago died, and the attorney married the Southern belle. Before then, the boy's childhood was spent mainly in hotels abroad, accompanying his mother to Brussels and London and summering in Biarritz and Boulogne-sur-Mer. In 1907 he was packed off to Choate in Wallingford, Connecticut, then a fledgling prep school not far from Hotchkiss, where Murphy and MacLeish were studying. He spent his holidays at the nearly seven thousand acres of Westmoreland County along the west bank of the Potomac at Sandy Point that his father, who challenged Woodrow Wilson for the Democratic presidential nomination, had amassed. Dos Passos was called "Frenchie" at school for his European manners and antipathy to sports. He failed Greek, had only a C in French and Latin, and fought his way through more than four years of teasing and harassment. Although he skipped his last year and never received a diploma from Choate, in 1911 he passed the Harvard entrance exams. After a Grand Tour (England, France, Italy, Egypt, Greece, Turkey), he became a big literary man on the Harvard campus, writing for the *Monthly*, a star-studded journal founded by the illustrious philosophy professor and best-selling novelist George Santayana and edited, in earlier days, by Bernard Berenson and William Vaughn Moody.

Because students were seated alphabetically at Harvard in those days, Dos and his good friend the future literary scholar S. Foster Damon were near another rather eccentric lad, Edward Estlin Cummings. He was a local, brought up in a conservative Cambridge house playing word games with his mother and staying out of the way of his father, a former Harvard professor of philosophy who preached at the South Congregational Church of Boston. Cummings prepped for the inevitable, entrance into Harvard, at the rigorous Cambridge High and Latin School, and wrote poetry from an early age.

Theirs was one of those unforgettable college friendships that bring young men together for breakfast, lunch, dinner, late-night beers, day after day. Although we know them as literary lions, art took priority from their undergraduate years through most of the twenties. Both Dos and Cummings drew, and if there is a side of his legacy that deserves greater recognition, it is Cummings the artist. The slightly more sophisticated Damon, a music major who later became a prominent William Blake scholar, introduced them to his own enthusiasms, masterworks of Cézanne, Blake, El Greco, Whistler, the French Impressionists, and particularly the Fauves, who were a dominant force in the Armory Show, which came to Boston in 1913 after it had been the

After trips to Paris and Morocco, John Dos Passos spent time in 1927 roaming Mexico, completing a number of canvases including *Mexican Men and Woman Drinking from a Straw* (1928).

The close relationship between the novels and paintings of Dos Passos is felt in *People Pyramid at an Amusement Park,* which complements the Coney Island scenes in his early masterpiece, the high-energy *Manhattan Transfer.*

The bustling world of *Aerial View,* which scholars attribute to the mid-twenties, offers a visual version of what Dos Passos called "the creative tidal wave that spread over the world, from the Paris of before the last European war."

Dos Passos' close friends Fernand Léger, Natalia Goncharova, and the Japanese artist Yasuo Kuniyoshi encouraged him to make his painting bolder, as he did in the bright colors of *Shouter.*

When Dos Passos invited the critic Edmund Wilson
to his opening in New York, where *Nude 1* (1927)
and other paintings made their debut, he wrote on the
invitation: "Follow the green line to the cocktail
shaker. Any person caught looking at a picture will be
fined for infringement of rules."

talk of Manhattan. The influence of the Fauves can be seen in the incandescent palette of the paintings of both Dos and Cummings. Another Harvard buddy, Scofield Thayer, introduced them to the works of Picasso and Braque, Toulouse-Lautrec, and Aubrey Beardsley. Both Cummings and Dos were autodidacts in the studio, but far from casual about such necessary rites of passage as life drawing, anatomical studies, and still lifes. They talked Baudelaire and Rimbaud, studied French, Latin, and Greek, loved Henry James, and loathed Oscar Wilde. Both were on the *Monthly* and lived in Thayer Hall. Dos was often invited to the Cummings home for dinner in Cambridge, along with Damon and Dudley Poore, a school poet. When Diaghilev's Ballets Russes arrived in Boston on its first American tour, Dos Passos was in the audience. When Cummings was invited to speak at the 1915 commencement ceremony, where he received his degree magna cum laude, he presented an essay on "The New Art," linking literature and painting. In a nice bit of symmetry with his prep school days, Dos never bothered to attend the Harvard graduation in 1916 or pick up his diploma (he graduated cum laude). Cummings was still in town, completing a masters in classics before moving to Manhattan for a boring and short-lived (a matter of weeks) career in book publishing with P. F. Collier. During the summer after graduation Dos also did a bit of publishing, editing *Eight Harvard Poets*, a now-valuable anthology of lyric poems by Cummings, himself, and six others. Dos's father paid for it to be published by Laurence J. Gomme in New York.

When Dos made his move it was, like Gerald Murphy's departure for Europe, to study architecture — in Madrid. There his curriculum included drawing as well as Spanish language and literature. His father died unexpectedly of pneumonia, and Dos returned to New York to settle the estate, which ought to have set him up for life but ended up benefiting him very little, since his father had scarcely been thrifty and his cousins cheated him of the proceeds from the sale of the land. He returned to set himself up as a writer in New York.

In the spring of 1916, after a brief taste of Greenwich Village literary life, Dos Passos and Cummings volunteered for service in the Norton-Harjes Ambulance Corps. Even as they were training for their service they had in mind the writing they would base on the experience. In 1945, adding a preface to his novel *One Man's Initiation*, he described himself as "a bookish young man of twenty-two who had emerged half-baked from Harvard College and was continuing his education driving an ambulance behind the front in France." By August, Dos's unit was near Verdun, and the effects of nightly gassing caught up with him within a couple of months, when the Red Cross took over and gave him the choice of leaving or enlisting in the U.S. Army. Cummings, meanwhile, had been arrested and imprisoned for three months for mouthing off to his superiors and grumbling among the French drivers. Dos's antipathy to authority led him to quit, and he found himself a place on the Left Bank. He could not bear to stay out of the action for long, however. He volunteered for ambulance service in November in Italy. Cummings caught up by letter — he was back in Cambridge starting his book about the imprisonment (his father threatened to sue the French government for a million dollars), and Dos's anti-authoritarian correspondence with Cummings

Dos Passos created the poster in 1926 for *Processional*, a politically charged play by his fellow ambulance driver John Howard Lawson (later driven into exile after being blacklisted by the House Un-American Activities Committee).

actually caused some friction with the Red Cross higher-ups.

Dos Passos was evacuating the wounded in Italy when he first met Hemingway, who was with another Red Cross section. Dos eventually wound up in the U.S. Army (following training back in the U.S. and a tense trip back to Europe). After the chaos that surrounded the Armistice (his papers were lost and it took weeks for him to get discharged) he and Hemingway and everyone else, it seemed, were heading to Paris to devote themselves to writing, contemporary art, and music, venerating Joyce, romancing the *jeune filles,* and forgetting the carnage they had seen.

Cummings quickly found a publisher for *The Enormous Room,* but thirteen rejected Dos's manuscript before George H. Doran accepted *Three Soldiers,* which appeared after heavy editing in the fall of 1921. That year, he and Cummings had returned to Europe together aboard an old Portuguese freighter, the *Mormugao,* which left New Bedford, Massachusetts, in March. During their colorful adventure on the high seas and hiking the back roads of Europe, Cummings drew while Dos translated Camoëns. Cummings trusted Dos so implicitly that he deputized him to go over the proofs of *The Enormous Room,* which his publishers, Boni and Liveright, had butchered. Even though Dos, who had experienced something similar at the hands of Doran, did his best, Cummings was still furious with the bowdlerization his text suffered. Two years later, Hemingway asked Dos to intervene at the proof stage with Boni and Liveright, as they were editing his collection of stories, *In Our Time.*

Early success gave Cummings the chance to spend three years in Paris, the city he loved above all others. During his first visit, en route to his ambulance-driving assignment, he had written home that Paris was a "divine section of eternity." He loved not only the literary cafés but the cabarets and bars, the brothels and street corners. He filed an article for *Vanity Fair* on expatriate life, drawing on the escapades of his circle of Harvard buddies and former ambulance drivers that included Scofield Thayer, Stuart Mitchell, Slater Brown, John Howard Lawson, and Gilbert Seldes. He took tea with Ezra Pound in his studio and spent an evening with the MacLeishes in St. Cloud. He formed fast friendships with French poets, including Louis Aragon, as well as with Michael Larionov, Picasso, and Cocteau.

He was, like Hemingway, a magnetic personality with conversational abilities that matched his charisma. But that sort of magnetism has its dangers. His personal life was messy, especially during the time of his affair with Elaine Thayer, the wife of his dear friend and editor Scofield Thayer (who consented at first). Elaine and Cummings had a daughter, who became legally his when they married. Just three months later he contemplated a courtroom murder-suicide attempt when she left him to marry a handsome Irish banker she met on board ship.

Although Cummings was at the easel daily, Dos beat him to the punch in having his first exhibition early in 1923, alongside the work of Adelaide Lawson and the sculptor Ruben Nakian at the Whitney Studio Club on West Fourth Street in New York. He invited the Fitzgeralds to the opening: "Come and bring a lot of drunks," he wrote on the invitation. Both Cummings and Dos were taking what they had seen in the Armory Show and in the galleries and transforming it into their own idiom. There is in these works plenty of Munch, more than a dash of Fauve (especially Derain and early Matisse), and an added dollop of Expressionism that hints at an acquaintance with Austrian and German artists of the time, such as Egon Schiele and Max Beckmann.

Like many well-educated, over-stimulated members of the avant-garde, Dos and Cummings used both their typewriters and their paintbrushes to devour and digest the stimuli around them. Dos's city views or Coney Island moments throb with the infatuation he felt for the little guy, the marginalized, the laborer, the forgotten. They are the heroes of *Manhattan Transfer,* which was the novel he was working on in the spring of 1923. His friend Donald Ogden Stewart took him to meet Gerald and Sara Murphy in Paris. Dos was not at first a fan: "Gerald seemed cold and brisk and preoccupied. He was a dandified dresser," recalled Dos, who later became a dear friend. During that spring and summer in Paris, Dos and the Murphys were together quite a bit, working on the sets for the Ballets Russes as *Les Noces* was prepared. Dos, who had been a painter for the first Josephine Baker Revue Nègre set, was also in on the preparations as Murphy and Porter put together *Beyond the Quota,* which in many ways parallels *Manhattan Transfer* (another tale of an innocent in Manhattan). Dos brought Cummings to the theater to meet the Murphys, but Cummings sat in the back row and inexplicably avoided them.

Dos Passos was an intimate of the Murphy circle for decades. Sara and Gerald invited him aboard their sailboat for a cruise in June of 1924, the first of several annual summer visits to Villa America. That summer, he and Hemingway bought cycling gear and made a spectacle of themselves on the boulevards. They took in the bullfighting in Pamplona, horse racing

E. E. Cummings as captured by fellow American
expat artist and poet Man Ray.

When E. E. Cummings arrived in Paris, he was far
more interested in painting street scenes than in
writing poetry. On whether his passion for painting
interfered with his writing, he wrote, "Quite the
contrary, they love each other dearly." This untitled
painting, like all his canvases of the period, is undated.

Shades of Munch as well as the Fauve masters are
discernible in *Fantastic Sunset*, one of Cummings'
many rainbow-hued landscapes.

at Longchamps and Anteuil, and hiking in the Spanish Pyrenees to Andorra. Arriving in Antibes, Dos stayed at first at the Hôtel du Cap, then found himself "working in a plush room at the Murphys' place at Antibes where I'm being 'entertained,' as the *New York Herald* would say, with great elegance and a great deal of gin fizz." His official residence at the Villa America was a guesthouse they jokingly called the Bastide. He used the mornings to write and in the evenings it was not uncommon to gather with Archibald and Ada MacLeish, the Fitzgeralds, Picasso, or others. He left each year at the end of August.

He was back at the Villa America again almost precisely a year later, joining the Murphys on their picnics into the hills above Antibes and aboard the yacht, which Gerald and Vladimir Orloff, another of the Diaghilev set, sailed. Dos and Gerald were on a far-from-smooth trip to Genoa, their spinnaker snapping in the squall and their lines hopelessly tangled. They missed the channel to Savona and had to drop two anchors to pull the ship to a stop just off a rock reef. Eventually they were towed into harbor and spent the night by a dock (the tug knocked off the bowsprit). Dos met up with Hemingway in Schruns for skiing in 1926 — "the last unalloyed good time," he called it — when Hadley, Gerald, and he followed Hemingway down the icy slopes, often on their backsides. In the evenings, Hemingway read from *The Sun Also Rises*.

Marion Morehouse Cummings, the poet's third wife, had been a renowned New York fashion model and had also posed for Edward Steichen.

Dancer, one of the most exuberant of Cummings'
paintings, echoes the style of the Fauves and early
Kandinsky.

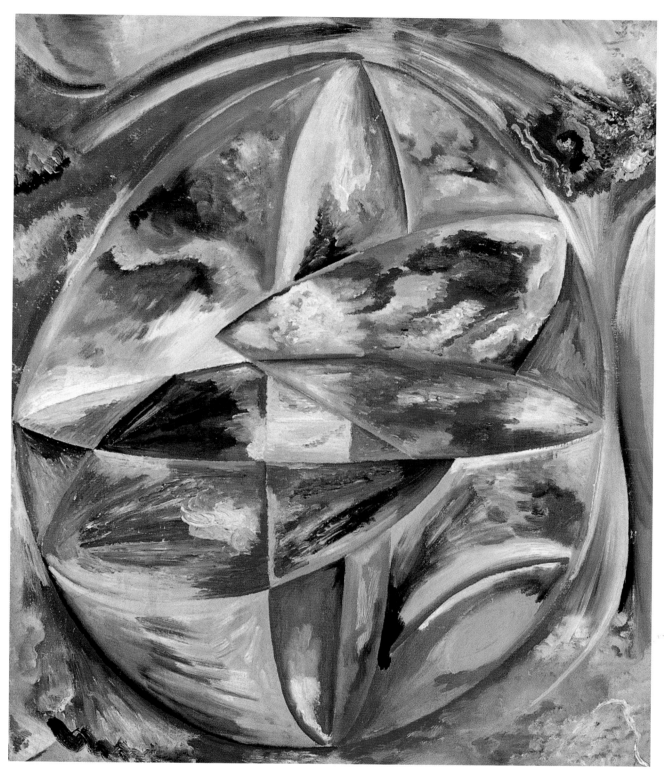

Although Cummings disparaged abstraction in his writings, his *Dream* follows the example of Kandinsky and others in allowing figure and still life to drift into pure color and atmospheric effects.

Hemingway and Cummings were not the only Jazz Age writers Dos knew. He and Fitzgerald had a bit of a history before France. One early autumn day in New York, Zelda and Scott invited him to an elaborate lunch (champagne, lobster, the works) at the Plaza Hotel with Sherwood Anderson, who floats like a guardian angel over so many of the stories of the Jazz Age writers. Scott and Zelda mortified him with an interrogation about his sex life. Dos parried and spent more time talking about the writing game with Anderson. Later, Dos tried to excuse the Fitzgeralds on aesthetic grounds: "There was a golden innocence about them and they were both so hopelessly good looking." Anderson wisely slipped out after lunch, but the Fitzgeralds prevailed upon Dos to ride out to Great Neck for a house-hunting expedition. The "kidnapping" would be fodder for a bittersweet memory of the drunken hilarity strewn by the Fitzgeralds throughout the age. They mercilessly imitated the spiel of the real estate salesman, then burst in unexpectedly on a completely soused Ring Lardner at his house nearby (not a light was on). When Lardner was unresponsive — literally, too drunk to speak — they moved on to a carnival alongside Northern Boulevard, then the main artery from the Gold Coast suburbs to the city. Zelda insisted on taking Dos on the Ferris wheel — over and over. Finally they headed back to the city with Scott slugging whiskey from a bottle under his seat and Zelda, who wanted another Ferris wheel ride, sulking like a child in the back.

For Hemingway, Dos Passos, Cummings, Fitzgerald, MacLeish, and younger writers such as Hart Crane, William Carlos Williams, and Malcolm Cowley, being in Paris in the twenties meant being in proximity to Cubist painting and Joyce. They were breaking apart and putting back together the language of novels and poems in ways that resembled the Cubist assault on form. Inspiration thrived on the occasional glimpse of their demigod, Joyce, whose *Ulysses* had taken Modernism to its height when it was published by Shakespeare and Company in 1922. For the young Americans eager to advance the standard in the direction Joyce had charted, writing meant taking language to its extremes. Dos wrote about it as both critic and novelist. In an essay on Cendrars that was decades ahead of its time, he put the importance of Paris on paper:

After all, Paris, whether we like it or not, has been so far a center of unrest, of the building up and the tearing down of this century. From Paris has spread in every direction a certain esperanto of the arts that has "modern" for its trademark. . . . Turbines, triple-expansion engines, dynamite,

high tension coils. Navigation, speed, flight, annihilation. No medicine has been found strong enough to cope with them; in cubist Paris they have invented some fetishes and gris-gris that many are finding useful.

That brilliant "esperanto" was the idiom of Dos and Cummings, while Hemingway had his own rougher tongue. The Parisian style of writing in the twenties ranged from the cleverly inaccessible to the breathtakingly virtuosic, as in the paragraph-long prose poems, mostly descriptive, at the head of the chapters of *Manhattan Transfer*, a novel Dos mainly wrote in Paris during 1923–24, or his daring trilogy, *U.S.A.*

As with Cummings, the uncanny ability of Dos Passos to capture the sense of acceleration, the spirit of the age, is what makes the writing so powerful. It is different from the silken lyricism of Fitzgerald or the hammered precision of Hemingway. Dos Passos used the "fast cut" of cinematic montage, the rhythms of advertising as well as other "low" sources (he had a great ear) to commit to paper the sensation of being in twenties New York or Paris. Dos and Cummings even tried their hand at plays. In 1925, Dos's *The Moon Is a Gong* (later retitled *The Garbage Man*) was presented at Harvard. It bore a certain resemblance to Murphy's *Within the Quota*. A year later Cummings created *Him*, a sexually charged Surrealist play laced with vaudeville turns that ran for twenty-seven performances at the Provincetown Playhouse in Greenwich Village, to dreadful reviews.

In the play and in the novels, Dos was sensitive to the little guy and not shy about letting his imagination take visionary wing, as in this sentence from the "Metropolis" chapter of *Manhattan Transfer*, in which he very accurately predicts the architecture of the future at a time when I. M. Pei was still in his elementary school uniform in Shanghai: "Crammed on the narrow island the millionwindowedbuildings will jut glittering, pyramid on pyramid like the white cloudhead above a thunderstorm." Dos Passos' politics drifted left and became boring and muddleheaded, but his heartfelt portraits of the struggling lower rungs are, particularly in the earlier works, moving and unforgettable. Just as the elegance of moneyed aesthetes like the Murphys and the Porters has its charm, one admires the other end of the social spectrum as honestly explored by Hemingway, Dos, and Cummings. They came from the same background as the MacLeishes and the Murphys, but they always had a touch of the Toulouse-Lautrec in them, slumming, flirting with downward mobility, sniffing about the edges of polite society, wondering how the waiter feels as he shifts his weight from foot to foot during the long banquet.

You can almost hear the Gershwin soundtrack under this super passage from *Three Soldiers,* in which the young American enjoys his first steps of freedom in Paris after the Armistice: "His heavy shoes beat out a dance as they clattered on the wet pavements under his springy steps. He was walking very fast, stopping suddenly now and then to look at the greens and oranges and crimsons of vegetables in a push cart, to catch a vista down intricate streets, to look into the rich brown obscurity of a small wineshop where workmen stood at the counter sipping white wine. Oval, delicate faces, bearded faces of men, slightly gaunt faces of young women, red cheeks of boys, wrinkled faces of old women, whose ugliness seemed to have hidden in it, stirringly, all the beauty of youth and the tragedy of lives that had been lived; the faces of the people he passed moved him like rhythms of an orchestra."

As Dos fashioned his poetically charged prose style, Cummings was painting madly and turning out four volumes of poetry at the same time. In December of 1922 he shipped home fifty-nine watercolors, mainly landscapes in what he himself described as Cézanne's palette. Even without knowing the paintings of Cummings (and few have seen them) it would be possible to pick them out in a lineup using the style of the poetry as a guide. Sinuous nudes in a passionate palette, abounding in purple (color of eros) and magenta, portraits that pulse with glowing reds and oranges à la Jawlensky, rolling hillsides in ringing tones of gold and green, they seem dashed on the canvas with a jaunty, busy brush that never labors, never hesitates. They are so fast and vivacious that they blur in just the Modernist way his poetry does.

Returning to the poems from the paintings, the continuities become apparent. Parisian scenes also show in the poems, especially in the early volume *Tulips and Chimneys,* which was published in 1923 and two years later won the prestigious Dial award. This opener has all the tender attentiveness to form and color of an artist whose easel is set before Notre Dame for an unusually warm December sunset:

*it is winter a moon in the afternoon
and warm air turning into January darkness up
through sprouting gently, the cathedral
leans its dreamy spine against thick sunset*

Cummings the painter is omnipresent in the early poetry. His own metaphor for the destruction of realism in new forms was that of the prism: "To break up the white light of objective realism, into the secret glories it contains," he wrote in the essay "The Symbol of all Art Is the Prism." This may be overreading a delightfully erotic poem, but I sense the presence of the painter (could he be the "invisible spectator"?) as well among the dramatis personae of an exquisite romantic idyll set on a cliff overlooking the sea, with what could easily be the Villa America rendered à la Cézanne in a few sun-dappled strokes. The "fat colour" invokes one of the basic maxims of oil painting, "fat over thin," which stipulates that each superimposed layer of paint has more oil in the medium than the one beneath, so that the later layer is more flexible and will not crack or flake. As depiction, it begins with the blue beyond expectation and adds, stroke on stroke, the boats, the trees and villa, the palpable effects of the light, all fresh from the brush. The lovers find a secluded overlook and get down to what Cummings always does best:

*under us the unspeaking Mediterranean bluer
than we had imagined
a few cries drifting through
high air
a sail a fishing boat somebody an invisible
 spectator,
maybe certain nobodies laughing faintly*

playing moving far below us

*perhaps one villa caught like pieces
of a kite in the trees, here
and here reflecting
sunlight
(everywhere sunlight keen complete
silent*

*and everywhere you your kisses your flesh mind
 breathing
beside under around myself)
by and by the sea
a fat colour reared itself against the sky and
 the sea*

The last line of the poem has the climactic heat of the Wagnerian *Liebestod,* melding the couple as they in turn are alloyed with the surrounding beauty: "the world becoming bright and little melted." This was the temperature of the times. By mid-decade, the Jazz Age had reached the upper echelons of its fevered state. Hemingway, Dos Passos, and Cummings, crossing the threshold between obscurity and recognition, welcomed the light, which gave the Murphys their golden glow but was beginning to burn the Fitzgeralds. More and more they were all beginning to realize they had been basking in the brilliance of some of the world's great artists. Picasso and Léger, Cocteau and Diaghilev — those radiant geniuses were reaching their zenith.

THE GIANTS

Fernand Léger and Pablo Picasso

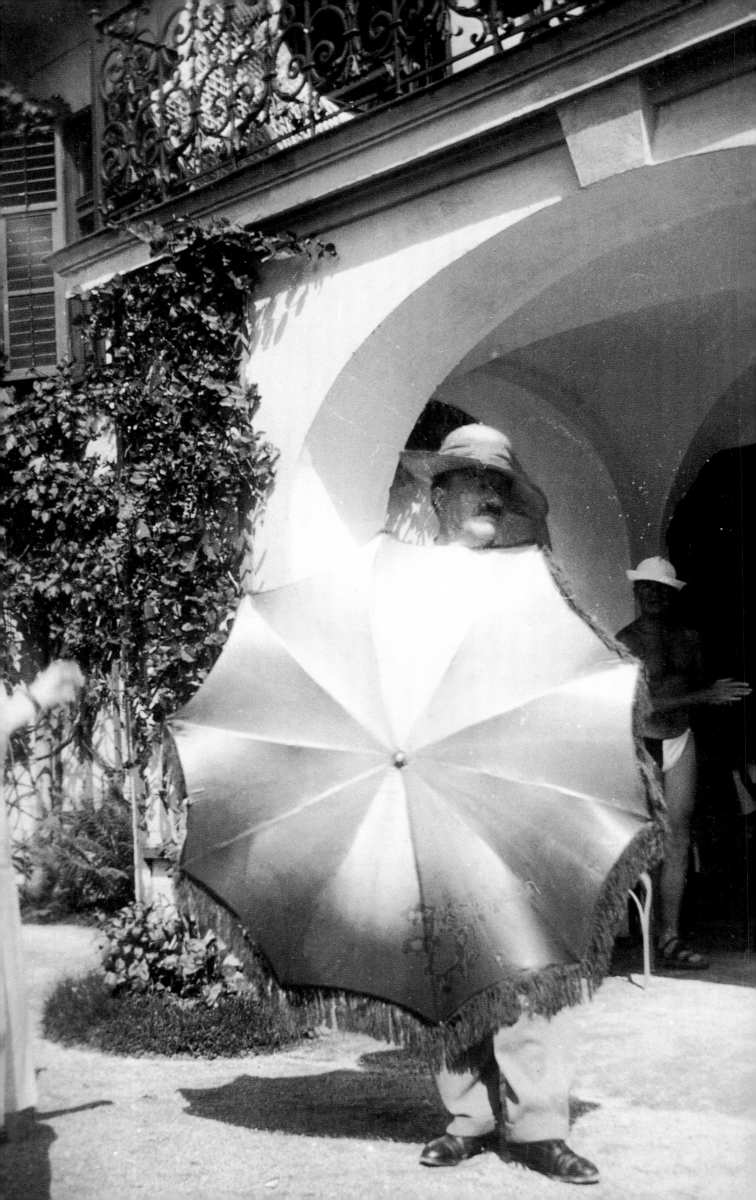

"My era was one of great contrasts, and I am the one who made the most of it. I am the witness of my time."
—Fernand Léger

If the company they kept is any indication, the Murphys and their fellow Americans were certainly familiar figures among the art world's Olympians. Two of the regulars at the Villa America were Pablo Picasso and Fernand Léger, whose careers were in full stride through the twenties. Their deep respect for Gerald Murphy as a painter and their love for Sara shine in the smiles photographed by Picasso on the beach at La Garoupe and the tender drawings they made of the couple. After the decade ended, all their lives remained intertwined, but nothing ever matched the blissful *années folles* when the bustling Villa America was the unofficial headquarters of the painters' southern circuit.

The two great artists took starkly different routes to that point. Léger, nine months older than Picasso, was still in his native Argentan, a town in the northwest of France, when Picasso arrived in Paris for good in 1900, quickly rising to stardom. Once Léger moved to Montparnasse in 1908, the two were part of the same circle, bumping into one another quite often, eyeing each other as friendly rivals in a league that also included such players as Miró, Giacometti, Chagall, Modigliani, and Soutine. They showed at the Maison Cubiste of 1912, where Léger was considered more of a realist than Gleizes, Metzinger, and the others. Their paths diverged in 1914, when Léger went to war while the Catalan remained in Paris (a fact that rankled). In addition to the major show of *Les Demoiselles d'Avignon* at the Salon d'Antin of 1916, that year Picasso beat Léger in the competition to win Diaghilev's commissions. By the twenties, a frequent nexus in the rivals' lives was offered by their friendship with Gerald and Sara Murphy.

The pan-European cast of characters on the scene in Paris — Swedes, Russians, Italians, Germans, French — was not universally enamored of the Americans. But Léger did extend his meaty, battle-hardened hand to the Yanks. The passion for things American even shows in his work, which contemporary critic Henry McBride characterized as "really expressing

the soul of America, machines being more prevalent here than almost anywhere else." Léger was also an intimate of the Russians, befriending Larionov, Goncharova, and the poet Vladimir Mayakovsky, and eventually marrying a Russian former student from his school, Nadia Khodossievitch.

Just as Léger embraced the Americans, they were among the first to love his work. Many of his earliest collectors were from the States, and the Armory Show curators, Walter Pach, Arthur B. Davies, and Walt Kuhn, spent a great deal of time in his studio in 1912 as they scoured Europe putting the historic show together. The two Léger paintings (now unidentified) they included marked his American debut. Coat-tailing the Armory Show's notoriety, Gimbel's department store in Milwaukee displayed Léger's work, along with that of Gleizes and Metzinger, in mid-May 1913. Gimbel's paid the artists a flat $100 per painting. The show went on tour, appearing in stores in Cleveland, Pittsburgh, New York, and Philadelphia, returning to Milwaukee, this time to the Milwaukee Art Institute, in April 1914, where it was expanded to include American artists. In our time snobs sneer at the peculiar Japanese practice of showing major art in department stores, but when Americans did the same thing in the teens with Cubist masterworks, one has to admit it served a thoroughly educational purpose, smoothing the way for difficult art to gain a broad audience.

The strapping son of a Norman cattle breeder, Fernand Léger was a nineteen-year-old apprentice architect when he entered military service in 1897. Afterward, he studied at the Académie Julian (missing the cut in the entrance exams for the Ecole des Beaux-Arts). To make ends meet he retouched photographs and forged Corots. Judging from the chaos in the Corot market at the time — it was flooded with fakes — he certainly was not alone. Closely following Cubism from the start, he established his style early, a variant on the crystalline

Fun but unpolished, and always supportive of Gerald's painting, Fernand Léger at Ramgut while on holiday with the Murphys.

Cézanne landscapes that were already gaining renown among fellow avant-garde painters and poets before 1910. Daniel-Henry Kahnweiler signed him to a contract that year, and told the story that when Léger showed the document to his mother, she refused to believe it was valid and took it to an uncle who was a notary to verify that it was genuine. The great Kahnweiler "clearance sales" of 1921, when German property was confiscated by the French government to repay war debts, included forty paintings by Léger. By 1914, his trademark "tubism" (the puzzle-like intersection of tubes and barrels) was well known in Parisian circles.

Léger was, like Robert Motherwell in the era of Abstract Expressionism, admired for his articulate theoretical statements on form and color, delivered in lectures and essays, which became an aid to deciphering his paintings' complexity. By the 1930s he had opened his own Académie Moderne within the Académie de la Grande Chaumière (his was later renamed the Académie d'Art Contemporain and included among its distinguished alumni Louise Bourgeois). In the early teens he was associated not only with the Cubists but

with Delaunay, Chagall, Archipenko, Laurens, and Lipchitz — they all lived and had studios in the famous "Ruche" of Montparnasse. The busyness of Léger's work reflects the multi-faceted idiom of the day — compare one of Robert Delaunay's kaleidoscopic Eiffel Tower paintings with the contemporary forest scenes of Léger, and the similarity becomes apparent. He was also surrounded by poets (particularly Guillaume Apollinaire and Blaise Cendrars), composers, and other intellectuals. Everything was in place to launch an art star's upward trajectory. Then came the call to arms.

The war represented a decisive phase in Léger's life, robbing his career of altitude but rewarding him with an Antaeus-like strength derived from contact with the most fundamental of realities: the earth, in the elemental form of the trenches. He was thirty-three when he donned the uniform again. Despite putting in for an assignment as a "draftsman, writer, cyclist, or chef," Léger was sent to the front. He was a sapper in the Argonne Forest in late 1914, scene of some of the heaviest fighting. Even under the worst of conditions, he drew his fellow soldiers, *les poilus* ("the

An important early oil painting by Léger, *Trois Personnages* was painted in 1920 when his pioneering "Tubism" was still in the experimental stage.

hairy ones"), in day-to-day activities. The abrupt confrontation with brutality was swiftly applied to canvas. As he later recalled, "I left Paris in a period of abstraction, of pictorial liberation. Without any transition I found myself shoulder to shoulder with the entire French nation; assigned to the sappers, my new buddies were miners, laborers, wood and ironworkers.... I was dazzled by the breechblock of a seventy-five millimeter gun opened in the sun, the magic of light on polished metal. That was just what it took to make me forget the abstract art of 1912–14. Since I got my teeth into that reality the object has never left me. The breechblock of that seventy-five millimeter gun opened in the sun taught me more for my artistic evolution than all the museums in the world."

His health, however, suffered. He was hospitalized in 1917 for rheumatism (although some biographies say he had been gassed in the fighting, and only a year later he was hospitalized again for pulmonary tuberculosis) and began painting again, notably a major work showing fellow soldiers playing cards.

Léger came back from his illness roaring like an engine, pounding the sensations garnered from the street into highly productive days in the studio. By 1918 his *période mécanique* of paintings based on vast machines was going full throttle. He roamed Paris with a vast appetite for sensation sharpened by deprivation. As he wrote to his friend Louis Poughon: "I'll fill my pockets with it, and my eyes. I'll walk about in it like I've never before walked about there.... I'll see in things their 'value,' their true, absolute value, for Christ's sake! I know the value of every object, do you understand, Louis, my friend? I know what bread is, what wood is, what socks are, etc. Do you know that? No, you can't know that because you haven't fought a war."

The machine that was the source of his pictorial vocabulary — brutal, factual, precise, *terrible* (his word) — was also identified with the Americanization of Europe. While others may have resisted industrial design, commercial advertising, tabloid graphics, and other examples of twentieth-century Yankee ingenuity as vulgar, Léger, like the Pop artists who pointedly took after him in the sixties, recognized great raw material when he saw it. When Léger and Cendrars put together the artist's book *La Fin du Monde Filmée par L'Ange N-D*, it begins with God the father, an American businessman at his desk in a conglomerate, complete with fat cigar, green eyeshade, telephone, and watch, overlaid with a stencil, "English Spoken." It sounds like parody, or resentment, but Léger actually relished the

tough talk and "tasteless" visual sense of Americans. Many of the Americans he cultivated as friends were artists, such as Patrick Henry Bruce and Morgan Russell, while others were potential patrons, including Ferdinand Howald and Katherine Dreier (cofounder, with Man Ray and Marcel Duchamp, of the influential Société Anonyme in New York).

Of all the Yanks, his favorite personally as well as artistically was Gerald Murphy. Within the first few weeks of his arrival in Paris in 1921, Murphy used his friendship with Goncharova and Léger's acquaintance with his sister as a pretext to meet with the artist, who initially took him for a rich American member of the "booboisie" and a potential buyer. Very soon after their first encounter, however, it became clear that Murphy and Léger were colleagues, soon to be collaborators on set designs for the Ballets Suedois. Léger's friendship proved to be Murphy's initial passport in Montparnasse, where Léger lived, although a man of Murphy's social skill scarcely needed someone to open doors for him. The two talked painting as well as the technical niceties of shop-window displays, popular culture, and music. Léger gave Murphy pointers on studio practice and technique, and after Murphy's first show Léger declared that Murphy was "the only *American* painter in Paris." That must have irked Stuart Davis, Charles Demuth, A. E. Gallatin, Charles Shaw, and Patrick Henry Bruce.

Other Americans in Paris, including MacLeish, Hemingway, and Dos Passos, reached Léger's studio through Murphy. In an enchanting paragraph from his memoir *The Best of Times*, Dos captures a stroll that he took with the artist and Murphy in June 1923 in which the typical tourist's views are eschewed for a keen, clear vision of the capital reflected wonderfully in the paintings of both men:

Léger ... seemed to me to have a sort of butcher's approach to painting, violent, skillful, accurate, combined with a surgeon's delicacy of touch that showed up in the intricate gestures of his hands.... As we strolled along Fernand kept pointing out shapes and colors ... yet Gerald's offhand comments would organize vistas of his own. Instead of the hackneyed and pastel tinted Tuileries and bridges and barges and bateaux mouches on the Seine, we were walking through a freshly invented world. They picked out winches, the flukes of an anchor, coils of rope, the red funnel of a towboat.... The Banks of the Seine never looked banal again after that walk.

Both Murphy and Léger were fascinated with projects that took them out of the studio. As art historian Judi Freeman divulged in a

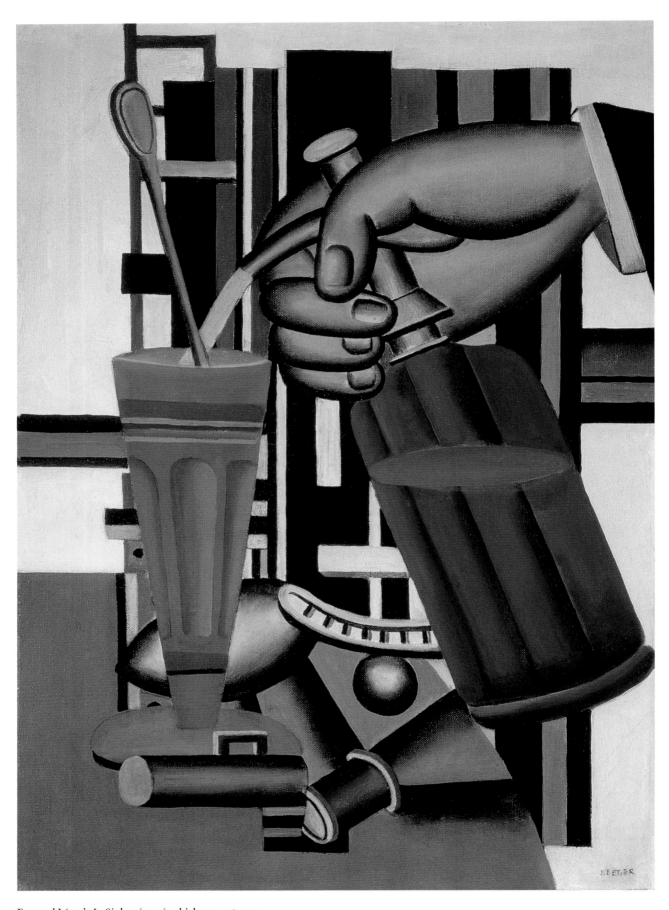

Fernand Léger's *Le Siphon* (1924), which was a strong
influence on Gerald Murphy's still-life style, is a
classic example of the artist's cool glorification of the
poetry of the machine.

recent book on the Ballets Russes, Léger's ideas for the stage predate his famous collaborations with the Ballets Suedois. During his war service he anticipated working with Diaghilev, to whom in February 1917 he sold a painting and two drawings he made on the front in Verdun. The contrast of forms that was the basis of the artist's imagery appealed to Diaghilev, who also bought Léger's 1914 masterpiece *L'Escalier*, later giving it to Massine. Léger's towering *Exit the Ballets Russes* of the same year is in the collection of the Museum of Modern Art, where it has traditionally occupied a staircase wall. He wrote to a friend, "He's a great collector and I am delighted that my work will become part of his collection and then, when Diaghilev is in Paris with his company, we shall be able to go and watch them in the director's loge! That is always a treat. Diaghilev, a perfect European type, likes my painting very much and would absolutely like to know me." The path to the impresario was opened by Goncharova and Larionov, who had known Léger since 1914. Léger had given an important lecture series at the Académie Wassilieff in May 1914, run by a Russian émigré, Marie Wassilieff, who was one of their intimate friends. Léger helped Wassilieff when she was imprisoned during the war — showing up in uniform to speak on her behalf at the magistrate's offices — and became godfather to her son Pierre. During the war he sent Goncharova and Larionov letters and *dessins de guerre*, and they planned together to collaborate with Diaghilev. By then Picasso had already scored his great success with *Parade*. The official title for the avant-garde artists who worked with Diaghilev was *artiste-décorateur-collaborateur*. Léger managed to get leave six times in four years, using the time to return to Paris to keep his artistic career alive, solicit commissions, and plan shows. After all that, Léger's projected contribution to the Ballets Russes never made it to the stage. Instead, he was drafted by Rolf de Maré, who in 1916 had bought a Léger painting through the artist Nils von Dardel.

That led to Léger's big break on stage with the Ballets Suedois. In January 1922, the premiere of *Skating Rink* at the Théâtre des Champs-Elysées marked the first of Léger's creations for de Maré's company. The sets, costumes, and makeup, all by Léger, were inspired in part by Charlie Chaplin's *The Rink* (released in 1917 and a favorite of the artist). The music was by Arthur Honegger and the choreography by Jean Börlin. While Murphy, who was recommended to de Maré by Léger, painted the huge front page for *Within the Quota*, Léger was next to him working on a

Charlie Chaplin was immensely inspiring to many of the visual artists of the time, including Cocteau and Léger, whose paintings and films paid homage to the American comedian. "For me he was the first image-man," Léger said.

The Ballets Suedois commissioned Léger to create
the set for *La Création du Monde*, for which Darius
Milhaud, just back from New York, created a wild
new jazz sound.

wonderful tableau of clouds and skyscrapers as well as African-inspired costumes for *La Création du Monde*. The double bill opened on October 25, 1923, at the Théâtre des Champs-Elysées, and eventually showed up in New York at the Century Theater (the opening was arranged by Edmund Wilson, who became the public relations rep of the company) but the reviews there were frosty.

Léger loved the movies when he was on leave, often going with Apollinaire. He was fascinated by the choppy movements of Chaplin, and was particularly taken with the cinematic close-up, which isolates the detail. He was a charter member of the Club des Amis du Septième Art in Paris, a "cine-club" for artists, writers (Blaise Cendrars, of course, and Cocteau), musicians including Arthur Honegger and Maurice Ravel, and filmmakers including Louis Delluc, Marcel L'Herbier, and Jean Epstein. In 1921, he joined Cendrars as poster artist on the staff of Abel Gance's movie *La Roue*, and in 1923 designed the set for a scientific laboratory for L'Herbier's film *L'Inhumaine*. His *Ballet Mécanique* of 1924, a film produced in collaboration with Man Ray, was the culmination of scenarios he had sketched during the war. Although it cost him ten thousand francs to produce, it broke ground for a whole burst of new painting on related themes.

During this time, Léger became a frequent houseguest of the Murphys on the Riviera as well as in Austria and the States. One particularly wonderful period they spent together at the Villa America was the month of January 1926, just before *Ballet Mécanique* was released. Both men were painting at the top of their form at the time. It is not hard to see a family resemblance between the paintings they were working on virtually side by side in Paris and Antibes. The precise contours, bold but flat color forms lined in crisp black, the fascination with gears and flywheels and other machine parts, the "truthful" quality of the rendering (one thinks of Hemingway, as well) are all shared characteristics. While Picasso was busy pushing the scale of his figures to that of giants and giantesses, Murphy and Léger were also building their pictures up to a monumentality of scale and feeling. All three were classicists in their fashion.

Gerald and Sara financed Léger's first trip to New York in 1931. In an article for the *Cahiers d'Art* that he dedicated to Sara, "New-York vu par F. Léger," he celebrated the "overloaded spectacle" of the city, overloading the facts a bit in the process: "Letters thrown in to the mail chutes on the fiftieth floor get hot from friction and catch fire by the time they arrive on the ground floor. They have to chill the mail chutes — too cold, and the letters will arrive with snow." I chuckle over that canard whenever I drop a letter into my chute on the eighteenth floor.

Léger's American contacts were proving his liveliest prospects. Katherine Dreier was organizing an exhibition at the Anderson Galleries, his first one-man show in the States, in which twelve paintings were on view. They included some of the artist's greatest work, including *La Ville*, *Le Déjeuner*, and *Les Disques*. Over 500 people showed up for the opening, and four watercolors sold for $25 each (to Dreier herself). They were the only sales. Eventually, of course, A. E. Gallatin and Alfred H. Barr made sure that *La Ville* and *Le Déjeuner* became stars of two great collections: the Philadelphia Museum and New York's Museum of Modern Art.

The show made a deep impression on many American artists, principally Stuart Davis, and marked the beginning of a number of exhibitions showcasing Léger in the States. American collectors began acquiring his paintings. Gerald Murphy's sister-in-law, Mary Hoyt Wiborg, bought several paintings, as did Ferdinand Howald (at the suggestion of Man Ray), Mrs. John Saltonstall, and A. E. Gallatin, who showed Léger's work at his Gallery of Living Art on Washington Square, part of New York University. By 1930, when the Baroness Hilla von Rebay was driving Solomon R. Guggenheim to create a museum of Non-Objective Painting, she made sure he bought five paintings and four watercolors by Léger despite the fact that the artist alienated her by being too pushy.

The impact of New York on Léger's painting has been discussed by several art historians, notably Carolyn Lanchner in a superb essay in the catalogue that accompanied a recent retrospective at the Museum of Modern Art. The great, late work *La Grande Parade*, completed in 1955 after fifteen years in the studio, is a huge, exuberant panorama of the circus. It uses great bands of blue, gold, and red that flow beyond figures and lines across its vast horizontal expanse. Léger specifically related the independence of color from form to the effect of the lights on Broadway. With the Murphys' help, he had built a bridge between Paris and New York, but the raw appetite for life is there in both the painting and his verbal account of it:

The takings depend on this parade and so it is powerful and dynamic. The instruments play at full blast. The big drum takes on the trombones and the trumpets fight the kettle drums. All this uproar is projected from a raised platform. It

One of Picasso's earliest portraits of his wife, the dancer Olga Koklova, from 1921–22, when she was still a member of Diaghilev's Ballets Russes.

Backstage at the Ballets Russes, Picasso (following in the footsteps of Degas behind the scenes) drew the dancers and musicians.

Picasso's *L'Entretien* was painted in the summer
of 1923, when he was spending much of his spare
time on the beach at La Garoupe with Gerald and
Sara Murphy.

Picasso celebrated the verdant charms of the villas of the Côte d'Azur in *Paysage* (1928).

hits you full in the face and slams against your chest. It's like a party whistle. Behind, to the side, in front, appearing and disappearing, figures, limbs, dancers, clowns . . . The music, linked with the glare of the spotlights, sways the whole aggressive mass.

While Léger never shed the soldier's rough-and-ready style, Picasso in the twenties was morphing from professional Catalan into international art celebrity. He wore an embroidered matador's cummerbund under his dinner jacket for black-tie galas and gallery openings. Even his friends were astonished at the changes in lifestyle as well as painterly style. The nasty label for this phase in Picasso's life was coined by Max Jacob and echoed by gossips including Cocteau: It was his "époque des duchesses" ("duchess period"). They were miffed because he had traded the bohemians of Montparnasse for the swells of the Riviera. One of the reasons why the international art set was on the Riviera, however, was to follow him. As Gertrude Stein had predicted in her response to his portrait of her, Picasso was a leader:

This one always had something being coming out of this one. This one was working. This one always had been working. This one was always having something that was coming out of this one

that was a solid thing, a charming thing, a lovely thing, a perplexing thing, a disconcerting thing, a simple thing, a clear thing, a complicated thing, an interesting thing, a disturbing thing, a repellent thing, a very pretty thing. This one was one certainly being one having something coming out of him. This one was one whom some were following. This one was one who was working.

The "duchess period" coincided with Picasso's new life as a husband and father. He had fallen in love with a dancer in the Ballets Russes, Olga Koklova, and heeded Diaghilev's advice: "Une Russe on l'épouse" ("With a Russian woman, one has to be married"). They were joined in a Russian Orthodox ceremony in Paris on July 12, 1917 (Cocteau, Max Jacob, and Apollinaire were witnesses). At first it seemed Picasso had found the society belle who might please his mother. A star onstage, she was intent upon keeping up appearances offstage even if it meant stretching the truth. She had said her father was a general (he was a railroad engineer). Friends bristled when she filled the dining room with "period" French antiques, a stark contrast to his African carvings elsewhere in the Paris apartment. The couple honeymooned in Biarritz, a playground to the rich since Napoleon's time, which he adored. The next year he and Olga traded the cold,

Picasso's set for *Pulcinella* (1920) was one of the
early collaborations between a top-tier painter
and Diaghilev. Later commissions went to Braque,
De Chirico, Matisse, Miró, and Modigliani.

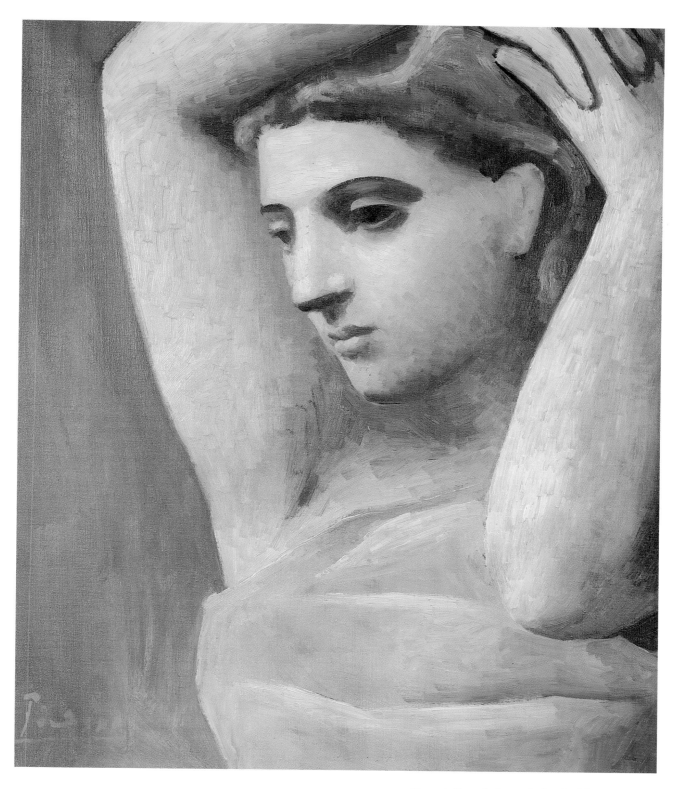

Picasso's *Buste de femme, les bras levés* is an outstanding example of his Neoclassicist style. Painted in 1924 during the summer when Picasso and the Murphys were often together, it combines Sara's features with those of Olga and the Farnese Marbles he had seen with Cocteau in Naples.

wild waves of the Atlantic for the gentle swells of the Mediterranean and began vacationing at St.-Raphaël. This was at the height of his collaborations with Diaghilev, including their gems *Parade* and *Pulcinella,* which were doing more to make Picasso famous at that time than his paintings. Olga was not the only woman around, of course. The angel of the productions was Eugenia Errazuriz, an older woman (and Chilean silver heiress) who was madly in love with the artist. She took Picasso to the Soirée Babel of Count Etienne de Beaumont, introduced him to the King of Spain, and presided over his high-society wedding. Picasso believed she had Inca blood. She was painted by Sargent, gave Stravinsky an allowance of a thousand francs a month for tobacco, and commissioned Le Corbusier to design her villa at Viña del Mar in Chile. Picasso and Olga stayed at her Biarritz villa on their honeymoon. In 1920 the Picassos left Paris even earlier to stay at Juan-les-Pins, arriving in June. By September, he had started a series of drawings and watercolors on the attempted rape of Dejanira, Hercules' bride, by the centaur Nessus. Picasso felt strongly that mythological subjects would come to him exclusively when he was staying on the Côte d'Azur. The curvy, muscular figures of his Classical phase were conceived there after he had encountered two great sources of ancient art, Pompeii and the Farnese Marbles in Naples.

Although Picasso had vacationed on the coast for years, mainly in Juan-les-Pins and St.-Raphaël, the best summer of the twenties came in 1923, when he was a powerful presence in the Murphy group. He even brought his mother, Doña Maria, to visit them at Cap d'Antibes, and they joined the crowd on the Plage de la Garoupe, along with the colorful

Count de Beaumont. The historic first meeting with the poet André Breton dates to this miraculous summer, which Picasso extended as long as possible, not returning to Paris until September. In addition to the portraits of Sara that are among the most compelling of his paintings of that year, there is an amazing story of a painting that might have been. It began as a valentine to Sara, tentatively titled *Toilet of Venus* and inspired by the American beauty as well as by the Farnese marbles. Partway through the year, back in Paris, he changed his mind and painted her out, leaving a pan-pipe player on the right who sets the tone for the revision. It became the all-male *Pipes of Pan,* which John Richardson calls "a synthesis that celebrates the new mode of Mediterraneanism, which he and the Murphys claimed with some justice to have inaugurated."

The next year, Picasso's triumphant run of stage works was gaining momentum. His collaborators would literally applaud as he worked his magic with paint and chalk on the stage during rehearsals, swiftly conjuring pillars and outdoor scenes as they watched in awe. The Count de Beaumont and Massine produced *Mercure,* a farcical ballet (possibly an allegorical slap at Cocteau, who was beginning to be a pest) for which Picasso created the decor and costumes, with a score by Satie and choreography by Massine. It was one in a series of chaotic avant-garde performances titled *Les Soirées de Paris* at the Théâtre de la Cigale in Paris. Picasso created *praticables,* movable scenery that is manipulated by the dancers. The Surrealists, who had long been trying to recruit Picasso for their revolutionary purposes, attacked it as prostration before the international aristocracy — the performance was a benefit for Russian refugees.

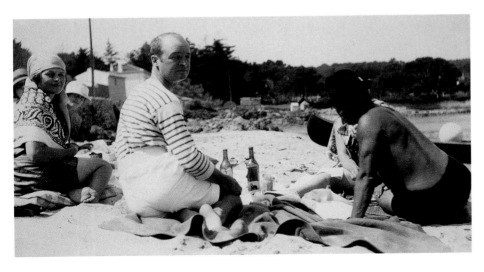

Sara and Gerald Murphy with Picasso, in his fedora and Sara's pearls, on the beach at La Garoupe in 1923.

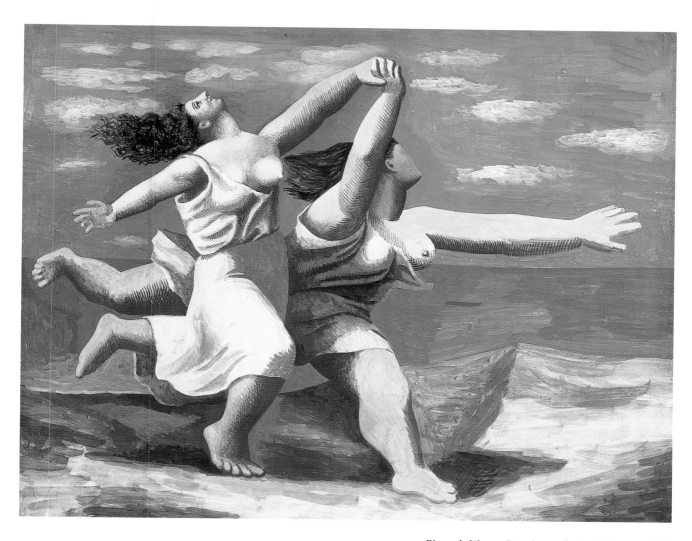

Picasso's *Women Running on the Beach,* the powerful curtain design for *Le Train Bleu* (1924), became the signature graphic image of the Ballets Russes in its heyday.

June 1924 also marked the debut of *Le Train Bleu* by the Ballets Russes, with Picasso's stunning *Women Running on the Beach,* originally a small but bold composition, enlarged for the curtain. It was first performed at the Théâtre des Champs-Elysées on June 20, 1924. Cocteau created the scenario and Milhaud the score, while the scenery was prepared by Henri Laurens and the choreography by Nijinska. The costume designer was a former singer and natural athlete from a small Auvernois village called Saumur, Gabrielle "Coco" (her choice for a stage name) Chanel, who had made her start in couture by designing hats in her lover's Paris apartment. As her taste in men improved and she began spending the summers with minor aristocrats in Biarritz or Deauville, she offered her burgeoning clientele the straight linen skirts or flannel trousers and sailor tops she enjoyed wearing on the shore. Pretty and a gifted entrepreneur, she gained the approval of Misia Sert, who made the introductions to Diaghilev and Cocteau, Picasso and Hemingway, Stravinsky (who fell madly in love with her),

Cole and Linda Porter, and the smart set. "I was the first to live the life of this century," she claimed. The Ballets Russes was her break: "It was when I saw the Diaghilev ballet I decided I was going to live in what I loved," she said. Her work for Diaghilev brought her message — simplicity and perfectionism — to a broader audience, while Mrs. Porter's conspicuous success in the "little black dress" guaranteed good press clippings. Picasso rattled her with his frankness, but never made her his mistress. "I regarded him as a clown. But his black eyes petrified me. I turned round, and was furious with myself for doing it. He disturbed me," she admitted. The Christmas of 1925 in Monte Carlo, she was invited to dine aboard the *Flying Cloud,* the Duke of Westminster's yacht. The life Coco and her Duke led was a fairy tale, of palaces and balls, private musicales and soirees, Rolls-Royces for which the engines were changed annually, and long yachting trips that, truth be told, bored her and made her worry about wrinkles. Coco had other plans, however, and fairy tales have to end

somewhere. Before the end of the decade, she found a wife for Westminster and decamped to the Ritz, summering at La Pausa, her fashionable estate south of Roquebrune.

Meanwhile, the Riviera became more and more important to Picasso, both as an artist and as a family man. He spent five straight summers on the Côte d'Azur, creating some of his most powerful paintings as well as the drawings he made daily on the beach, observing the gait of bathers, capturing their movements, following their holiday routines and habits. In March of 1925, he and Olga visited Monte Carlo during the dance season, and later that spring he finished *The Dance*, which is thought to telegraph his disenchantment with her. They were back at Juan-les-Pins in the summer of 1925, just before the major Surrealist show at the Galerie Pierre that grouped him with Arp, de Chirico, Klee, Miró, and Man Ray. Picasso chose only Cubist pictures for the show, but in the studio he was already on to other fare. He painted a tender series of portraits of his son Paulo when they were living at the Villa la Vigie in Juan-les-Pins during the summer of 1925. By the next summer, back in Juan-les-Pins, he advanced to the powerful interweaving of Cubist and Classical styles, with *Musical Instruments on a Table*. A year later, the teenage Marie-Thérèse Walter was in the picture. He had spotted her in front of the Galeries Lafayette and delivered that smooth classic line, "Mademoiselle, you have an interesting face. I would like to make your portrait. I am Picasso." Picasso spent his vacation that year at Cannes with Olga and Paulo, creating the great series "The Metamorphoses," based on figures of bathers who become massive biomorphs. He wanted them made into colossal sculptures to line the Croisette, the promenade between the beach and the grand hotels of Cannes.

It was the last summer of the decade on the Côte d'Azur for Picasso. The next years he moved his summer studio to Dinard, in Brittany, where he was having an affair with Marie-Thérèse while Olga and Paulo played on the Atlantic beach. The scene in Antibes was never quite the same without him. Decades later he would return, creating a studio and pottery that would be a major factor in the revival of the region (an early example of the "Bilbao effect," or culture leading an economic revival), but nothing would ever match the magic of those summers of the twenties.

Picasso's *Bathers* (1918) is one of the first Neoclassical paintings he made from his observation of beachgoers the year he married Olga and they honeymooned at Biarritz at a borrowed villa.

The autobiographical *Family at the Seaside* (1921), which celebrates the blissful beach afternoons Picasso enjoyed at Antibes with his wife, Olga, and newborn son Paulo.

ENTER THE BALLETS RUSSES

Diaghilev, Cocteau, and Modern Music

"We must be free as gods."
—Sergei Diaghilev

When one grows up in a mansion where opera and ballet are privately presented, where afternoon tea is served daily in the orangerie after a morning spent at the easel probably followed by a stint at the Bechstein piano, then becoming Europe's greatest impresario seems almost natural. Sergei Diaghilev was brought up on Thursday musical soirees presided over by his uncle, an accomplished cellist, where the music of Tchaikovsky (an in-law of his stepmother) would be played along with works of Glinka and Mussorgsky (dear friends of the family) and Russian folk music from the area around Perm, the small provincial city where they lived. They were bagatelle nobility, elevated to their title in the eighteenth century for service to the czar, and pillars of the local arts community. The whole household painted, played an instrument, sang, composed, and collected rare books and manuscripts.

It was a charmed existence. During his trips abroad while a law student in St. Petersburg, he was introduced by a cousin to Brahms and Zola, Verdi, Chabrier, Massenet, and Tolstoy, watched Sarah Bernhardt and Eleonora Duse on stage, and dined with Anna Pavlova and Isadora Duncan. In St. Petersburg he was present for Anton Rubinstein's final concert, attended the dress rehearsal for the debut of Tchaikovsky's *The Sleeping Beauty*, heard Nellie Melba on stage, and accompanied Feodor Chaliapin. He summoned the nerve to present his own operatic version of *Boris Godunov* to Rimsky-Korsakov for a critique. In a progressive art magazine he cofounded, *Mir Iskusstva* (The World of Art), he wrote in a fin-de-siècle mode about aesthetic questions along the lines of Ruskin, Whistler, and Delacroix. His essays on the "complicated creation" of art were highly influential in St. Petersburg art circles and offer a window on Diaghilev's later accomplishments. For example, although he may have been writing about painting or chamber music, there is insight into the dance breakthroughs of the twenties in this observation of 1898: "To any beholder the value —

significance — of a work of art consists in the clarity with which it expresses the artist's personality and in the accord between the artist's personality and the beholder's." It is no wonder that Diaghilev and Cocteau would see eye to eye, for this is almost precisely Cocteau's position on the need to synchronize the sensibilities of creator and audience. Diaghilev was an elitist (the Surrealists never forgave him for it), but he was really just addressing his own kind.

The magic of aristocratic grandeur lost its potency as the Revolution neared. The family fortune lost, the distinguished legacy now a target for persecutors, Diaghilev in 1907 followed the caravan west. He was but one of thousands in the diaspora of distinguished Russians who fled to France. Not all landed on their feet at first, and stories abound of noble hotel doormen greeting arriving European aristocrats who had once dined at their tables. So many limousine and taxi drivers had been White Russians that they had their own magazine, *Le Chauffeur Russe* — back home they had driven their own elegant cars, as motoring was a beloved pastime. Eastern Europeans were mainstays of the orchestras and opera casts, and many of them were among the critics who supported Diaghilev in print or as benefactors. Misia Sert was a Pole, musical and refined, who instantly recognized Diaghilev's taste and intelligence. Apollinaire was born Wilhelm Apollinaris de Dostrowitzky, a minor Polish aristocrat now known as one of the great "French" poets of the age, celebrant of the Eiffel Tower, and author of the great avant-garde volume *Alcools* (1913). One line of his poetry marvelously summarizes the way all of them were shedding their past identities and rules to reinvent themselves for the new age: *"A la fin tu es las de ce monde ancien"* ("In the end you tire of that old world").

As superbly educated and equipped as he was, Diaghilev still had to figure out an occupation. He had been artistic adviser to the Maryinsky Theatre in St. Petersburg for a couple of years at the turn of the century, and

Diaghilev and his star Serge Lifar, on the sand, with two Ballets Russes dancers on the beach in Monte Carlo.

An aristocrat who made his name as an art critic and a curator, Sergei Diaghilev revolutionized dance and ushered in the era of the private (non-government) and experimental ballet company.

One of the prima ballerinas of the Ballets Russes, Flora Revalles.

then performed the complicated duties of what we today call an independent art curator, bringing Russian exhibitions to Paris beginning in 1904. In 1908 he produced his first opera in Paris, Mussorgsky's *Boris Godunov*, starring Fyodor Chaliapin. Emboldened by rave reviews and a strong box office, the next year he presented a full season of opera and ballet featuring many of the top dancers and singers of the Maryinsky. By 1911 he had the backing for an independent private ballet company, a bizarre notion in an age of imperial patronage, when ballet companies were either on the government payroll or subsidiaries of the opera. Diaghilev almost overnight became the most powerful figure in European dance.

Remarkably, despite the brevity of its run, the Ballets Russes was the most influential dance company of the century from its founding in 1911 to its collapse upon Diaghilev's untimely death in 1929. But the highlights of those brief eighteen years! The classically inspired masterpieces of Michel Fokine (*Narcisse*), the great Pavlova roles (*Daphnis and Chloé* and *Giselle*), the Russianness of *Firebird*, the fireworks of Nijinsky and Massine, who succeeded Fokine, the innovations of Nijinska (sister of the dancer, who became a mainstay choreographer after her brother lost his mind). The style was wholly modern, but the spirit was rooted in ancient Greece and Mother Russia. Above academic footwork and legs, Nijinska had her dancers create angular, athletic arm and torso movements that nobody had seen on a ballet stage before.

While the company was building its foundation, Georgi Balanchivadze, a young Georgian dancer who had just had his first whiff of success in staging dances as ballet master of the Mikhailovsky Opera Theater in St. Petersburg, was choreographing his own escape. It was a tension-filled time, when finagling one's way into a company booked for a Western tour was risky business. One of his dearest friends and fellow dancers, Lidia Ivanova, had just been murdered (officially, killed in a "boating accident") by the Bolshevik secret police because the officials who had been wining and dining her decided she knew too much and could not be permitted to leave the country. Balanchivadze had been tracking the success of Diaghilev's company since its inception, reading the press clips and yearning for the chance to dance one of the Stravinsky ballets — but the part scores were simply too expensive to lease. In the summer of 1924 the door opened a crack, and he took his chance to be free. He danced on tour in Berlin and Vienna under the watchful eyes of his Russian handlers. In Vienna, Balanchivadze and two other dancers in on

Vaslav Nijinsky in his greatest role — the faun — propelled the Ballets Russes to success before his mental condition deteriorated on a company tour of South America.

Lydia Lopokova was one of Diaghilev's many recruits from St. Petersburg for the Ballets Russes. In 1925 she married the economist John Maynard Keynes, who would help found the Royal Ballet for her.

Serge Lifar leads one of the comic masterpieces of
the Jazz Age presented by the Ballets Russes.

the escape plan met Rachmaninoff backstage after a concert and the young dancer committed an innocent faux pas, requesting permission to choreograph one of the composer's piano works without realizing it would be construed as an insult to turn a piano work into a dance score. Summarily tossed out of the dressing room, for the rest of his life the choreographer greeted the mention of Rachmaninoff with the condemnation, "lousy music."

An invitation to dance in London was his opportunity to slip the hold of the Russian tour manager. After a month performing in a music hall, he wound up in Paris in a cheap pension, down to his last ruble after selling his best suit to pay for his room. But Diaghilev, who was always scouting for Russian talent in Europe, tracked him down and telephoned the pension just when the money ran out. Diaghilev needed a choreographer more than he needed a dancer, for he and Boris Kochno had been devising the ballets ever since Massine had departed from the company in 1921. Just after the phone call, in November, the great muse Misia Sert brought Diaghilev and Balanchivadze face to face for the first time in her Paris salon. After the impresario had watched the young man dance one of his own works to music by Scriabin, he asked if he could also make ballets for operas. Hungry and desperate, and certainly inexperienced, the twenty-year-old said he could. "Can you do them quickly?" Diaghilev asked. Again, yes, and soon they were all on the way to the Opéra de Monte Carlo for its January through April season. A barrage of telegrams from St. Petersburg went unanswered. Diaghilev, who Russianized the English dancers' names, also renamed his Russians. Nizhinsky became Nijinsky, Miassin was Massine, and Spessivtseva had turned into Spesiva. As the programs for the 1924 season in Monte Carlo were going to press, Georgi Balanchivadze was transformed into George Balanchin (for the first Paris season, the final "e" was added).

With Balanchine's arrival, the synthesis of St. Petersburg and Paris ascended to a new level (the company regularly presented its most experimental works in Paris, saving the more conservative fare for Monte Carlo or the tour to London, Rome, San Sebastian, and the United States). His first Stravinsky ballet was *Le Rossignol*, to a score that had been around since 1914. The composer lived in Nice, half an hour by train from Monte Carlo, and frequently dropped in for rehearsals — a blessing, as he often had to correct the tempi set by Diaghilev. For fifty years, extending into their great collaboration at the New York City Ballet, Balanchine and Stravinsky would work

side by side. During his fourteen years with Diaghilev, Balanchine also created ballets for more than twenty operas, which secured the company's finances.

All this required extraordinary levels of work as well as talent. Diaghilev was a tyrant. His dancers even went on strike once in Paris when the schedule of rehearsals and performances became too demanding. When the company was at its height at mid-decade, it resided in Monte Carlo, although Diaghilev himself was more often in Paris, accompanied by his creative team. The daily schedule during the season would outrage today's union leaders: morning class followed by rehearsals from ten to one in the afternoon, more rehearsals from half past two until five, a performance at nine (at three on Sundays) or a final rehearsal from nine to eleven or later at night. This regimen of two rehearsals and a performance, or three rehearsals, was in effect seven days a week. Most dancers worked for four hundred francs a month under an exclusive contract to Diaghilev, who was notoriously unforgiving regarding any shred of disloyalty to the company.

To know what it felt like to be in on the creation of one of the great Ballets Russes collaborations, watch the scene from *The Red Shoes* (1948) in which Moira Shearer is whisked from her hotel to a villa in the hills above Monte Carlo to have the status of *étoile* bestowed upon her by the slightly sinister but always dapper Diaghilev figure, known in the film as Boris Lermontov. The young English composer races through highlights of the score at the piano while the choreographer, played by Leonid Massine himself, sketches movements in the ballroom and the old set designer, a Matisse-like Frenchman, muses over decor. For Hollywood, it is not a bad effort at capturing some of the creative process and what it might have been like, on a good day, for those gathered around the stately Diaghilev. As *The New Yorker* dance critic Arlene Croce once observed, "The real-life story that was the basis of the script (that of Diaghilev and Nijinsky) was already so bizarre that one didn't question the absurdities piled on top of it. The movie was made from the viewpoint of infatuated outsiders; it had an appetite for magic."

In our time, only a few collaborative ventures come close to the success enjoyed by Diaghilev and his attendant talents. There was the golden era of Balanchine, Stravinsky, and Lincoln Kirstein at the New York City Ballet from 1948 through the 1970s — two-thirds of which had been part of Diaghilev's magic kingdom. The authority of Diaghilev combined with the collaborative receptivity to new ideas that makes an avant-garde company dynamic is

echoed in the studios of such dance-world figures as Merce Cunningham, Martha Graham, and Pina Bausch. We can also relate it to the magnificent global colloquies of two contemporary theater geniuses, Peter Brook and Robert Wilson. At the international laboratory of creativity that Robert Wilson runs at his Water Mill campus on Long Island, committees of international designers, musicians, performers, artists, and writers concoct experimental theater pieces "major" enough to be booked at major opera houses and theaters all over the world. The excitement of their brinksmanship and the United Nations–caliber mix of nationalities in the cast of characters are throwbacks to Diaghilev's great experiment.

That it was done by a Russian in Paris should not come as a surprise. The whole group surrounding him were existentialists before that term was coined, capable of the sort of extreme gestures that are the stuff of fiction. Stravinsky, Larionov, Goncharova, Bakst, Nijinsky, and Fokine were all daredevils both in life and art. Stravinsky was the son of a great opera singer from St. Petersburg and, unlike Diaghilev, when he presented his scores to Rimsky-Korsakov, the master urged him to drop law school and turn to music full time. The originality of his early works, including *The Firebird* (1910), *Petroushka* (1911), and *Le Sacre du Printemps* (1913), was enough to provoke riots in the theater. Under Diaghilev's wing, offered a series of commissions, he emigrated to Switzerland before he was thirty. Despite constant fights over money and the cutting of his scores, he became a staunch member of the Ballets Russes family. He was an involved composer, often attending rehearsals, banging out his complex rhythms on the piano lid, and altering his phrasing with great sensitivity to suit a choreographer's needs.

The story of Natalia Goncharova and Mikhail Larionov is no less dramatic. The two were in Paris in 1914, a writer-painter couple well known in the avant-garde, but Larionov returned to Russia and was drafted. Once he was wounded and hospitalized for three months, he began looking for a way out. After receiving a telegram from the Villa Bellerive in Lausanne that commanded: "Leave immediately. Waiting anxiously. Diaghilev, Stravinsky," Larionov and Goncharova made their way to Geneva, where they joined Massine, Balanchine,

and what was the second generation of the Ballets Russes creative team. They took over the jobs of set and costume design from Leon Bakst and Alexandre Benois, beginning with *Soleil de Nuit* for the Paris Opera in the 1915 season.

Diaghilev was bending the rules not only onstage but off, shaking up social and sexual conventions with the same brash abandon he applied to the formulas of ballet as it had been known to his time. For *Les Biches* in 1924, Marie Laurencin painted provocatively sinuous backdrops and designed the costumes. Picasso's famous curtain for *Le Train Bleu* in 1924, an alarmingly gigantic study in movement, was but one of many Ballets Russes commissions, the most famous of course being *Parade*. Keeping Picasso interested in the ballet was simple — once he fell in love with one of Diaghilev's dancers, Olga Koklova, he was always around. Other artists became involved over the years. Matisse, Braque, Utrillo, De Chirico, and Delaunay all received plum assignments. Just as Diaghilev had been a prime mover among composers through his commissions, he was a force in the art world, with painters clamoring to catch his eye.

Many assume that the soundtrack of the twenties was all jazz all the time, and it is certainly true that it reverberated through the expatriate community. But jazz contended with a panoply of other styles. As in the glory days of the Moulin des Galettes, Paris was a capital of world music long before the recording companies discovered that market segment and made ragas as popular as ragtime used to be. There were foreigners on the scene who brought their native styles and modes, among them plenty of Poles, Russians (Stravinsky and Prokofiev), Hungarians, and Romanians (Georges Enesco, Bohuslav Martinu). Puccini's operas were the top draw at the Garnier. Villa Lobos lived in Paris from 1923 through the end of the decade — he brought not only the samba rhythms of his native Brazil, but hard currency as well. Funds entrusted to him by the Brazilian government underwrote concerts and publicity for national music.

Latin dance bands, string sections full of displaced Russians, and the usual sprinkling of Italian tenors all contended with the distinctively, almost defiantly French idiom of a stylish group of composers who were as socially adept as they were skilled in counterpoint.

Overleaf: Goncharova's design for the curtain of the *Golden Cockerel*, choreographed by Fokine to music by Mussorgsky. Goncharova was Gerald Murphy's painting instructor.

The paintings and haute couture of the period may be better known today than the music but it is hard to beat the popularity of Picasso and Coco Chanel. Few would argue against the sad fact that "serious" music has not kept pace with art in its capacity to draw a broad audience, so it is easy to forget that many of the most important and beloved masterpieces of modern chamber and symphonic music were first heard in Paris in the twenties. Connoisseurs and later composers never abandoned the sophisticated taste for Erik Satie, Francis Poulenc, or the Paris period of Prokofiev and Stravinsky. Among their champions through the eighties, for example, was John Cage. The avant-garde rules for the painters went as well for the composers — coddled by aristocratic patrons, lionized by poets, freer than ever before to cock a snook at the Conservatoire where they had trained and even taught — it was a marvelous time to be in Paris. As a defensive Darius Milhaud told a documentary producer for the BBC in the sixties, "I am always very angry when I hear now people speaking of the twenties and referring to them as the 'silly twenties,' or when I read about the 'silly twenties,' because I think it has been the most marvelous period that I have been through. I think at this time everything was

possible, we could try everything we wanted, it was a period of experiment, of liberty in expression in the widest sense of this word. We had a lot of possibility that we enjoyed very much."

The firmament of serious French music in the twenties was dominated by a constellation known as Les Six, a clubby group of rebels from the academy whose members consisted of Erik Satie, Francis Poulenc, Gabriel Fauré, George Auric, Darius Milhaud, and Arthur Honegger. Like Steve Reich and Philip Glass in our own era, they were prominent members of the inner circle of the painters and poets, and whenever one of the big, boisterous events took place in Paris, most or all of them would be there, accomplices in the struggle. The "happenings" of the sixties were anticipated by these outlandish agglomerations of art, music, dance, and drama of the twenties, some cooked up by writers, like the *Relache* of Cocteau (a mixed-media ballet and theater work that moved from site to site in 1920). Orchestrated as a tone poem, the decade-long story of Les Six "opened" in January 1920 with an artfully placed article in the magazine *Comœdia* by Henri Collet, a journalist they had taken into their midst at a party at Milhaud's the week before. They gave him a proof copy

Picasso's pochoir for the set design of *Tricorne*, a ballet choreographed by Massine, which had its Ballets Russes premiere in London in 1919.

of the upcoming *Album des Six*, the sheet music for the first group of piano pieces they published together, and anointed him as spokesperson. However elitist the clubby French answer to Russia's Big Five (or Mighty Handful) might have been, they never had dues or officers, and held together from mutual respect and allegiance to an idea of a French (read, non-German) sound. Since the Great War, Beethoven was on the outs with the French musical public (a proposed festival on the centennial of his death fell short of donated funds) and Wagner was under fire. Webern, Schoenberg, and the Austrians were limited in their appeal not just in the usual ways (their own impenetrable irascibility, added to the political incorrectness of *bochisme*, or "Germanism," a postwar political no-no) but because they were not physically in Paris, as Gershwin, Stravinsky, and others were. For Les Six, the way was open not just in the concert halls but in the salons of such music supporters as the Vicomte and Vicomtesse de Noailles, the Count and Countess Polignac, and the more fashionable American and English millionaires. A coterie based on French taste proved a stroke of marketing genius just as recordings and radio came into play in mid-decade.

The éminence grise of the group was Erik Satie, who was in his fifties during the Jazz Age and, partly for his ascetic lifestyle, was considered a figure of gravitas and mystery. He had been born in Honfleur, and legend has it fled his home in 1887 after being discovered in flagrante with the chambermaid. He took a "grant" of 1,600 francs from his father to rent an apartment with barely room for a piano in Paris, where he made his living conducting a cabaret orchestra. The one great emotional episode of his life was his affair with his neighbor, the notorious model (for Toulouse-Lautrec, Picasso, and many others) and former trapeze artist Suzanne Valadon, which ended in 1893. By that time, his mesmerizing *Gymnopédies* for piano had become famous (they are favorites of amateurs to this day), although they were published with his father's help. Satie's reclusive existence was part of his aura. He never let anyone inside his modest apartment in the town of Arcueil, and preferred to compose in cafés or the home of friends — often to their despair, because Satie was as slow as Picasso was fast. All this may lend the impression that he would be dull and serious, but Satie was actually a great apostle of humor in music and on the stage, one of the reasons he became invaluable to the Ballets Russes. A photo of him by Man Ray captures the twinkle in his eye and impish smile that perfectly suit the lightness of his touch as a composer.

The other members of Les Six were also characters. A son of privilege (his family founded and controlled the massive chemical firm that became known as Rhône-Poulenc), the first major break for Francis Poulenc came on December 11, 1917, when his *Rhapsodie Nègre* premiered. As had Satie, the young composer rose from the café-concert and cabaret to more formal venues and expectations without leaving behind the fashionably "untrained" aura that, like the honky-tonk flavor of the ragtime pianist, lent cutting-edge credibility. Today we know the most modern of Poulenc through his archly clever score for *Les Biches*, a "ballet" that debuted in 1924 and used a harpsichord concerto written for the great Bach champion Wanda Landowska. Poulenc met her at one of the soirees of the Polignacs, where de Falla's *El Retablo de Maese Pedro*, based on a scene from *Don Quixote*, was given its aristocratic preview. The Polignacs thoughtfully provided not only refreshments but a full orchestra, with Landowska as soloist. Poulenc, understandably encouraged, wrote a carefree *concert-champêtre* for Landowska. In 1924 Cocteau and Diaghilev were looking for a ballet for women. It would be soft and sexy, with set designs by the painter Marie Laurencin that were all curves. Poulenc's elegant score for *Les Biches* suited the occasion. (It took until June 1929, but Poulenc also had his own noble house concert thanks to the Vicomte and Vicomtesse de Noailles, who gave him and his *Aubade* the star treatment.)

Among those in the audience at the premiere of *Les Biches* was Darius Milhaud, a veritable musical sponge who absorbed the mesmerizing local dance rhythms when he tailed along as personal secretary to the poet Paul Claudel, who was appointed France's minister to Brazil. Milhaud returned to Paris in 1919 and then, three years later, headed to the United States, where he stalked the clubs of Harlem to listen to such jazz greats as Yvonne George and James P. Johnson (master of the "Harlem Stride" school of piano playing), or the clubs of Fifty-Second Street where he heard Paul Whiteman and Billy Arnold, and the saxophone of Vance Loury. It was all a long way from the stuffy Paris Conservatoire, where he had taken top honors not only for counterpoint and fugue but for violin as well.

Just as it is said that certain actors can read the phone book and make it compelling theater, Milhaud prided himself on being able to set the most mundane textual sources, transforming them into unexpected lyrical and dramatic experiences with a humorous edge. Fascinated by the massive farm machines of an agricultural exhibition in Paris — which

Gr*and fromage* of the composers' group known as Les Six, Erik Satie was the witty genius behind *Parade* and other Ballets Russes masterpieces. He is caught here by the lens of Man Ray.

Heir to an already thriving pharmaceuticals empire, the composer Francis Poulenc was a darling of the aristocratic set who held private, staged previews of his ballets, such as *Les Biches* (1924).

made him think of giant insects — he scooped up copies of the sales brochures from the exhibitors' booths and made them his text for what many (including Leonard Bernstein) have called his masterpiece, the breakthrough, jazz-inflected symphonic work *La Création du Monde* (1924). Given the Parisian fascination with the pastorale, and the way machinery was au courant in the paintings of Léger and Murphy, the idea of an aria dedicated to the *déchaumeuse-semeuse-enfouisseuse* (harrow-plow, seeder, stubble burier) is as logical as it is audacious. In the unforgettable party scene of Fitzgerald's almost precisely contemporary *The Great Gatsby*, the orchestra plays "Vladimir Tostoff's Jazz History of the World," a remarkable coincidence, if not proof that Fitzgerald was attuned to the musical avant-garde, since Milhaud's piece had its debut only when Fitzgerald's novel was in proofs. Milhaud caused a sensation with the piece, which certainly "made a lady out of jazz" well before the concert hall triumphs of Gershwin and others. Some were not amused. The 1927 edition of *Grove's Dictionary of Music and Musicians*, compiled while the jury was still out on Milhaud's standing, has a stiff British take on his experimental work. The encyclopedia's contributor sniffs, "But his humour, too, is of a somewhat crude type, and in works such as his setting of a florist's catalogue for voice and chamber orchestra it verges disastrously on mere eccentric trifling." One would think with the British passion for perennials that the piece would have received more tender treatment.

In an essay on "l'évolution du jazz-band et la musique des nègres d'Amérique du Nord," Milhaud justifies his position: "This music is far from the elegant Broadway dances we hear at Claridges in Paris! In it we touch the very source of this music, the profoundly human aspect it is capable of possessing and which overwhelms you as completely as any other universally recognized musical masterpiece you care to mention." Milhaud was particularly taken with the rhythmic element of jazz. On a sociological level, some historians have suggested that as a Jew, he identified with the marginal place of blacks in America as well.

All this art, dance, and music took piles of money to produce. Thanks to the efforts of Diaghilev's Paris agent, Gabriel Astruc, the funds for many of his projects came not only from sympathetic French patrons — the fabulously wealthy Polignacs or de Beaumonts — but also from German Jewish families (Bischoffsheim, Gunzburg, Oppenheim, Natanson, Lazard, Schiff, Bernheim, and Guggenheim), many of them in finance. The great fortunes of the Third Republic, which had been steadily

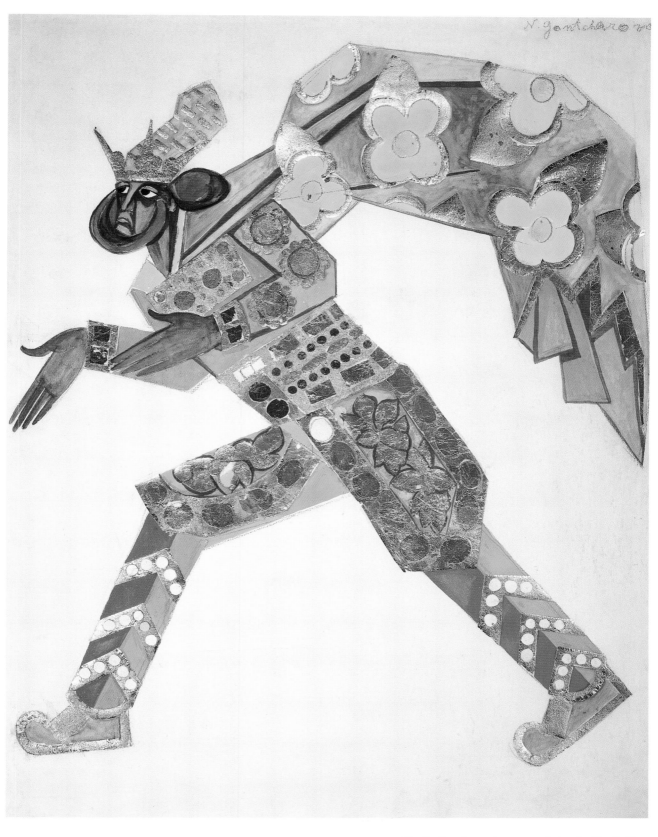

Natalia Goncharova's costume design for *The Golden Cockerel*. She and her husband, Mikhail Larionov, took the places of Alexandre Benois and Léon Bakst, the pre-War design stars of Diaghilev's company.

amassing with the bull markets that had started in the 1880s, were important sources of support for the arts.

In the meantime, Diaghilev suddenly found himself facing competition. There is nothing like a rich Scandinavian in love for mobilizing an art project. Rolf de Maré arrived in Paris in 1920 determined to showcase his young companion, a dancer named Jean Börlin, in tolerant Paris, as well as to promote the musical and terpsichorean traditions of Sweden (one senses that this was decidedly a secondary agenda). He created the Ballets Suedois, virtually every performance of which was choreographed by and starred Börlin. De Maré was an art collector who drew deeply upon his grandmother's copious bank account. To start the Ballets Suedois they unabashedly raided the chorus of the Stockholm Opera, paying lavish fees and top dollar to rent the lavish Théâtre des Champs-Elysées for an ambitious five seasons. They hired the rising star Roger Desormière as conductor and put together a superb orchestra. Never mind that the principals and the composers were not Swedes, and that they were scarcely doing ballet. They gave Diaghilev a run for his money, and the provocative manifesto published in the program for the 1924 season made clear their avant-garde ambitions: "The Ballets Suedois distrust all preconceptions, they live in space and not in time, they do not rely on the authority of anyone, do not follow anyone. They are in love with the moment and tomorrow will go still further onward."

The contest between the Ballets Russes and Ballets Suedois drove both companies to extremes. The winners were audience members excited to see innovation in dance and theater. The Ballets Suedois pushed the envelope, both musically and onstage, with Porter's *Within the Quota*. The Ballets Russes went from the groundbreaking *Les Biches* to the even more daring *Le Train Bleu*. New ballets to scores by Prokofiev and Stravinsky, including such masterpieces as *Prodigal Son* and *Apollon Musagete*, were in the wings.

No account of the Ballets Russes is complete without Cocteau. Catalysts are as vital as geniuses to artistic revolutions. The twentieth century was blessed not only with the immense talents who made the masterpieces, but with impresarios who delivered people and ideas

to one another, facilitating chemical reactions that led to breakthroughs. Part of their gift was often the ability to make things happen, to finish projects and get them on stage, in print, out to an audience. Diaghilev, clearly, was the maestro of the genre. Later years brought such figures as Ezra Pound, Andy Warhol, Nadia Boulanger, Pierre Boulez, and André Malraux. The most colorful and charming of the great catalysts, however, was Jean Cocteau. The true Cocteau is, from the present-day perspective, difficult to pin down despite the fact that many remember their own encounters with him. Smothered in political and sociological rhetoric, accounts of his life and deeds propagate agendas that ill serve this Ariel. Because he had so many irons in the fire artistically — ballet, theater, opera, film, poetry, criticism, painting and drawing, decor, and, for lack of a better term, aesthetics — academic specialists wave him aside as a dilettante. He was saddled with the label of lightweight for his comic gifts. Devotees of the giants by whom he stood (Stravinsky, Picasso, Satie, among many others) step on his shadow. Even the catchy formula by which the leading Diaghilev scholar, Lynn Garafola, describes part of Cocteau's contribution to the dance is a bit of a back-handed compliment: "lifestyle modernism," a blend of sophistication and the diurnal. Nobody would dare apply that to a Braque still life.

The real Cocteau? An extraordinary bundle of talents and pure creative energy whose label for his vocation — "poet" — applies as aptly to his quips (he would say *boutades*) as to the whiplash arabesques of his drawing or the fleet successes by which he corralled the top dogs in the arts for collaborative adventures that make our heads spin now when we consider the stars in the playbill. He seemed constitutionally incapable of being prosaic in any sense of the word. Nor was he an amateur, a common misapprehension even in his day, in any of his many fields of experimentation. One of the first of these all-star productions was the landmark operatic work *Parade*, which he pulled together by main force, marshaling the talents of Picasso and Satie, Massine, and the great conductor Ernest Ansermet for what he called a "realist ballet" that had its debut on May 18, 1917. Its success affirmed what those in his circle knew — that Cocteau had substance to go with his style.

Omnipresent behind the scenes at the Ballets Russes, Cocteau supplied the graphics for many productions, including this poster for *Le Spectre de la Rose.*

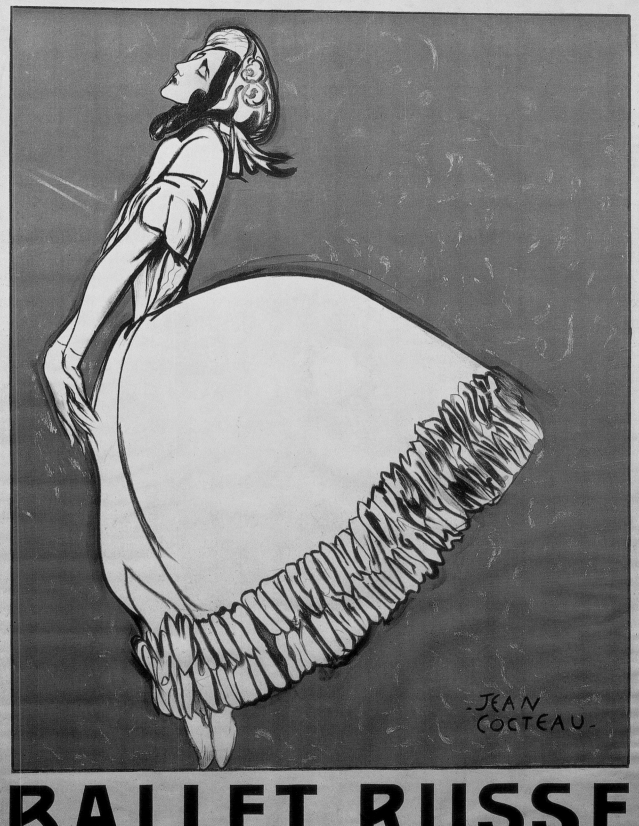

Finding a precedent or comparison for someone of Cocteau's unique stature is not easy, but his own boyhood fascination with the Belle Epoque offers one hint. Hovering as subtly as a silhouette in many of the crowds that Toulouse-Lautrec used in the background of his prints was often the unmistakable profile of Oscar Wilde, whose role in fin-de-siècle Paris offered the prototype. Like Wilde, Cocteau could make the art and act as the arbiter of taste. The mantle of this dual role was assumed by Cocteau at an amazingly young age — in his early twenties he was already the buzz-setter for the arts press in Paris — perhaps in part because the war (in which he had served as an ambulance corpsman) had decimated the ranks of his generation. A prodigy born to a small-town lawyer who committed suicide when Jean was nine, Cocteau daydreamed through his numbered days at the prestigious Lycée Condorcet until they threw him out. By the time he was nineteen he had drifted into the world of the actors, circus performers, composers, and choreographers that he would help to galvanize from 1909 on through his vastly productive collaboration with Diaghilev. When they met, the maestro delivered the celebrated line: *Etonne-moi* ("Astonish me").

As in Toulouse-Lautrec's day, access to areas of the theater now the exclusive province of players and union members was easy for the socially adept. Many of Cocteau's most entertaining and perceptive writings were informed by his backstage curiosity, verbal versions of the pastels of Degas or Toulouse-Lautrec. In an irresistibly written account of the performance-day rituals of an American transvestite clown called Barbette (his real name was Vander Clyde), Cocteau follows with admiration the highly professional preparation for the evening's "turn" from the sandwich and egg at home in the afternoon to the dressing-room solemnities all the way to the pulling off of the wig and the audience's mixed response. It is real smell-of-the-greasepaint stuff, elevating the "boy disguised for a joke" to an initiation into the secrets of the theater as Cocteau relished it, night after night. The piece sets up a philosophical paragraph that returns to Barbette's nationality and perhaps offers an insight into Cocteau's skeptical view of Yankees in general: "All minds which are disordered, sick, despairing, exhausted by the forces which threaten us from both shores of death, find repose in an outline. After years of vague Americanization when the capital of the U.S. hypnotized us, ordering 'hands up' as though producing a revolver, Barbette's turn shows me at last the real New York, with the ostrich plumes of its sea and its factories, its siren voice and its adornments, its aigrettes of electric lights." Forgiving the writer his shaky grasp of geography, we catch an interior glimpse of the basis for an uneasy romance with America.

A map of the artists and personalities gathered in France shows an archipelago of creative groups. Cocteau was an inveterate island hopper who helped form and keep these clusters together. He was alert to the need of artists to reach a responsive audience. This included both the undiscovered talent and those often forgotten or dismissed by the most avid denizens of the avant-garde, eager to move on to the new new thing. The essays, poems, plays, journalism — the volume of his written output — records his prodigious effort to make the theater- and gallery-goers of the day appreciate the pearls before them. "Know that your work speaks only to those on the same wavelength as you," he counseled fellow artists. Because so much of the period's most advanced art and thought emanated from a few tight circles — the remarkable Diaghilev coterie, Les Six, the Americans gathered under the Murphys' linden tree, the Pound disciples, the Picasso crew, the studio and café set of Montparnasse — and Cocteau was admitted to the inside of all, he can be viewed as the mastermind who fiddled with the dials capably and made sure these independent channels were on a compatible bandwidth. He was the epitome of avant-garde bravado, relishing a dust-up in a concert hall or, further echoes of Wilde, catcalls at the curtain. He kept the artists themselves on edge: "Respect movements. Flee schools." One's work could grow stale and be passé if the comfort level grew too high. Although quality and craft often take a backseat when a movement takes off (certainly a problem in our own contemporary art scene), Cocteau was not one to compromise. For all his celebrated speed as a draftsman and journalist, he lamented the lack of finish in what was quickly tossed off and presented as art: "Today we no longer see what is well done. It throws us off. It is in the direction of the well done that one must take one's course, those who count on the ill-done miss the boat." You can see Gerald Murphy, fresh from a morning in the studio applying a bead of black outline with a two-haired brush, or Ernest Hemingway, exhausted from a struggle with a not-quite-there descriptive paragraph, nodding in agreement. It reminds one of the revealing letter Toulouse-Lautrec wrote to his friend the sculptor and decorator Henri Nocq in 1896 in praise of William Morris and the books that he produced: "We could summarize

the following desideratum: Fewer artists and more good workers. In a word: more craft."

Cocteau knew not only how to make an entrance, but how to extricate himself as well. James Joyce swore by the dark motto, "Silence, exile, and cunning." In a similar if somewhat more sociable vein, Cocteau was a great advocate of what he termed "invisibility," a skill that combined elegant distancing with eagle-eyed perception. One of his favorite citations was Beau Brummell's aside to the Prince Regent: "I can't have been elegant at the ball, because you noticed me." Because he seems ubiquitous in accounts of the period — simultaneously, it seems, in Antibes and Paris and New York when all the important openings occur — we think of Cocteau as a ringmaster constantly in the spotlight. Like Diaghilev, however, he spent much of the evening in the obscurity of the wings, stroking his chin and mentally comparing the performance with the original dream from which his scenario was sketched

and then realized. A lovely line from *Diary of an Unknown* offers the valediction: "Withdraw quietly from the dance."

The most dramatic exit was Diaghilev's. Just as no one in the world of finance was genuinely prepared for the Wall Street crash of 1929, the family of the arts was unprepared for the sudden death of Diaghilev, from diabetes, in the summer of 1929. Curiously, Diaghilev had always dodged the entreaties of Picasso, Léger, Cocteau, Delaunay, and other artists to sit for a portrait, and avoided the camera, because he so despaired of aging. He was only fifty-seven when he lay on his deathbed in Venice, unable to fight a fever, singing passages from *Tristan und Isolde* and tended by Misia Sert and Coco Chanel (who had the Duke of Westminster bring the yacht into the harbor so she could see Diaghilev at the end). Within months, both the Ballets Russes and Ballets Suedois dissolved as swiftly and subtly as a chorus of swans glides offstage.

THE PARTY'S OVER

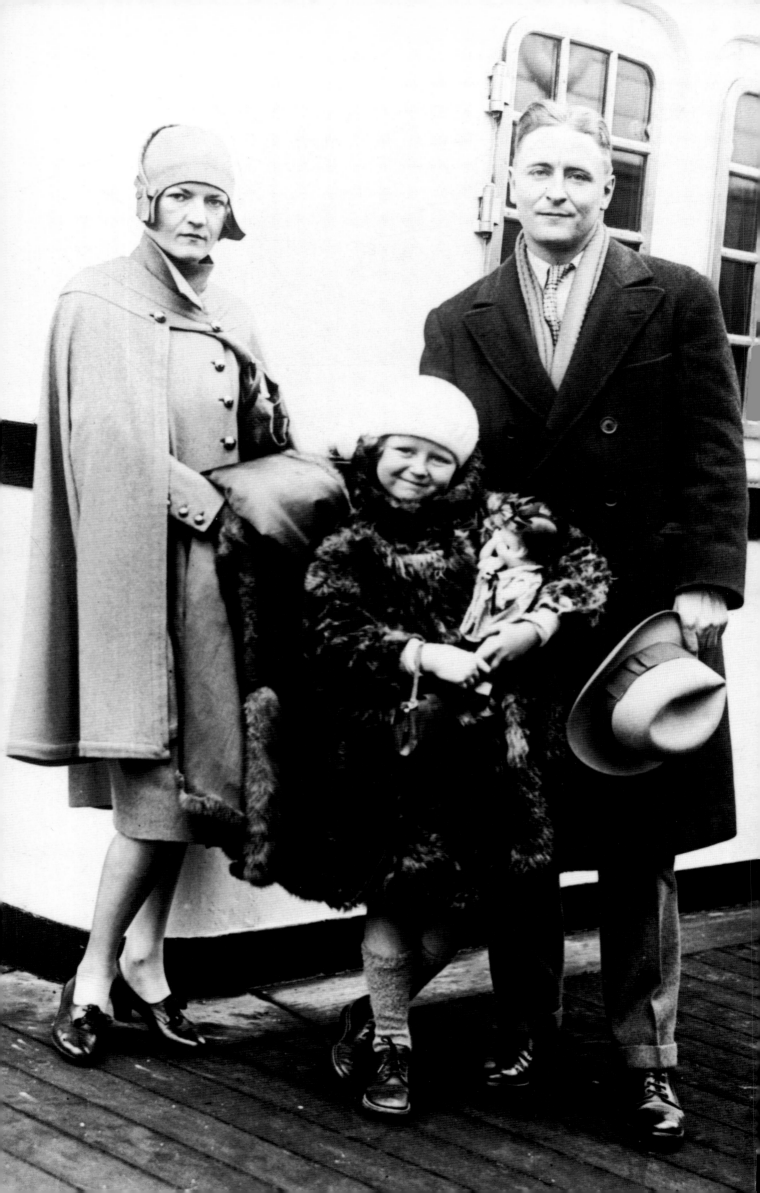

Dorothy Parker was a great support to her friend Sara Murphy during Patrick's long hospitalization in Switzerland.

"Paris had grown suffocating": The Fitzgeralds' voyage home aboard the *Aquitania,* the same liner that had carried them to Europe for the first time a decade earlier.

Swiftly the curtain came down on the *années folles.* In October of 1929, Wall Street endured the paroxysms of what we still call, even after similar market drops, The Crash. Beyond cutting off the funds that were the lifeblood of the party, the Depression was the knell that recalled the Americans to their Puritan duties back home. Gerald Murphy was summoned to the boardroom of Mark Cross, a company in fiscal disarray verging on bankruptcy. It was only the beginning of a sobering return to earth for him and Sara. Their younger son, Patrick, was diagnosed with tuberculosis, and would spend the precious few years he had left in sanitoriums in Switzerland and overlooking the East River in Manhattan. Gerald put down his paintbrushes for the final time as the worries mounted. He later remarked, "I was never happy until I started painting, and I have never been thoroughly so since I was obliged to give it up." Just six months before eleven-year-old Patrick passed away, however, a cruel stroke of fortune took his brother, who had contracted meningitis at boarding school and died at age fifteen. The extraordinary strength Gerald and Sara showed during this period inspired the last masterpiece devoted to them, their dear friend Archibald MacLeish's drama *J.B.* (after the Book of Job).

The clouds rolled in on the Fitzgeralds as well. For most of the thirties, Zelda was in and out of mental hospitals as her cycles of manic depression tightened, while Scott's drinking spun out of control. Both of their fathers died within a year, and the rift in their marriage deepened. Clinging as best he could to the stylistic attainments of the prior decade, he mined its sunny memories for material and, after many false starts, in 1934 produced its elegy: *Tender Is the Night.* As did many of the creative types, Fitzgerald soon followed the caravan to Hollywood to work on the first of a handful of Metro-Goldwyn-Mayer films. He died in Hollywood of a stroke in 1940, never having recaptured the brilliance of his Gatsby moment.

By then, Cole Porter was the toast of both Hollywood and Broadway. With each movie and show, the stars he wrote for grew progressively brighter, including Fred Astaire singing "Night and Day," Ethel Merman belting "Anything Goes" and "Another Op'nin' Another Show," and Bing Crosby crooning "True Love" to Grace Kelly in the cockpit of a sailboat off Newport. Soon there would be the Moss Hart

collaborations, *Kiss Me Kate* with Patricia Morrison and Alfred Drake, and even more chart toppers. Fellow Yalie Archibald MacLeish was recruited in 1929 by Henry Luce as one of the pioneering reporters for the new Time Inc. business magazine *Fortune*. After a decade as a journalist, he became Librarian of Congress, then started writing speeches for Franklin Delano Roosevelt and ended up in the State Department as assistant secretary. His poetry earned two Pulitzer Prizes.

Hemingway, too, was just hitting his stride in the thirties. With Sherwood Anderson on the wane, and Fitzgerald in his cups, Papa was the new heavyweight champion of the literary world. Until war recalled him to Europe as a correspondent, the new backdrop to his adventures became Florida and Cuba. French scenes, however, bubbled up in many of his later works, most notably that masterpiece of short fiction, "The Snows of Kilimanjaro."

The growth of liberal arts colleges for African-Americans in the South brought academic jobs for many of the black painters who had been in Paris, notably William H. Johnson, Hale Woodruff, and William Edouard Scott.

John Dos Passos, inveterate voyager, sailed back to the States and embarked on his epic *U.S.A.* trilogy as well as a lifelong tendency to mix it up in politics as an activist on the side of Labor and the Left, while his pal E. E. Cummings had family messes to tend to back

in New York, where he soon became central to the Greenwich Village literary scene.

As Picasso grew in stature, his Paris and Riviera studios became international gathering places for dazzled fans and greedy art speculators. Eventually, the Grimaldi castle in Antibes would house a museum dedicated to his work, and the ceramics he joyfully painted each summer by the Mediterranean would be a lifeline for artisans in the neighborhood who worked under his direction. Léger catapulted into the upper ranks of the international art set, thanks to the Murphys' tireless assistance, and his American shows were if anything as popular and ambitious as any he had in France.

If the chiaroscuro of sunshine and clouds seems particularly dramatic, we must remember that world historical forces abruptly defined the era of the Jazz Age. Past, present, and future are outlined with particular crispness when the contrasts are this sharp. After the deprivations of the war, joie de vivre enjoyed a renaissance. For artists, the urge to capture the present and all its excitement was immense. As steeped in the past and traditional technique as artists have to be, and as prophetic as they often prove with regard to future styles or ideas, the Jazz Age geniuses were celebrants of what was immediately at hand. Picasso's poetry, for instance, is almost entirely in the present tense. His rapid-fire

As Patrick Murphy endured one of his first treatments for tuberculosis in Montana-Vermala, Switzerland, in 1929, Fernand Léger did this tender drawing of his young friend.

drawings and delight in the photographic snapshot testify to his delight in the immediate. Léger celebrated the industrial machinery of the docks and garish billboards of the Place Clichy in Paris, incorporating their pushy typography in his big, bold paintings. He shared his marvelously miserly grasp on the sights and sounds of post–World War I Paris with the American visitors who walked its streets and riverbanks with him, listening to him rhapsodize over gears and winches. After a horrendous stint in the trenches near Verdun he was delirious with joy to return to normalcy. The Americans of course brought a tourist mentality, pausing to notice what the natives would call mundane, but this is also a hallmark of modern art, fiction, and music, which elevate to high art the scrap of paper (a cigarette label, a newspaper banner in collage) or street noise (Gershwin's appropriation of the Parisian cab horn). Fitzgerald's instant nostalgia for the good times just past, Hemingway's ear for snippets of overheard conversation between waiters, or MacLeish's attention to slang were the verbal equivalents of this infatuation with the ordinary. Think of Gerald Murphy's lovingly rendered details of pocket watches, razors, fountain pens, and other ordinary denizens of the tabletop or vanity, meticulously blown up to heroic scale. They are fanfares for the common object. They reflect the era's passion for the marketing aesthetic, the elaborately arranged store window, the well-designed print advertisement, the catchy magazine or sheet music cover. Unlike a Jeff Koons vacuum cleaner or an Andy Warhol soup can, however, these were rhapsodies without the ironic bite. It was early enough in Modernism for them to make their impact without undercutting.

Assessing the achievements of the Jazz Age, the extent of the breakthroughs is dazzling. Picasso made the leap from Cubism to Neoclassicism in his Riviera studios, painting the stately variants on the Farnese marbles and, in response, the bizarre biomorphic bathers against a blue never seen in his famous Blue Period. Porter elevated the musical to new heights of sophistication, while Diaghilev and his team fractured the rules of dance to create masterpieces that are canonic in our time. Dos Passos and Cummings threw out the style sheets and liberated poetry and prose from conventions of syntax and punctuation. Hemingway turned literary celebrity into performance art. Armed with their Parisian successes, African-American artists and performers were smashing the color barriers back home. Fitzgerald wrote the greatest sentence ever penned by an American on the Riviera, the plangent final words of *The Great Gatsby:*

"And so we beat on, boats against the current, borne back ceaselessly into the past."

The label of the Lost Generation has never been torn off, although it is interesting that figures of the time resisted it and the heirs are even more vehement in trying to dislodge it, as they frequently reminded me while I was researching this volume. What if we posit the idea that these refugees from anti-intellectual or politically and socially repressive societies *found* themselves in France in the twenties? The high degree of collaboration attests to the importance of finding each other. The Jazz Age will always be known as the heyday of the party with an arty edge. The making of art caught a great gust of energy from the collision of American and European storm fronts in a period of tenuous peace. One of the secrets of the creative success of the groups we have examined was the whole excitement symbolized by the transcending of borders. After all, they had all made the "crossing." Art moved beyond traditional divisions among nations and cultures, as well as gender, media, and academic categories. Intermarriage was in the air. Suddenly audiences were challenged and delighted by the yoking of gut-bucket jazz and the symphony, easel painting and advertising graphics, camouflage and set design, journalism and poetry or fiction, fashion and architecture, cinema and all of the above. In terms of aesthetic history, the epochal frontier crossing many of them dared was the move from expressionism to abstraction. As William Carlos Williams, who was there, observed, "The abstract kick was on."

"Lost and forever writing the history of their loss, they became specialists in anguish," wrote Alfred Kazin in his classic study of the literary progress of the group, *On Native Grounds*. The comet trails blazed across the artistic and literary firmament by these spectacular explosions proved beautiful and long lasting. Far from being consigned to period taste and rapidly losing impact as they became outmoded, the art, design, literary styles, and thinking of these shock troops of the avant-garde resounded in the reception of Modernism both back home in the U.S. and internationally. In response to their giddy heights and their spirals into darkness as well, the artists and writers developed startlingly original modes of writing, painting, posing, and dancing that have never been fully explicated. Plumbing the secrets of the art and the lives, we bring to light the full contribution of an extraordinary group to our modern aesthetic sense. The books on our shelves, the paintings in our museums, the dances in the repertoire, the songs we sing along to on the radio are all echoes of the Jazz Age.

For Further Reading

The literary treasures of the Jazz Age include masterpieces by F. Scott Fitzgerald (*The Great Gatsby* and *Tender Is the Night*), Ernest Hemingway (*A Farewell to Arms* and the short stories set in Paris, such as "A Clean, Well-Lighted Place," as well as the controversial but irresistible memoir, *A Moveable Feast*), Gertrude Stein (*The Autobiography of Alice B. Toklas*), and John Dos Passos (the powerful and neglected trilogy *U.S.A.*), all available in standard and many paperback editions. In addition to these major works, a wealth of insight and pleasure is offered by some of the lesser-known novels and memoirs, including Zelda Fitzgerald's *Save Me the Waltz* (in *The Collected Writings*, Scribner, 1991), Jean Cocteau's *Past Tense* (Harcourt, Brace, Jovanovich, 1988), the journals of Edmund Wilson (*The Twenties*, Farrar, Straus & Giroux, 1975), the *Virgil Thomson Reader* (Houghton Mifflin, 1981), *Archibald MacLeish: Reflections* (University of Massachusetts, 1986), Malcolm Cowley's *Exile's Return* (Viking Press, 1951), and Elsa Maxwell's *R.S.V.P.* (Little, Brown, 1954).

Gerald and Sara Murphy have been blessed in their biographers as the subjects of Calvin Tomkins's slim and elegant *Living Well Is the Best Revenge* (Viking, 1971), Amanda Vaill's comprehensive *Everybody Was So Young* (Broadway Books, 1999), and their daughter Honoria Murphy Donnelly's *Gerald and Sara: Villa America and After* (New York Times Books, 1982). There are big, fat biographies of all the stars of the Jazz Age. The Fitzgeralds have been covered individually and as a couple by such notable biographers as Matthew Bruccoli (*Some Sort of Epic Grandeur*, Harcourt, Brace, 1981), Nancy Milford (*Zelda*, Harper & Row, 1970), James R. Mellow (*Invented Lives*, Houghton Mifflin, 1984), Kendall Taylor (*Sometimes Madness Is Wisdom*, Ballantine, 2001),

and, if I may be so bold as to recommend a book I edited, the French literary scholar André LeVot (*F. Scott Fitzgerald*, Doubleday, 1983). Ernest Hemingway's first biographer was my teacher Carlos Baker (*Ernest Hemingway: A Life Story*, Scribner, 1969) and he has also been examined by James R. Mellow (*Hemingway: A Life Without Consequences*, Houghton Mifflin, 1992), Michael S. Reynolds (*Hemingway: The Paris Years*, Blackwell, 1989) and A. E. Hotchner (*Papa Hemingway*, Morrow, 1983). Although John Richardson's multi-volume life of Picasso has not yet reached the twenties, the period is covered by his friend Pierre Daix (*Picasso: Life and Art*, HarperCollins, 1993) and by Pierre Cabanne (*Picasso: His Life and Times*, Morrow, 1977), as well as by several art historians in museum catalogue essays and articles. Superb biographies offer behind-the-scenes views of our theatrical leading men, Sergei Diaghilev (Richard Buckle's *Diaghilev*, Atheneum, 1979) and Cole Porter (*The Life That Late He Led* by George Eells, G.P. Putnam's, 1967, and *Cole Porter* by William McBrien, Knopf, 1998).

For deeper detail on the art, literature, music, and history of the period, allow me to recommend Kenneth Silver's *Making Paradise: Art, Modernity, and the Myth of the French Riviera* (MIT Press, 2001) and his *Esprit de Corps: The Art of the Parisian Avant-Garde and the First World War, 1914–1925* (Princeton University Press, 1989), along with Jack Anderson's *The One and Only: The Ballet Russe de Monte Carlo* (Dance Books, 1981), Lynn Garafola's *Diaghilev's Ballets Russes* (Oxford University Press, 1989), Theresa Leininger's *Paris Connections: African-American Artists in Paris* (QED, 1992), and Roger Nichols's *The Harlequin Years* (University of California Press, 2002).

Photograph Credits

4–5, 16, 30, 31, 32, 33, 34, 36 above and middle, 40, 41, 47, 48, 49, 50, 51, 112, 113 below, 128, 144, 171, 172, jacket back (row 1 left, center right, and right; row 2 center left): © 2004 Estate of Honoria Murphy Donnelly. Used by permission. 7, 14, 42, 57, 79, jacket back (row 1 center left): © 2004 Richard Lee Brennan/Estate of Fanny Brennan. 17: Collection of Suzanne and Stephen Weiss. Courtesy of Acquavella Contemporary Art, New York. 19: Henry Botkin, *An American in Paris*, 1929, oil on wood panel, three parts: 72 x 30", 78 x 30", 72 x 30". Private Collection; Courtesy of Michael Rosenfeld Gallery, New York, NY. 20–21: The Shubert Archive. 23–25, 88, 90, 92, 160, endpapers, jacket front: Graphic Arts Collection, Princeton University Library. Charles Rahn Fry Pochoir Collection. 27: Pavel Tchelitchew (1898–1957), *Pierrot*, 1930, oil on canvas, 21 1/4 x 28 3/4", signed. Courtesy of Michael Rosenfeld Gallery, New York, NY. 35: Collection of Dallas Museum of Art, Foundation for the Arts Collection, gift of the artist. © 2004 Estate of Honoria Murphy Donnelly. Used by permission. 36 below: Estate of Fanny Brennan, Courtesy of Salander-O'Reilly Galleries, New York. 38–39: Estate of Honoria Murphy Donnelly. Courtesy of Salander-O'Reilly Galleries, New York. Used by permission of Artists Rights Society (ARS), NY. 46: The Metropolitan Museum of Art, Rogers Fund, 1951; acquired from the Museum of Modern Art, Lillie P. Bliss Collection. (53.140.4) Photograph © 1994 The Metropolitan Museum of Art. 52: *Wasp and Pear* by Gerald Murphy (1927). Oil on canvas, 36 x 38 5/8" (93.3 x 97.9 cm). The Museum of Modern Art, New York. Gift of Archibald MacLeish. Photograph © 2004; The Museum of Modern Art, New York. © 2004 Estate of Honoria Murphy Donnelly. Used by permission. 53: *Cocktail* by Gerald Murphy (1927). Courtesy of the Whitney Museum of American Art. Purchase, with funds from Evelyn and Leonard A. Lauder, Thomas H. Lee and the Modern Painting and Sculpture Committee. 95.188. Photography by Geoffrey Clements. © 2004 Estate of Honoria Murphy Donnelly. 55: Private collection, New York. Courtesy of Salander-O'Reilly Galleries, New York. © 2004 Estate of Honoria Murphy Donnelly. Used by permission. 56: Courtesy of SBC Communications, Inc. and Hirschl & Adler Galleries, New York. 60, 62, 63, 66, 67, 68, 70, 71, jacket back (row 3 left and center): The Cole Porter Collection, Yale Music Library, Yale University, New Haven, CT. 64–65: Photograph by Sonia/Courtesy of *Vogue*, Condé Nast Publications Inc. 74, 76, 77, 78, 84, 168, 170, jacket back (row 3 right): Department of Rare Books and Special Collections, Princeton University Library, F. Scott Fitzgerald Papers. 93: Archibald J. Motley, Jr. (1891–1981), *Cocktails*, c. 1926, oil

on canvas, 32 x 40", signed. Collection of John P. Axelrod; © Valerie Brown; Courtesy of Michael Rosenfeld Gallery, New York, NY. 94, 97, 100 below, 103 above: Archives of American Art/Smithsonian Institution. 95: Henry Ossawa Tanner (1859–1937), *Coastal Landscape, France*, c. 1912, oil on gessoed panel, 9 x 13", signed. Collection of Ruby Tanner Rosenfeld; Courtesy of Michael Rosenfeld Gallery, New York, NY; *Birthplace of Joan of Arc at Domremy-la-Pucelle*, 1918, oil on wood panel, 9 x 13", signed. Private Collection; Courtesy of Michael Rosenfeld Gallery, New York, NY. 96: William Edouard Scott (1884–1964) *Along the Seine, Paris*, 1914, oil on canvas, 18 x 21 ", signed. Private Collection; Courtesy of Michael Rosenfeld Gallery, New York, NY. 98: Hale Woodruff (1900–1980), *The Peasant's House, France*, c. 1928, watercolor and gouache on paper, 14 x 17", signed. Private Collection; © Estate of Hale Woodruff/Elnora, Inc., Courtesy of Michael Rosenfeld Gallery, New York; *Normandy Landscape*, 1928, oil on canvas, 21 x 25 5/8", signed. Collection of the Baltimore Museum of Art; © Estate of Hale Woodruff/Elnora, Inc., Courtesy of Michael Rosenfeld Gallery, New York, NY. 99: *Medieval Chartres*, c. 1928, oil on canvas, 18 x 24", signed. Private Collection; © Estate of Hale Woodruff/Elnora, Inc., Courtesy of Michael Rosenfeld Gallery, New York, NY. 100 above: William H. Johnson (1901–1970), *Cagnes-sur-Mer*, 1928, oil on canvas, 19 x 23", signed, Courtesy of Michael Rosenfeld Gallery, New York, NY. 101: *Village Street, Cagnes-sur-Mer*, c. 1928–29, oil on canvas, 24 x 20", signed. Private Collection; Courtesy of Michael Rosenfeld Gallery, New York, NY. 102: Palmer Hayden (1890–1973), *A Corner in La Coupole*, c. 1935, ink and wash on paper, 11 x 15", signed. Private Collection; Courtesy of Michael Rosenfeld Gallery, New York, NY. 103 below: *Harbor Scene, France*, c. 1929, oil on canvas, 9 x 13", signed. Courtesy of Michael Rosenfeld Gallery, New York, NY. 106: Photo EH 7281N. The John F. Kennedy Library. 108 above, 110, 111, 152, 153, jacket back (row 2 left): Department of Rare Books and Special Collections, Princeton University Library. 108 below, 119, 162 above, jacket back (row 2 center right): © 2004 Man Ray Trust/Artists Rights Society (ARS), NY/ADAGP/Paris. Collection Timothy Baum, New York. 113 above, 152 below, 153, jacket back (row 2 right): Graphic Arts Collection, Department of Rare Books and Special Collections, Princeton University Library. 115, 116, 117: © Lucy Dos Passos Coggin, photographs by Katherine Wetzel. Courtesy of University of Richmond Museums, Richmond, Virginia. 120, 121, 122, 123: Courtesy of Ken Lopez Bookseller, Hadley, Massachusetts. 130: Private Collection, New York. Courtesy of Mitchell-Innes & Nash, New York. 132: Le Siphon (1924) by

Fernand Léger. Oil on canvas. 35 13/16 x 23 5/8" (91 x 60 cm). Collection Rafael Tudela Reverter, Caracas. © 2004 Estate of Fernand Léger/Artists Rights Society (ARS), New York. 133: © 2004 Estate of Fernand Léger/Artists Rights Society (ARS), New York. 134–135: Musée National Fernand Léger, Biot, France/Giraudon/Bridgeman Art Library. © 2004 Estate of Fernand Léger/Artists Rights Society (ARS), New York. 137: Musée Picasso, Paris, France/Giraudon/Bridgeman Art Library. © 2004 Estate of Pablo Picasso/Artists Rights Society (ARS), New York. 138–139: Hermitage, St. Petersburg, Russia/Bridgeman Art Library. 140: Jan and Marie-Anne Krugier-Poniatowski Collection. Photo: Patrick Goetelen. Courtesy of C&M Arts, New York. 141: Private Collection/Peter Willi/Bridgeman Art Library. 142: © 2004 Estate of Pablo Picasso/Artists Rights Society (ARS), New York. 143: Collection of Michael and Judy Steinhardt, New York. Photo: Chris Burke. Courtesy of C&M Arts, New York. 145, 146: Musée Picasso, Paris, France/Peter Willi/Bridgeman Art Library. © 2004 Estate of Pablo Picasso/Artists Rights Society (ARS), New York. 147: Musée Picasso, Paris. Giraudon/Bridgeman Art Library. © 2004 Estate of Pablo Picasso/Artists Rights Society (ARS), New York. 150, 154–155: Dance Collection, New York Public Library. 152 above: Private Collection/Roger-Viollet, Paris/Bridgeman Art Library. 158–159: Private Collection/Bridgeman Art Library. 163: Scottish National Gallery of Modern Art, Edinburgh, UK/Bridgeman Art Library. 165 below: The Fine Art Society, London, UK/Bridgeman Art Library.

Text Credits

44, 45: Excerpts from "Sketch for a Portrait of Mme. G— M—," from *Collected Poems 1917–1982* by Archibald MacLeish. Copyright © 1985 by The Estate of Archibald MacLeish. Reprinted by permission of Houghton Mifflin Company. All rights reserved. Quoted by permission of the Estate of Archibald MacLeish. 67, 69: Excerpts from lyrics by Cole Porter, Copyright © 2004 Chappell & Co., Inc. International Copyright Secured. All Rights Reserved. By permission of the Trustees of the Cole Porter Musical and Literary Property Trusts. 85: Excerpt from "The Hours" by John Peale Bishop, Courtesy of the Manuscripts Division, Department of Rare Books and Special Collections, Princeton University Library. Published with permission of the Princeton University Library. 125: From *E. E. Cummings, Complete Poems 1904–1962*, edited by George J. Firmage. © 1991 by the Trustees for the E. E. Cummings Trust. All Rights Reserved. Used by Permission of Liveright Publishing Corporation, New York.

Index

A

Apollinaire, 130, 136, 141, 151

B

Baker, Josephine, 16, 18–22, *20–21*, 24, *24*, 25, *25*, 89, 91, 92, *92*, 118
Balanchine, George, 15, 16, 26, 152–57
Barry, Philip and Ellen, *4, 5*, 6, 36, *36*, 37, 40, *40*, 42, 54–57
Beach, Sylvia, 15, 83, 89, 110
Benchley, Robert, 16, 32, 37, 40, *40*, 41, *41*
Benét, Stephen Vincent, *14*, 15, 37
Börlin, Jean, 23, *23*, 54, 133, 164
Braque, Georges, 26, 48, 108, *108*, 117, 142, 157
Brennan, Fanny Myers, 6, *7*, 36, *36*, 37, 41, *41*
Bricktop, 16, 66, 69, 89, 91

C

Cendrars, Blaise, 26, 124, 130, 131, 136
Cézanne, Paul, 22, 108, *108*, 109, 125, 130
Chanel, Coco, 15, 142, 160, 167
Chaplin, Charlie, 133, *133*, 136
Cocteau, Jean, 15, 16, 22, 48, 54, 69, 114, 118, 125, 133, 136, 141, 142, 151, 160, 161, 164–67, *165*
Colin, Paul, 6, 23, *23*, 24, *24*, 25, *25*, *88*, 89, 92, *92*
Cummings, E. E., 15, 16, 26, 37, 75, 107, 114, 117–20, *119–21*, 122–25, *122, 123*, 172, 173
Cummings, Marion Morehouse, 121, *121*

D

Diaghilev, Sergei, 15, 22, 37, 48, 54, 66, 114, 117, 121, 125, 133, 141, 142, *142, 150*, 151–52, *152*, 156–57, 161–64, 166, 167, 173
Dos Passos, John, 15, 16, 26, 32, 37, 42–44, 48, 75, 76, 80, 82, *106*, 107, 111–25, *113, 115, 116, 117*, 131, 172, 173
Dos Passos, Katy, 113, *113*

F

Fitzgerald, F. Scott and Zelda, 15, 16, 18, 22, 26, 31, 33, 37, 42–44, 54, 57, *74*, 75–85, *76–79, 84*, 107, 112, 121, 124, 125, 162, *170*, 171–73
Fitzgerald, Scottie, 75, *84, 170*, 171

G

Gershwin, George, 15, 19, 62, 64, 66, 161, 162, 173
Goncharova, Natalia, 15, 26, 47–49, 115, 129, 131, 133, 157, *158–59*, 163, *163*

H

Hayden, Palmer, 89, 91, 102, *102*, 103, *103*
Hemingway, Ernest, 15, 16, 18–22, 26, 31, 33, 37, 42–44, 69, 77, 79–83, *106*, 107–14, *108, 110, 112*, 118, 121, 124, 125, 131, 136, 166, 172, 173
Hemingway, Hadley, 44, 77, 81, 108–14, *111, 112*, 121
Hemingway, Jack "Bumby," 108, *108*, 111, *111*, 112
Hemingway, Pauline Pfeiffer, 40, *40*, 77, 111, *111*, 112–14, *112*

J

Johnson, William H., 15, 16, 89, 91, 93, 97–102, *100, 101*, 172
Joyce, James, 26, 83, 107, 118, 124, 167
Jozan, Edouard, 76–77, 78

L

Léger, Fernand, 15, 16, 26, 31–32, 34, 37–38, *38, 39*, 43–44, 48, 54, 79–80, 94, 110, 115, 125, *128*, 129–41, *130, 132, 133, 134–35*, 162, 167, 172–73, *172*
Lifar, Serge, 66, *150*, 151, 154, *154–55*

M

MacLeish, Archibald and Ada, 15, 16, 22, 26, 33, 40, *40*, 42, 44–45, 52, 57, 69, 75, 80, 82, 111, 114, 118, 121, 124, 131, 171–73
Man Ray, 15, 108, *108*, 119, *119*, 131, 136, 161, 162, *162*
Massine, Leonid, 26, 133, 142, 152, 156, 157, 160, 164
Matisse, Henri, 22–26, 89, 108, *108*, 109, 118, 142, 157
Maxwell, Elsa, 15, 66, 67, *67*, 69, 91
Milhaud, Darius, 54, 134, 160, 161–62
Murphy, Gerald and Sara, *4–5*, 6, 15–16, *16*, 18, 22, 26, *30*, 31–57, *33–36, 38–41, 46*, 48–53, *55–57*, 61, 63–64, 66–67, *67*, 69,

75–83, 91, *106*, 107, 110–12, *112*, 114, 118, 121, 124–25, 129, 131, 133, 136, 140, 143, *144*, 157, 162, 166, 171–73
Murphy, Honoria, 6, *7*, 31, *31*, 34, 35, 41, *41*, 112, *112*
Murphy, Patrick (Gerald's father), 32, 54, 56
Murphy, Patrick (Gerald's son), 34, 35, 37, 112, 171, 172, *172*
Myers, Alice Lee, *14*, 15, 37, 41, *41*, 42, 79, *79*
Myers, Richard, *14*, 15, 31, 37–43, *41*, 42

N

Nijinsky, Vaslav, 152–53, *153*, 156, 157

P

Parker, Dorothy, 15, 16, 37, 41, *41*, 171, *171*
Pfeiffer, Virginia, 16, *16*, 111
Picasso, Pablo, 15, 16, 22, 26, 33, 36, 37, 41, *41*, 42, 44–49, *46–48*, 54, 77, 79, 93–94, 108, *108*, 109, 114, 117, 118, 121, 125, 129, 133, 136, 137, *137–39*, 139, 140–46, *140–47*, 157, 160, *160*, 161, 164, 166, 167, 172–73
Picasso, Olga, 45, 137, *137*, 141, 143, *143*, 157
Porter, Cole and Linda, 15, 16, *16*, 19, 22, 26, 31, 33, 45, 49–54, *50, 60*, 61–69, *62–68, 70, 71*, 75, 79, 91, 107, 118, 124, 164, 171–73
Poulenc, Francis, 160, 161, 162, *162*

S

Satie, Erik, 15, 54, 142, 160–62, *162*, 164
Scott, William Edouard, 96–97, *96*, 172
Sert, Misia, 47, 151, 156, 167
Stein, Gertrude, 15, 37, 45, 81, 83, 85, 89, 91, 108–9, *108*, 110, 141
Stravinsky, Igor, 16, 26, 37, 93, 114, 156, 157, 160, 161, 164

T

Tanner, Henry Ossawa, 15, 89, 94–97, *94, 95*, 100
Tchelitchew, Pavel, 26, 27, *27*
Toklas, Alice B., 108, *108*

W

Woodruff, Hale, 89, 93–94, 97, *97, 98*, 99, *99*, 172